Images of a Journey
India in Diaspora

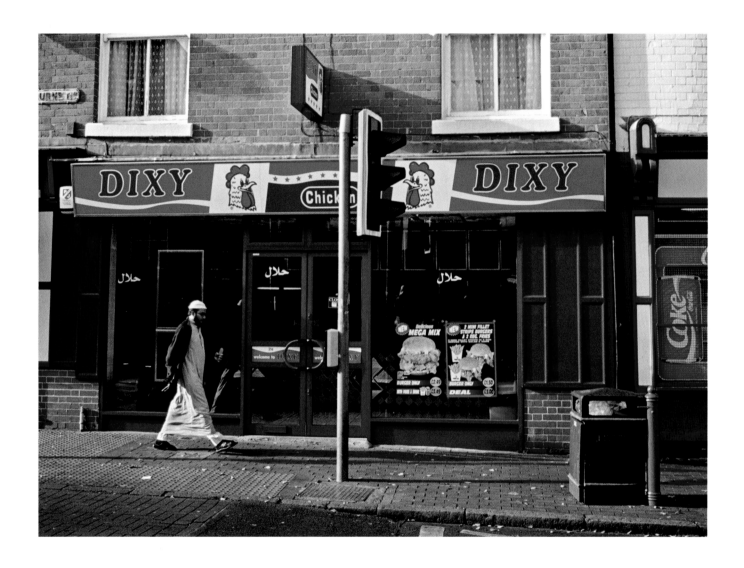

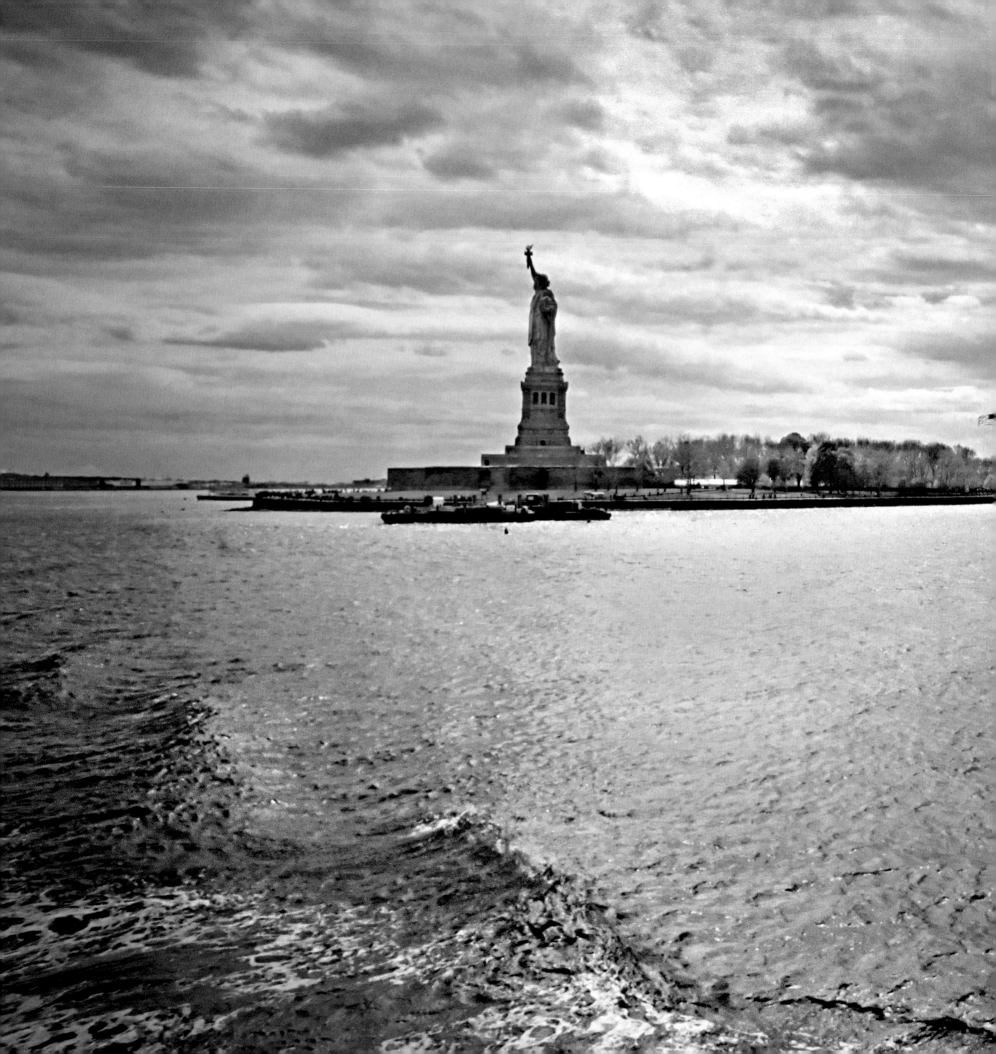

Images of a Journey
India in Diaspora

Steve Raymer

Foreword by
Nayan Chanda

Indiana University Press
Bloomington and Indianapolis

(PAGE 1)

Dressed for Friday prayers, a devotee
of Islam strides the slightly down-at-
the-heels streets of Leicester, where
Hindus, Sikhs, and, increasingly,
Muslims from the Indian Subcontinent,
East Africa, and the Balkans have made
the English Midlands city a model of
ethnic harmony.

(PAGES 2–3)

Icon at the mouth of the Hudson River
in New York Harbor, the Statue of
Liberty welcomes Americans, visitors,
and immigrants, including South
Asians on a sightseeing tour boat. The
United States, home to 2.32 million
persons of Indian origin, is perhaps the
greatest beneficiary of the worldwide
migration of Indians—people who
often bring a facility with English,
education credentials, democratic
ideals, and a tolerance for other
cultures to the more than
100 countries where they
live and work.

Indiana University Press thanks the following sponsors for their generous support
of the publication of *Images of a Journey: India in Diaspora*:

Anonymous
John C. Brewer and Ann K. Brewer
Ellen and Alfred Kohlberg, Jr.
Chandrodaya Prasad and Shilpashree Sadashivaiah

This book is a publication of

Indiana University Press
601 North Morton Street
Bloomington, IN 47404-3797 USA

http://iupress.indiana.edu

Telephone orders 800-842-6796
Fax orders 812-855-7931
Orders by e-mail iuporder@indiana.edu

Produced by Charles O. Hyman, Visual Communications, Inc., Washington, D.C.
Designed by Kevin R. Osborn, Research & Design, Ltd., Arlington, Virginia

Library of Congress Cataloging-in-Publication Data
Raymer, Steve.
 Images of a journey : India in diaspora / Steve Raymer ; foreword by Nayan Chanda.
 p. cm.
 ISBN 978-0-253-34959-0 (cloth : alk. paper) 1. East India diaspora.
 2. East India diaspora—Pictorial works. 3. East Indians—Foreign countries.
 4. East Indians—Foreign countries—Pictorial works. I. Title.
 DS432.5.R38 2007
 305.891'4—dc22
 2007009434

1 2 3 4 5 12 11 10 09 08 07

Contents

Foreword

Nayan Chanda

Wanderlust has created the world we know today. Ever since our human ancestors walked out of Africa in search of a better life, the journey has not stopped. That incessant journey or "scattering to the winds" summed up in the Greek word *diaspora* has emerged as a prominent factor in the making of a globalized world. With the rise of information technology India's role in globalization has earned belated recognition but the story goes far back. Indian traders represent one of the oldest diaspora communities in the world. An ancient Indian text observed the perils and promises of those who left home in search of a better life in Suvarnadvip (golden island) as modern-day Indonesia was known in the first millennium: "Who goes to Java, never returns. If by chance he returns, then he brings back enough money to support seven generations of his family." Researchers continue to find evidence of cultural intermingling in Southeast Asia that probably harks back to an Indian presence in the early centuries of the common era. Meanwhile, recently unearthed archaeological evidence also points to the presence of Indian traders settled in the Egyptian port of Berenike on the Red Sea, at around the same time. Imagine the surprise of Alexander the Great's troops in the fourth century before the common era, when they came across a colony of Indian traders as they invaded the island of Socotra—Shuktara (happy star) in Sanskrit—off the coast of Aden. The slow trickle of migration and overseas settlement changed dramatically in the colonial period. To the earlier wanderlust of traders and fortune-seekers was added a whole new class of people, from sepoys (soldiers) to convicts and bonded plantation labor, most of whom were forced or tricked to cross the "black water," as the vast ocean was fearfully called. European companies and colonists packed steamboats to carry over a million Indians to various corners of the world from which they would never return. From the Pacific to the Caribbean, from Malaysia to South Africa, the Indian diaspora has grown, creating enclaves of Indian languages and cultures amidst hitherto unknown peoples.

India's awakening to independence at midnight in August 1947 altered the long-established equation, with millions of Indians voluntarily leaving their homes in search of a better life elsewhere, the most attractive being the former colonial countries and the rising economies of Europe and the United States. Opportunities for employment in the oil-rich Middle East also offered a strong pull. By the beginning of the twenty-first century, the Indian diaspora had swelled to some 20–25 million, touching every continent. As Steve Raymer wryly notes, there is even an Indian research station in Antarctica. Whereas the members of the research station have only penguins for company—the Indian diaspora everywhere else has transplanted its traditions and culture on adopted soil, transforming the indigenous culture as well as changing others around. Trinidad's Marianne River has been reimagined as the holy Ganges and a golden-domed gurudwara has been raised to dominate Silicon Valley.

The revolution in transportation and communication technologies has, however, introduced a new twist to the old story of disapora transformation. Thanks to affordable air travel, the homeland left behind is no longer lost forever. Thanks to dozens of satellite television channels, diaspora Indians are being nourished and entertained by news, music, and movies from their fast-changing homeland. Many who had lost languages and traditions due to centuries of separation are relearning and re-appropriating their culture. There is a new sense of pride in their now-prospering country. India's rising economy and especially the success of its IT industry have for the first time encouraged reverse migration and created what Steve Raymer calls "reverse diaspora"—Silicon Valley—returned Indians living in gated communities in Bangalore, creating their own diaspora of Indian-Americans—living the American life and work-style in the midst of Indian familial and cultural patterns.

India's diaspora has inspired a rich literature—from scholarly studies to fiction. Steve Raymer's collection of vibrant images offers, for the first time, faces of these time-travelers and their descendants in all their pathos and pride, solemnity and playfulness. There are few photojournalists as qualified as Steve Raymer to document the epic saga of the Indian diaspora. Steve has spent over three decades covering Asia for *National Geographic* magazine and has developed an unblinking eye for capturing both the iconic and the particular images of Indias abroad—people at home and at work, foods and festivities, with all their distinctive flavors and colors. His photographs and his pithy, well-researched descriptions reveal a sensitive and sympathetic, yet critical mind. His nuanced portrayal of the diaspora shows an amazing range of emotions and his images grab you with a directness that makes you almost smell the incense and the spices from his richly textured photographs. While his portraits of generations of Indians, especially the less fortunate, are suffused with nostalgia and pathos, the vibrancy of a successful community is, on the other hand, often revealed with a touch of sardonic humor. The photographs are deeply evocative—a sumptuous visual feast to savor and relish.

A Word about Journalism and Reporting on the Diaspora

Roger Cohen, former foreign editor of the *New York Times*, writes that what brought friends of his to journalism was "probably some mixture of idealism, curiosity, wanderlust, insubordination, sentimentality, passion, and appetite." And he's right.

To my mind, journalism will always be more of a calling than a career—a reality that is sometimes difficult for my students to accept. Rarely do journalists travel through life in a straight line with well-marked measures of success. Still, most journalists take satisfaction in seeing the world up close. As I look back on my career, what come to mind are memories of reporting on the collapse of the former Soviet Union and the final chapters of the war in Vietnam—both of which I had the privilege of witnessing at close range.

As a professor, I am charged with the professional and intellectual preparation of students who are about to enter a globalized world—a world that will require them to constantly acquire new skills and knowledge. Students must learn to doubt, challenge, and engage the world robustly with an independence of mind and spirit. Yet, to be a journalist in America, there are no required courses, no requisite degrees, no licenses, and no exams to sit for. We have the First Amendment to thank for that. The journalists whom I most admire possess imagination, initiative, an interest in history, politics, other cultures, and the sciences—and a commitment to be a faithful witness.

I say this because, in the end, *Images of a Journey* is a work of journalism and should be judged as such.

Cohen, who writes now for the widely respected *International Herald Tribune*, is surely correct when he says that the best journalism is "more a journey without maps, and damn the destination." And so it has been with this odyssey of the Indian diaspora.

Images of a Journey has taken me around the world several times over. It also has allowed me to reconnect with India after a 20-year hiatus. I traveled well-worn routes around Asia, from Burma to Indonesia, and back and forth across the Atlantic to Israel, Dubai, and South Africa. At one point I volunteered to teach an Indiana University journalism class in London, where old friends and new helped me understand how Great Britain, once so familiar when I was a younger man, has become more diverse and multicultural. Closer to home, I ventured onto the streets of Brooklyn and Queens, boroughs of New York City that were only names in the newspaper until this book began. Silicon Valley nearly eluded me, with its crowded freeways connecting acres of nondescript office buildings and strip malls. Eventually I found "the valley" in the Asian restaurants and computer labs that have changed the way the world does business and the way we connect to one another.

A book of this magnitude, of course, would have remained an idea if it were not for the support—professional, personal, and financial—of countless friends, colleagues, drivers, guides, minders, officials, and other people who wanted nothing more than to help. I begin at Indiana University.

I want to express my gratitude for the generous

support, guidance, and unflagging friendship of Dr. Sumit Ganguly, the Rabindranath Tagore Professor of Indian Cultures and Civilizations and Director of the India Studies Program. Moreover, my colleagues in the Indiana University School of Journalism—and especially Dr. David H. Weaver, the Roy W. Howard Research Professor—have been exceedingly generous in supporting my travels, as well as in providing the assistance of Ashley Wilkerson, a graduate student and photographer of exceptional ability. Dr. Sarita Soni and her colleagues in the Office of the Vice Provost for Research also have generously supported my travels from South Africa and Dubai to Trinidad and California, as has Dr. Patrick O'Meara, Dean for International Programs at Indiana University. Moreover, my friend and colleague Paulipaka Balakoteswara Rao, a veteran Indian newspaperman and scholar, has diligently helped me understand what I saw through the camera's lens and craft text and captions to match the images.

I also want to acknowledge the support, assistance, and friendship of the following individuals without whom there would be no book: Lynda Lee Adams, Syed Abdul Bari Zafar Aejaz, Gene Bains, Leena Beejadhur, Nathan Benn, Namas Bhojani, Ira Block, Joe Breen, Trevor Brown, Bonnie Brownlee, Tim Callahan, Steve Castillo, Nayan Chanda, Nancy Chng, Kevin Davis, Shamshu Deen, Mimi Dornack, Bill Douthitt, Ted Durham, Alon Fargao, Deirdre Finzer, Carol Fisher, Bill Gillette, Andrew Gonsalves, Dave Griffin, Aziz Haniffa, Laila Harilela, Monte and Sandra Hayes, Bryan Hodgson, Chris Johns, Melanie Johnson, Judy Johnston-Penney, Mitra Kalita, Kaavya Kasturirangan, Abtar Kaur, K. Kesavapany, Zafar Khan, Pradip Kothari, Susan La Rosa, Sharad Lakhanpal, Karen Leonard, Rajan Mehta, Katelynn Metz, Shalini Mimani, Manisha Nagrani, Roshan and Vitra Nanan, M. N. Nandakumara, Jiva Odedra, Kevin Osborn, R. K. Patel, Mark and Tammy Pinkstone, Chandrodaya Prasad, Charlie Radin, Sarita Rai, G. Mohan Raj,

J. V. Raman, Sridhar Ranganathan, Susanna Reckord-Raymer, Peter Reeves, Herman Rodrigues, Dave Ross, Kamatchy Sappani, Ted Sibia, Sharon Siddique, Gary Singh, Ranjit Singh, Urmilla Singh, Steve and Becky Smith, Sree Sreenivasan, Tim Street, Mohini Sule, Irene and Allen van der Beek, Jeff Veidlinger, Zain Verjee, Arvin Verma, Shaalva Weil, Emily Whitten, Paul Winston.

Charles O. Hyman, the art director of this and other books that I have done, deserves special mention for his steadfast help and friendship. Chuck reviewed my pictures often and carefully long before Indiana University Press agreed to publish the book. His unwavering professionalism gave shape and elegance to a book that bridges the worlds of academia and a general interest audience. Finally, Barbara Skinner, my wife and partner in every adventure, encouraged me to take the creative and financial risks that transformed an unshaped idea into a book.

Steve Raymer
Bloomington 2007

1. Yuba City, California
2. San Jose, California
3. Atlanta
4. New York City
5. Trinidad
6. Leicester, England
7. Edinburgh
8. London
9. Israel
10. Dubai, UAE
11. Durban, South Africa
12. Mauritius
13. Bangalore, India
14. Rangoon, Myanmar
15. Kuala Lumpur, Malaysia
16. Singapore
17. Hong Kong

Out of India

Scholars have filled the shelves of the world's great libraries with books and articles about the Indian diaspora, a collective term that describes people who have migrated out of South Asia, but who generally think of themselves as Indian and are tied to the culture of India no matter where they might live. Journalists have usually shied away from reporting, in any comprehensive way, on this large-scale exodus that started in the days of the British Raj some 200 years ago and is, by all accounts, one of the most successful migrations in modern human history. That is, until the Indian government in New Delhi took up the issue several years ago, urging Indians to bring home their money along with the skills they have learned and innovations they have created with such aplomb on a global stage.

Suddenly the diaspora was on the front pages, along with a stream of commentaries and television documentaries about the pivotal role of India and Indians in a new post–Cold War world order, one in which talent, skills, money, goods, and services move easily—often at the speed of light—across borders and oceans. This growing interdependence of countries and peoples is called globalization. And Indians, for all their insularity and attachment to the culture of their homeland, have been the foot soldiers in the advance of free markets, free trade, widespread access to technology, and democratic ideals in many parts of the globe.

Today, the Indian diaspora reaches across all of the world's oceans and to every continent, including Antarctica, where India has a permanent research station. For the 20 to 25 million people of Indian origin living in a hundred or more countries, the sun never sets on this diaspora—a word borrowed from the ancient Greek that meant to disperse and has come to describe scattered peoples of a common culture and history. And since the early nineteenth century, Indians have indeed scattered to the far corners of the globe, though scholars rightly note that this migration we call the "Indian diaspora" is not the first time Indians have influenced the culture and politics of their neighbors and, indeed, the wider world. It is, however, the first time Indians have dispersed beyond the Subcontinent for such varied reasons and in such enormous numbers to become key players in the rise and fall of the British Empire, the creation of new states in the Middle East rich in oil and natural gas, and, in the end, a globalized world that today stretches from the villages of rural India to the boardrooms of Fortune 500 companies.

Images of a Journey documents the struggle of Indian immigrants to survive and succeed in the United Kingdom, the Middle East, South Africa, the islands of the Indian Ocean and the Caribbean, Southeast Asia and Hong Kong, and in the United States. But it is by no means an encyclopedic account of the diaspora—a scholarly undertaking better left to others. Rather, it is a sometimes larger-than-life story that begins with Great Britain's need for cheap and efficient laborers building railroads and working plantations, as well as for soldiers, policemen, coal miners, managers, and English-speaking teachers across the Empire. Not every Indian went abroad willingly, nor were they universally welcomed. Hundreds of prisoners were shackled in irons and

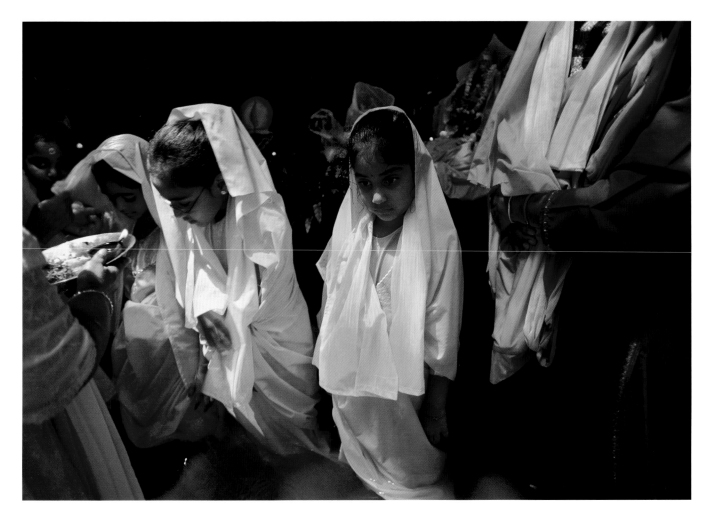

Reviving traditions after generations of being cut off from India, Trinidadians of Indian origin give thanks to Lord Shiva for food, water, and shelter in a celebration called Ganga Dhara in a shallow stretch of the Marianne River. The thanksgiving ritual mirrors rites on the banks of the Ganges, Ganga in Hindi, holiest of all rivers in India.

sent to help build, and later settle, colonial outposts like Singapore, today one of the world's marvels of trade, tourism, and material comfort for most of its citizens. Other Indians were known as notorious moneylenders, so loathed in places like Burma that they were expelled.

Simple economic geography helps explain why so many Indians have, over the generations, traveled abroad in search of education and greater economic opportunity. India is home to 17 percent of the world's people, but Indians live on only 2.5 percent of the world's land. India is crowded, and only in recent decades has it been able to feed itself, reasonably educate many of its millions, and reduce debilitating rates of poverty, literacy, and discrimination based on caste.

In the time of the Raj, the Indian elites, including many of the early advocates for independence, studied in the storied colleges of Oxford, Cambridge, and London, including a young man named Mohandas Karamchand Gandhi, who would turn the world on its head, not with the force of arms, but the force of an idea—nonviolent protest. Today, with more caste-based quotas at India's most competitive schools, the ambitious young still go abroad to pursue dreams and degrees not always available at home in the crowded classrooms of under-financed public universities. While British universities remain popular, Harvard, Wharton, and Stanford are the first choices of India's best and brightest. Still, the some 80,000 Indian students in the United States can also be found at hundreds of other colleges and universities—campuses like West Virginia, Northern Michigan, Utah, and California State at Chico—whose schools produce doctors, software engineers, high-flying CEOs, human rights

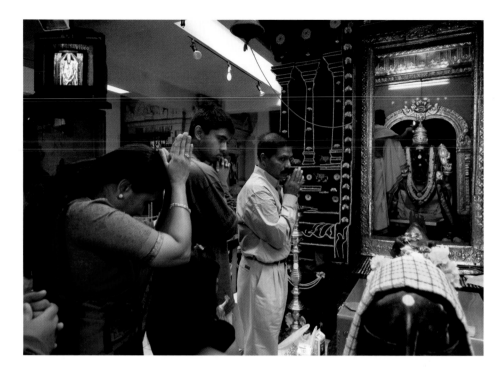

Worshippers gather at the Hindu Temple Society of North America in Flushing, one of several South Asian enclaves in the New York borough of Queens. Consecrated in 1977 as a gateway for Hindus in New York, New Jersey, and Connecticut, the Ganesha temple is one of the nation's oldest and most influential Hindu shrines.

lawyers, farmers, and motel owners along America's highways. In fact, some 2.32 million Indians now live in the United States, the most sought-after destination of the diaspora.

If there is a common thread running through the story of the diaspora, it is the constant movement of individuals and families in search of education, opportunity, and a sense of community and acceptance abroad. Success stories abound.

Consider Zubin Mehta, one of the world's most famous conductors who left Bombay as a young man to study music in Vienna and went on to lead the Los Angeles, New York, and Israeli Philharmonic orchestras. Or Ajay Puri, an Indian lad raised in Bangkok who developed his own website at the age of three and who now has the attention of Microsoft founder Bill Gates, though Puri is not yet a teenager. Or Satyanarayan Gangaram Pitroda, better known as Dr. Sam Pitroda, a telecommunications entrepreneur and inventor with more than 75 patents who never made a telephone call until he moved to America. Today, Pitroda is largely considered responsible for India's communications revolution and is chairman of India's National Knowledge Commission. Or the

multitalented Madhur Jaffrey, who has become famous as an actress, culinary expert, TV presenter, and writer of movie scripts and cookbooks—so famous, in fact, that it is no overstatement to say Jaffrey has changed the way many people in Great Britain and the United States cook, eat, and think about Indian food.

But often success has come at a price. In some former outposts of the British Empire, Indians today are seen as uninvited guests whose days are numbered and opportunities limited. Hence, the term "brown brain drain" has gained currency over the past several decades in parts of Africa, the Caribbean, Southeast Asia, and Oceania.

Some stories are well known, like that of the Nobel laureate V. S. Naipaul, a brilliant writer out of Trinidad. After studying at Oxford, Naipaul settled in Britain and found his voice as the prickly expatriate observing life as an outsider in England, India, and the Caribbean. Other stories are more anonymous, but inspiring nevertheless for their pluck and resilience. Beginning in the 1970s, Indian merchants, professionals, and more than a few politicians, along with their families, have been forced out of Africa, as well as Fiji, Vietnam, and Malaysia by nationalists, communists, xenophobes, and affirmative action policies for the indigenous majority. Their stories—of rebuilding lives anew in Britain, Australia, New Zealand, Canada, and most of all, the United States— will be recounted in books and film so long as the human spirit is celebrated.

Occasionally, the story of the diaspora is one of irony. In South Africa, with its violent past and present, the country's most famous Indian migrant seems largely forgotten today. South African bookstores are bereft of books about Gandhi. And its universities seldom teach his philosophy of nonviolence to students whose lives are touched almost daily by crime and cruelty—the legacy of a state-sponsored system of racial discrimination.

But hardship is only part of the story. This account of the diaspora ends in Bangalore, the high-technology capital of a resurgent India, where Indian émigrés from

places like Santa Clara and San Jose in California are at the forefront of an economic boom. Indeed, three of India's six largest companies, by stock market valuation, are in an industry that barely existed in 1991—information technology. But far from engineering the wholesale transfer of jobs from the United States and Great Britain, the Indian returnees of the so-called "reverse diaspora" are helping create a new Indian middle class, hiring educated Indians who, in turn, are buying Dell and Apple computers, Domino's pizza, and DaimlerChrysler Jeep Grand Cherokees. In the end, this story puts a human face on some of the notable, but more often than not, the ordinary people of the Indian diaspora—people who have changed the way the world sees Indians—and hence India.

Indeed, the Indians of the diaspora reflect the diversity of India itself. Many are Hindus, but among the diaspora are Muslims, Christians, Sikhs, Jains, Buddhists, Parsis, and Jews. In the United States and Canada, they often refer to themselves as Desis, a variant of the Sanskrit word *desha*, meaning motherland, or India, or even brown. They celebrate Diwali or Deepavali, depending upon whether their roots are in north or south India. And with equal enthusiasm Indians of the diaspora mark Dussehra, Gurupurab, the two Muslim Eid holidays, and the Prophet Mohammad's birthday, as well as Christmas, Passover, and Indian Independence Day. Firmly attached to the mother country in ways that might puzzle, say, Vietnamese or Somali immigrants, they are tuned, no matter where they live or how modest their homes, to TV Asia, Zee TV, Sony Home Entertainment, and the latest Bollywood films.

The transition from expatriate living abroad to citizen of a new country can be full of uncertainty and pain—more so, perhaps, for Indians of the diaspora because they tend to be so culturally self-contained and sometimes see little need to assimilate. An IBM engineer who shuttles between New York and Bangalore calls many of his fellow Indians in the United States "positively tribal in their isolation in 'Little India' ghettos." While this may be an overly harsh assessment, Indians find the twilight zone between past and present all the more difficult now that the idea of a melting pot, or assimilation, has given way to something called multiculturalism—an idea first advanced in Canada that gives immigrants the freedom to maintain their assorted faiths, food, languages, and other cultural traditions. Sadly, from California to the English Midlands, multiculturalism has ended up emphasizing differences and dividing communities, often at the expense of developing an allegiance to the values of one's adopted city, state, country, profession, and everything else that makes people the complex creatures they are.

Bharati Mukherjee, a native of Calcutta and a professor of English at the University of California–Berkeley, is by many accounts one of the most important writers of the late twentieth century. A critic of multiculturalism who calls herself an American, not a hyphenated American, Mukherjee sees arrival in a new land as a process of enrichment and transformation for both the immigrants and their adopted lands, whose culture they inevitably change. "In this age of Diasporas, one's biological identity may not be one's only identity," she wrote in a famous *Mother Jones* essay. "The experience of cutting myself off from a biological homeland and settling in an adopted homeland that is not always welcoming to its dark-complexioned citizens has tested me as a person."

Certainly the diaspora is an ongoing story. Some Indians will cling to the culture of India or construct, as Mukherjee calls it, a "phantom identity, more Indian-than-Indians-in-India," as a defense against discrimination. But the young will adapt, walking the tightrope between two competing worlds until they are transformed in ways unimagined by their parents and grandparents. Some will return home with foreign passports and money to invest in moving India forward. But immigrant dreams die hard. Indians will continue to leave home with visions of a better life for themselves and their families. And if history is any guide, many—maybe most—will succeed. Some will surely distinguish themselves, earning still more Nobel Prizes and the like. And nearly all of the Indians of the diaspora will change the culture of their adopted lands just as those lands will, in the end, surely change them.

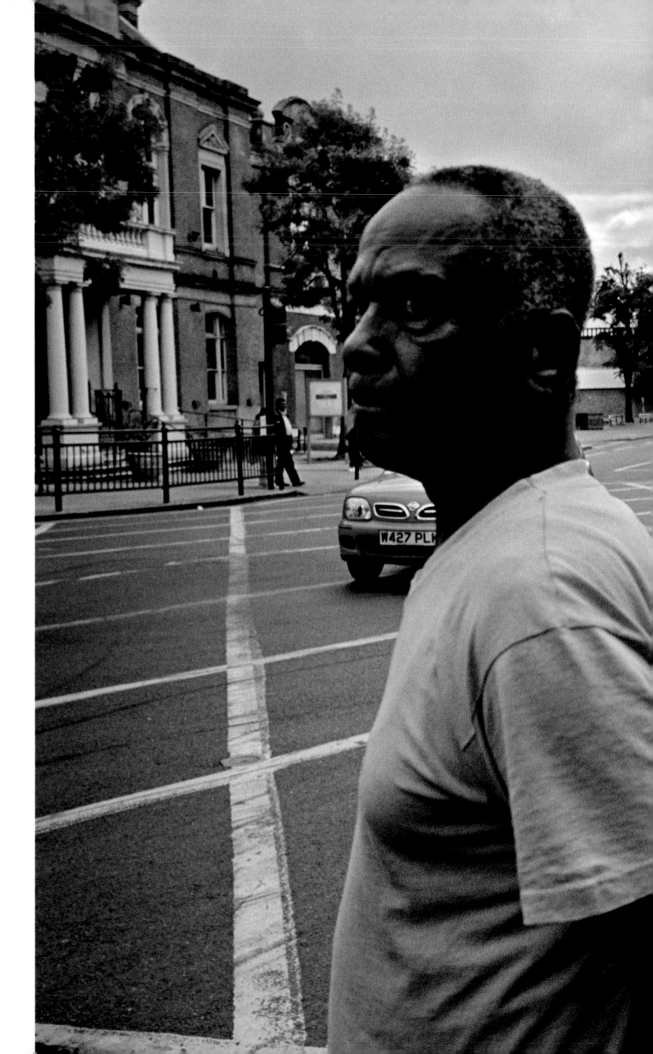

Sharing streets with Somali asylum seekers and Caribbean immigrants, Sikhs in the Punjabi enclave of Southall near London's Heathrow Airport are making room for newcomers. Even so, Southall's main street, called The Broadway, contains the largest number of South Asian–run shops in metropolitan London and was featured in the film *Bend It Like Beckham*. A commercial suburb along the Grand Union Canal since 1796, Southall has about 70,000 residents—more than half of them from India and Pakistan.

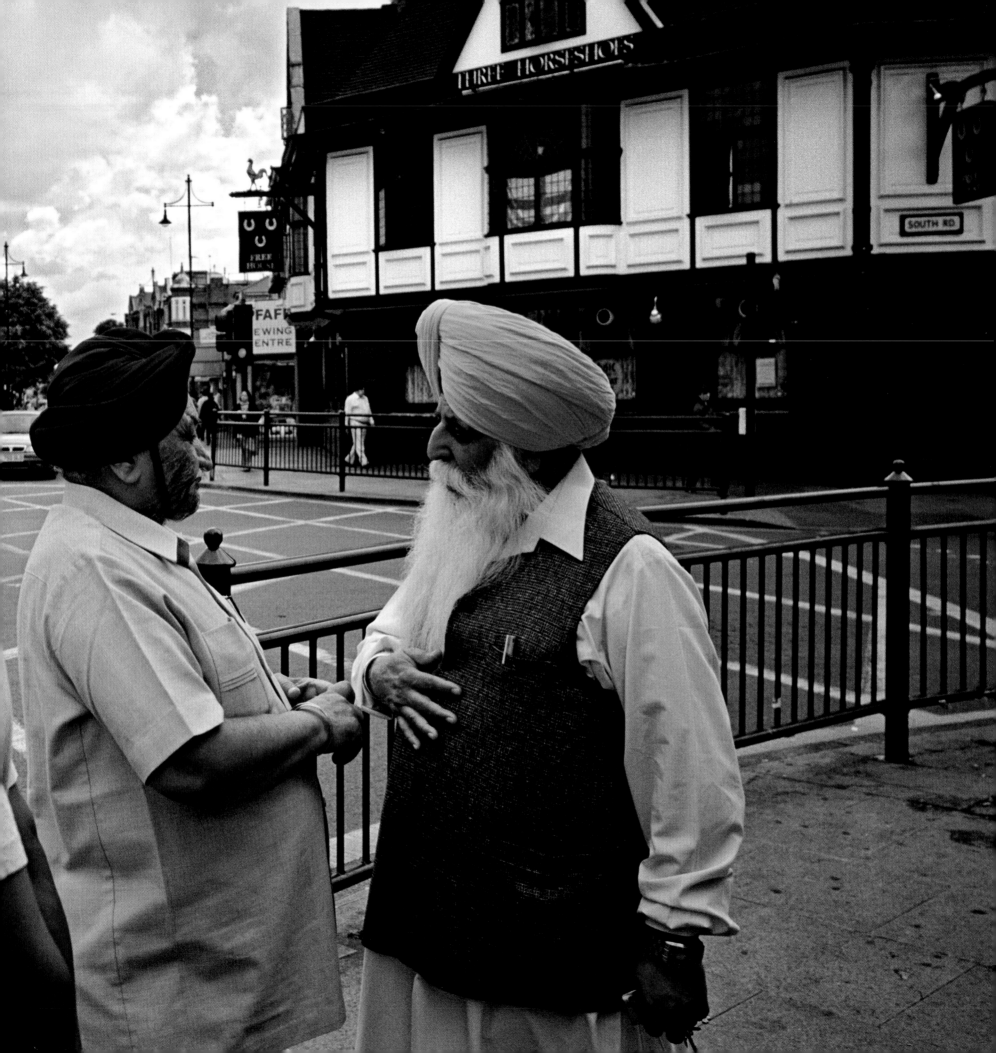

Dedicated to the Hindu god Vishnu,
the twelfth-century temple at Angkor
Wat in Cambodia was the seat of power
for the Khmer king Suryavaraman II
and testifies to the early reach into
Southeast Asia of Indian beliefs and
architecture. Theravada Buddhists
began using the temple in the
fourteenth or fifteenth centuries,
though eventually it fell into disuse and
was swallowed by the jungle. Damaged
by wars and looters, the temple, along
with others nearby, is being restored
by international conservationists,
including the Archaeological Survey
of India, which has been at work at
Angkor Wat since 1986.

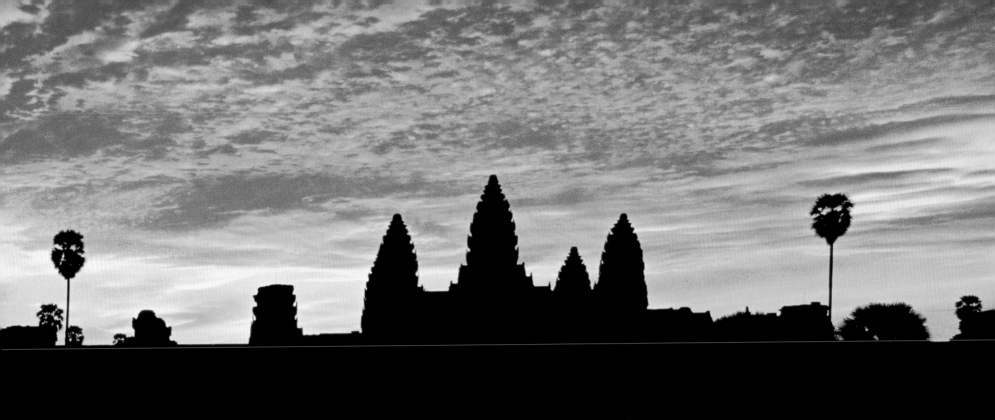

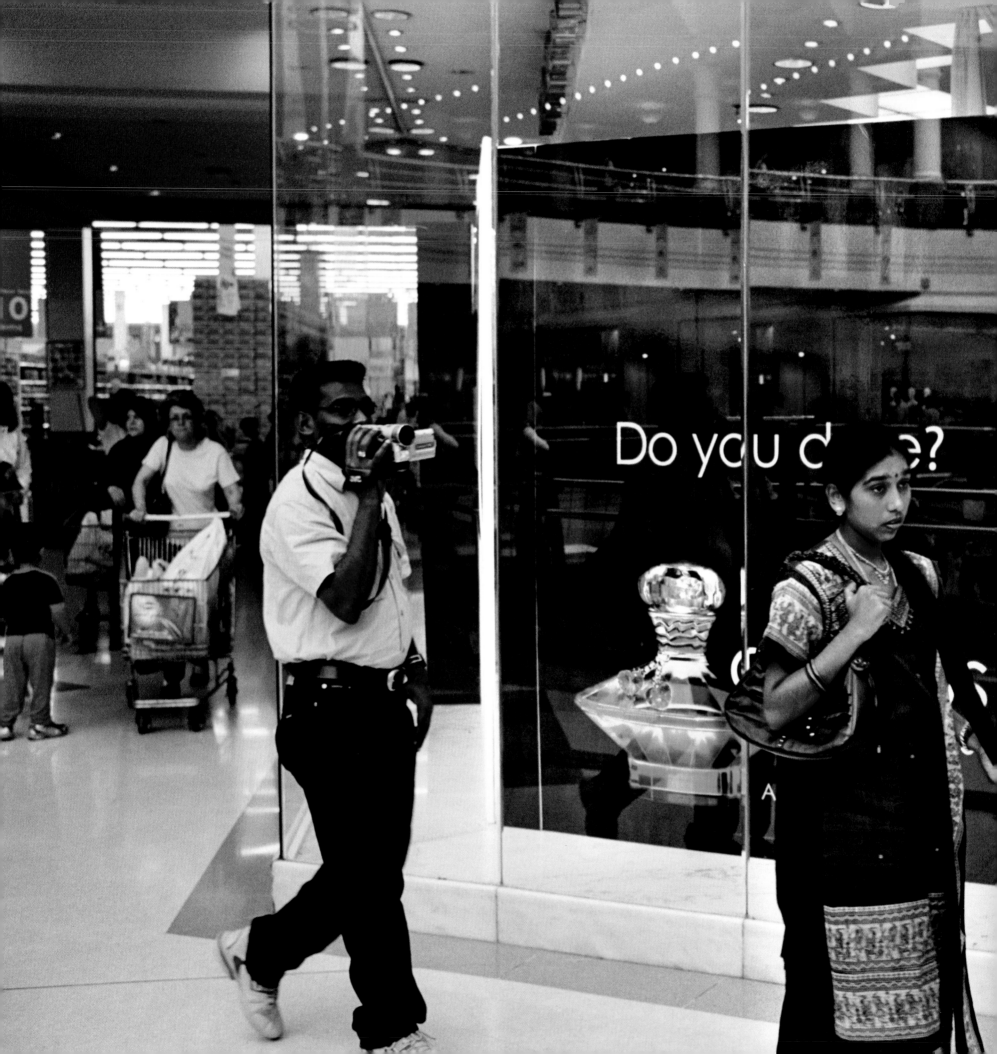

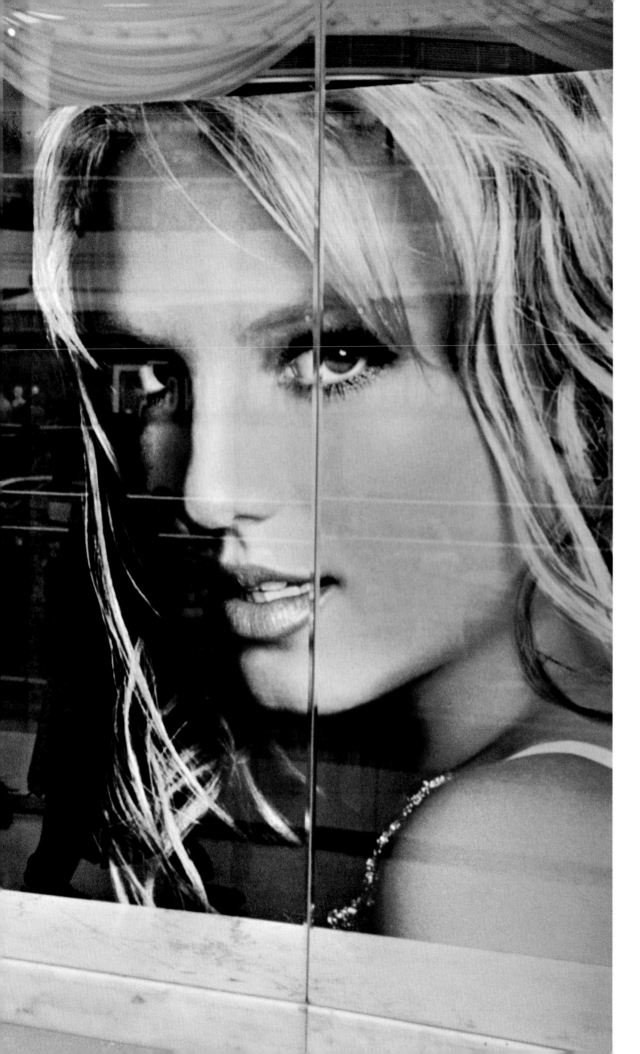

Enjoying the benefits of globalization, Indians of the diaspora are some of the world's most enthusiastic tourists and shoppers. A young Indian couple in the City Centre shopping mall in Dubai, commercial capital of the United Arab Emirates, passes by a giant photograph of pop singer Britney Spears in a perfume store that is popular with tourists and expatriates, including Indians.

Tucked in the jungle along the central coast of Vietnam, the My Son Sanctuary, with its distinctive temple towers adorned with Hindu deities, was the seat of politics and culture of the Champa, or Cham, civilization. UNESCO calls My Son an "exceptional example of cultural interchange, with the introduction of Hindu architecture of the Indian sub-continent into Southeast Asia." My Son was inhabited between the fourth and fifteenth centuries, far longer than any of the other Indian-influenced sites in the region like Angkor Wat in Cambodia, Borobudur in Indonesia, Pagan in Myanmar, or Ayutthaya in Thailand.

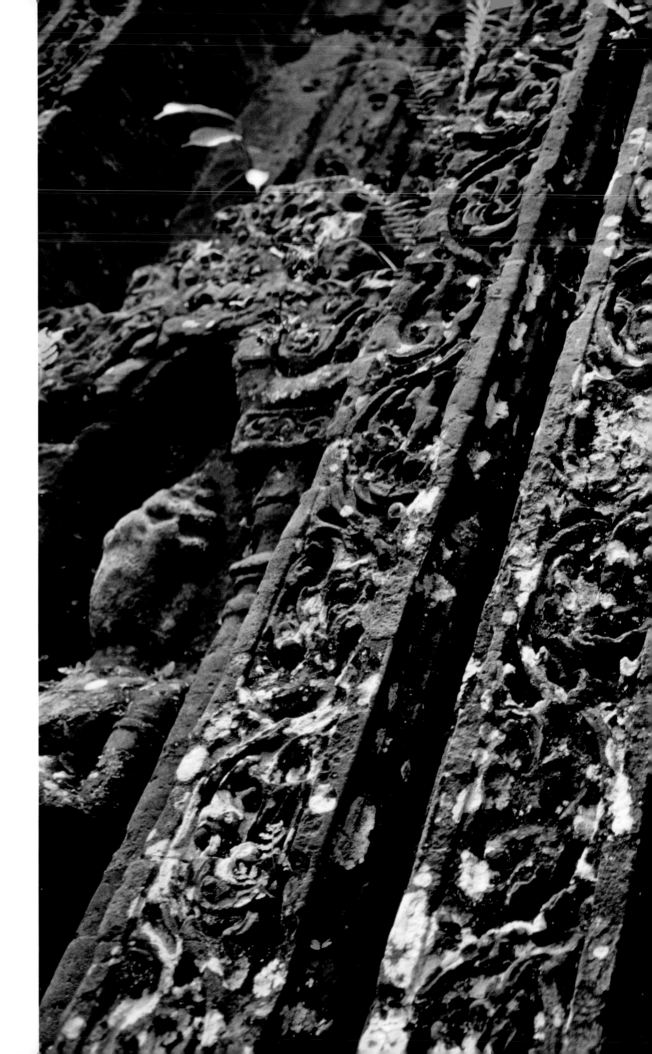

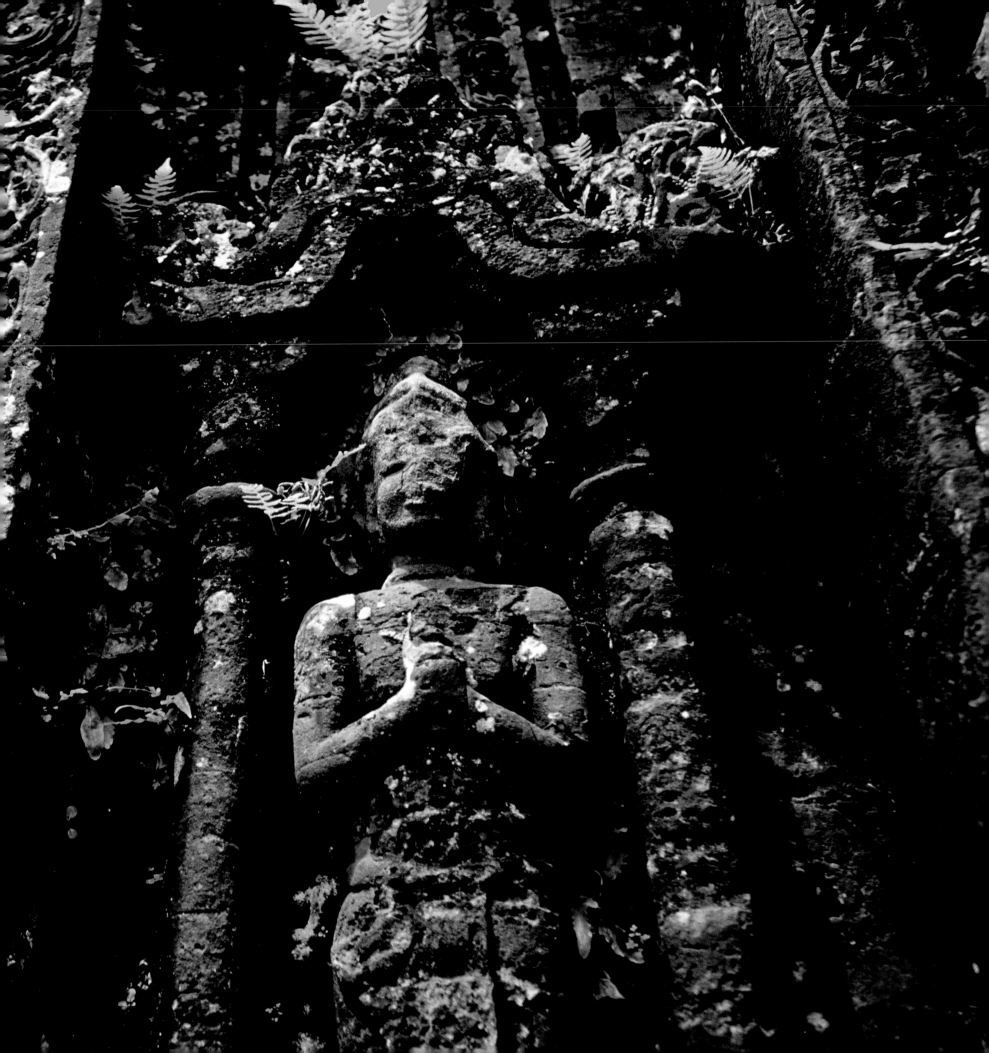

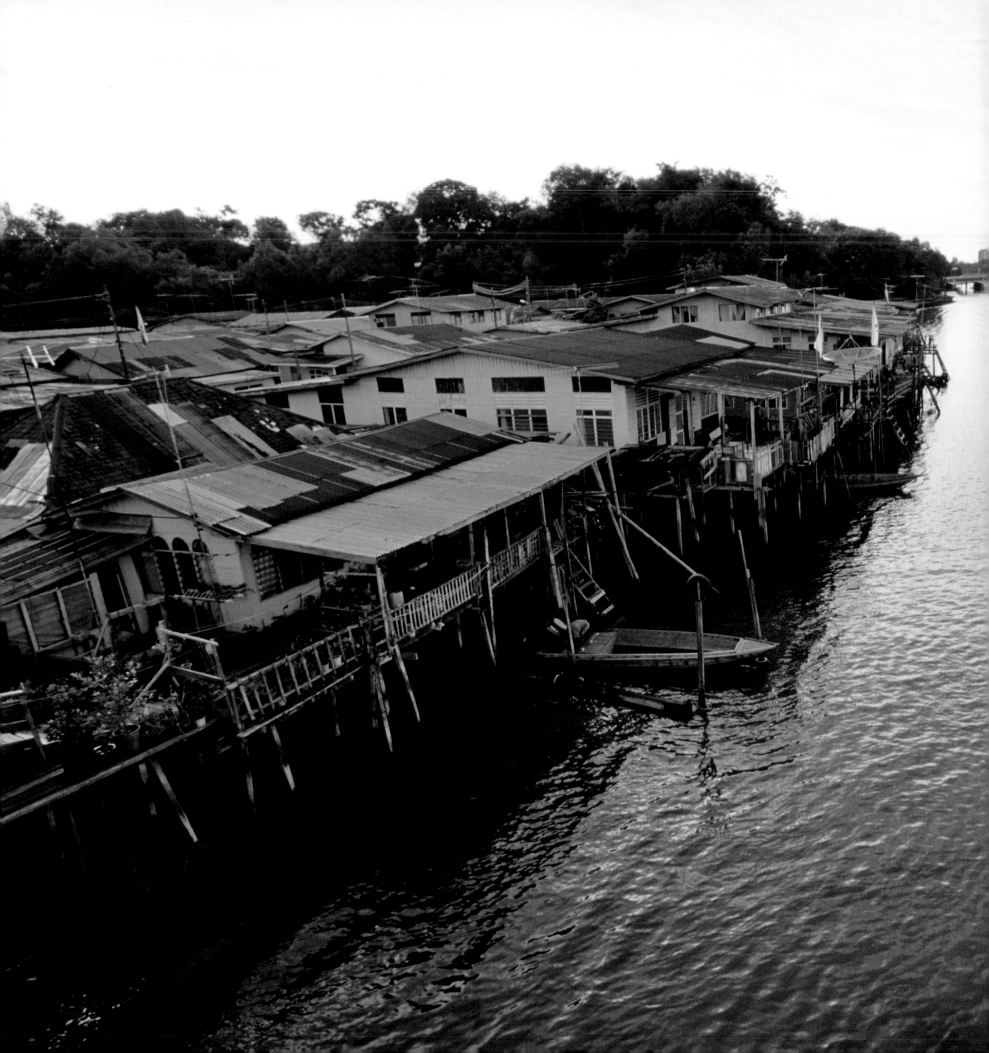

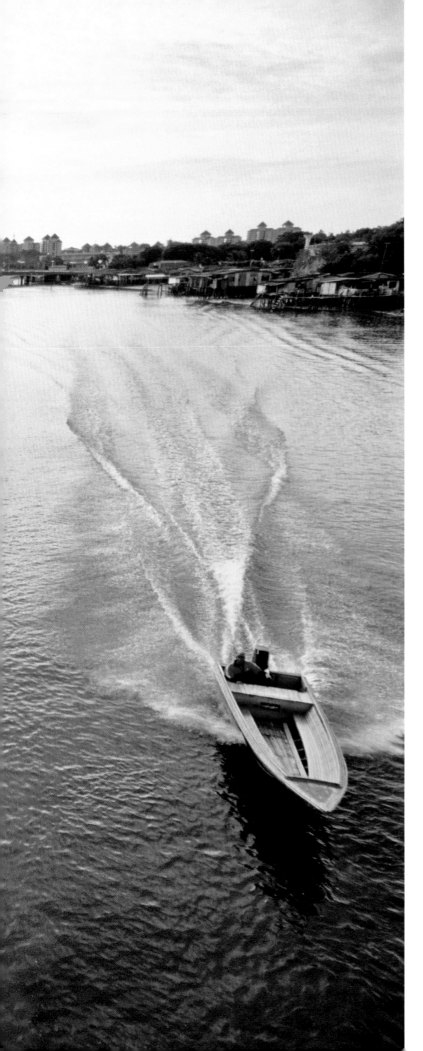

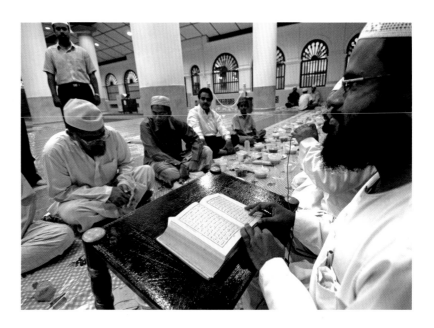

A speedboat racing along the canals of Bandar Seri Begawan, capital of the Sultanate of Brunei, recalls the earlier path of Indian traders who first brought Hinduism and then Islam to much of Southeast Asia, including coastal trading ports on the island of Borneo where Brunei is located. Between the eleventh and fifteenth centuries, Islam gradually assimilated Hinduism, which then dominated the region, as well as local animist sects. Over the centuries, Southeast Asian Muslims, like these breaking the Ramadan fast at the Masjid Jamae in Singapore, became known for their tolerance of other religious beliefs, though a new Islamic zeal—some Muslims call it a reawakening— has caught fire in Southeast Asia.

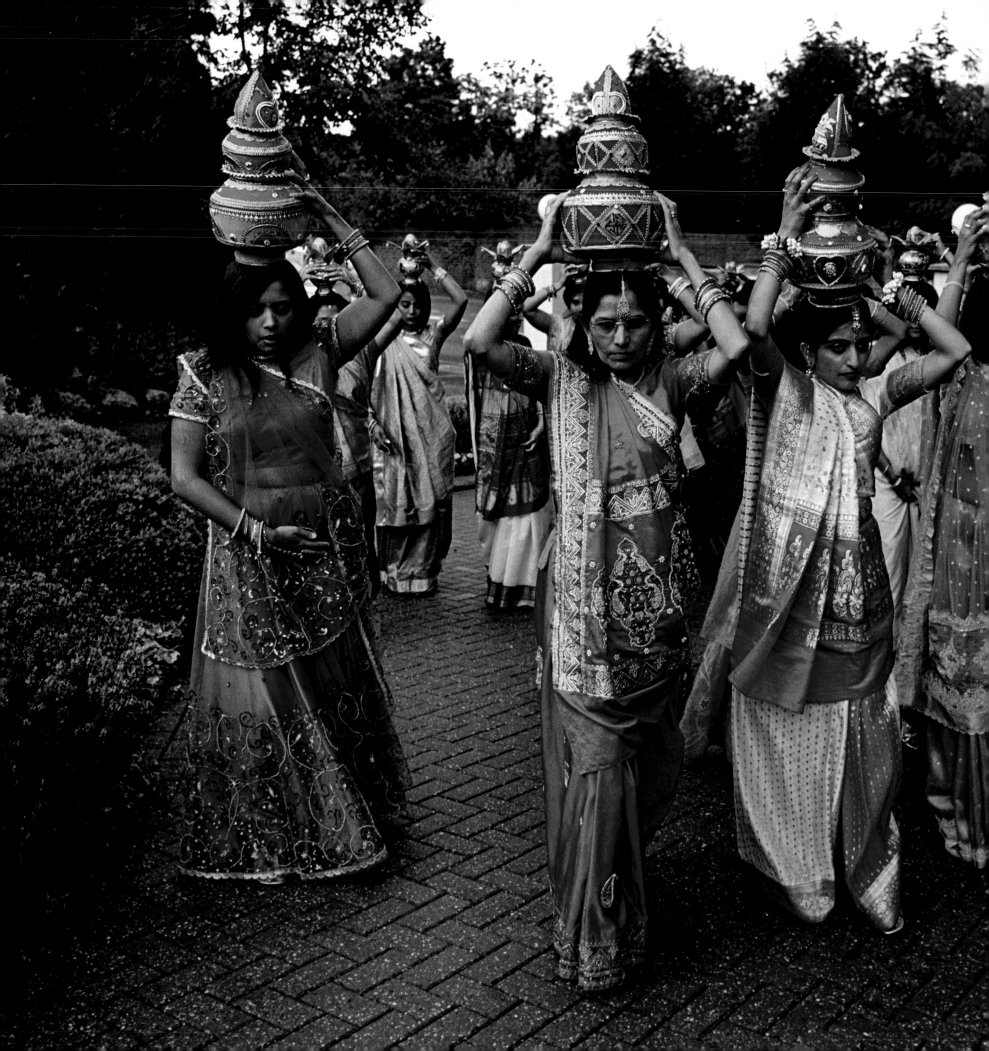

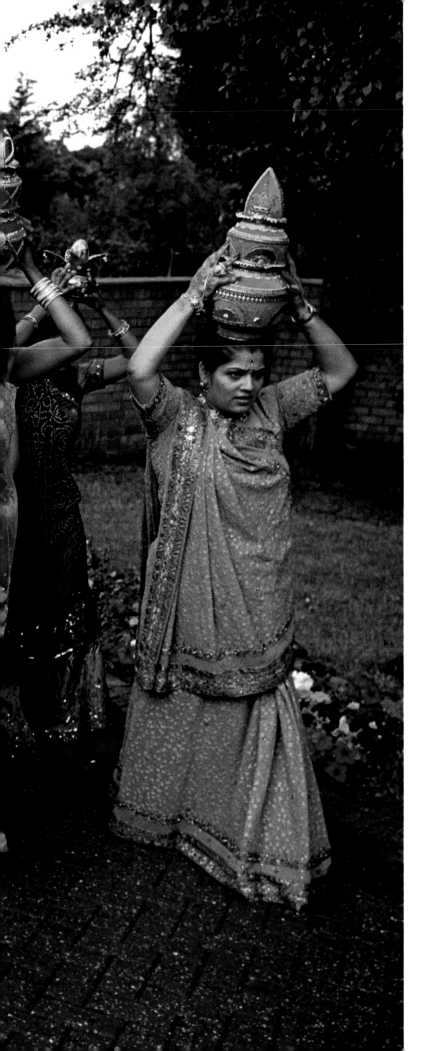

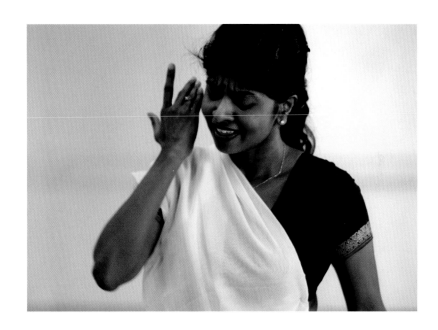

Maintaining their ties to India in the English countryside, relatives of a Hindu bridegroom dress in their best saris and carry earthenware pots on their heads in a religious ceremony called *Ghari Puja* on the eve of his wedding day outside London. Devotee of *Bharata Natyam*, a classical dance repertoire performed in the temples and courts of South India since ancient times, Arul Ramiah makes a plaintive *mudra* or hand gesture. Passed on by dancers from generation to generation, *Bharata Natyam* is enjoying a revival in India and among Indians of the diaspora like Ms. Ramiah, a Singapore attorney and much-in-demand classical dancer.

One of the world's best-known doctors, Sanjay Gupta rushes to broadcast live from the CNN newsroom in Atlanta. Gupta is CNN's senior medical correspondent, as well as a professor at Emory University and neurosurgeon at Grady Memorial Hospital in Atlanta. While reporting on the Iraq War for CNN, Gupta put down his microphone and notebook to operate on both American and Iraqi soldiers with severe head wounds—acts of compassion that earned him praise from soldiers and criticism from media ethicists.

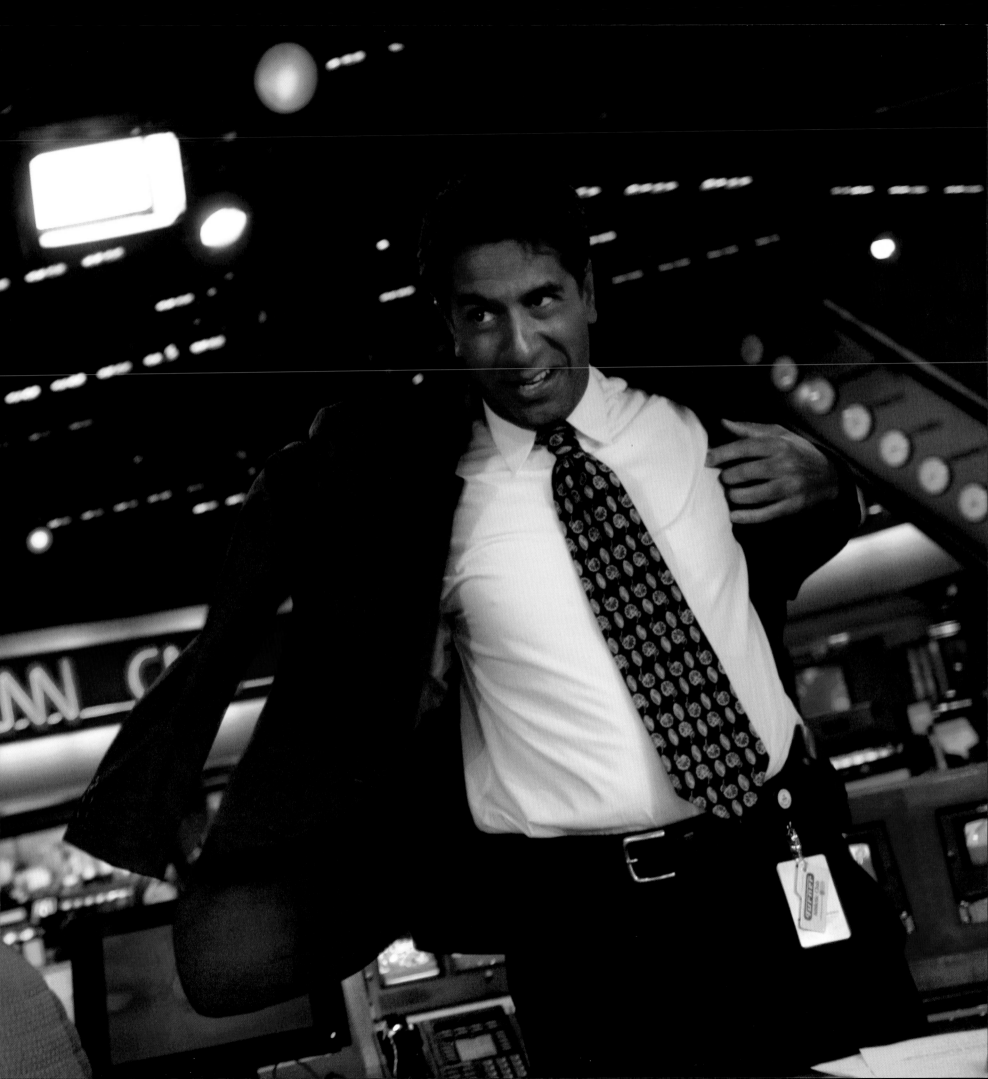

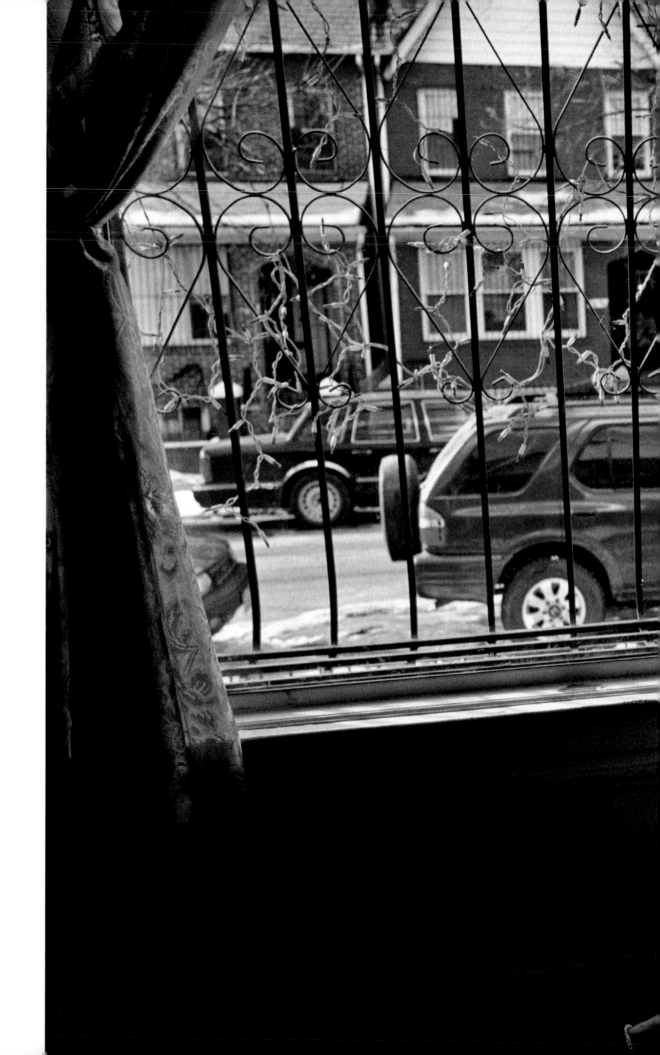

Constrained by an unfamiliar language and the violence of New York's immigrant neighborhoods, Tara Singh sits in the window of his son's home in Queens. A retired sergeant major of the Indian Army, Singh spends his days escorting his grandchildren to a nearby private school run by the Roman Catholic Church—a school the family of Punjabi Sikh immigrants finds superior to local public schools—and watching satellite television news from India. The nearly 60,000 South Asians in New York make up the city's fourth-largest immigrant group behind newcomers from China, the former Soviet Union, and Latin America.

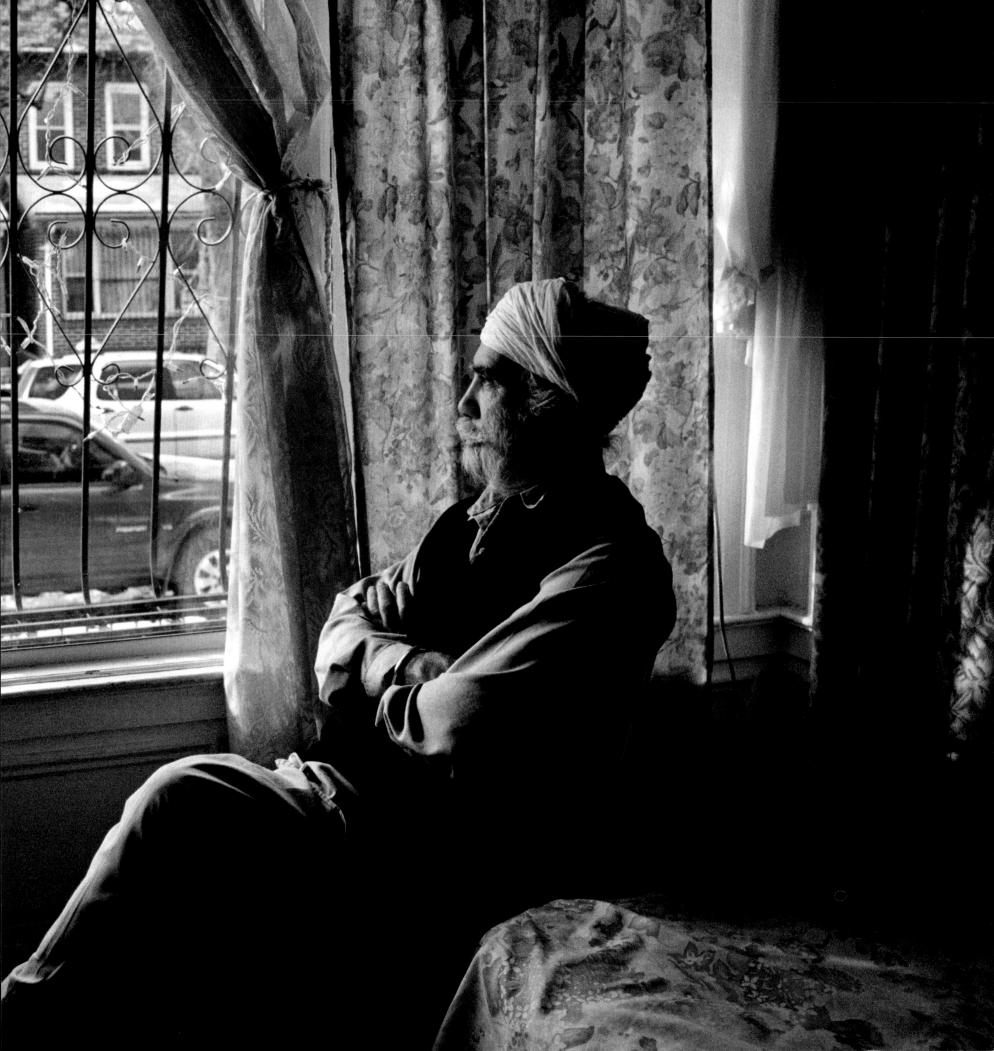

Great Britain
The Empire Comes Home

Wait in the arrivals hall at London's Heathrow Airport or drive through the industrial cities of the British Midlands. Even call for takeaway food in Scotland. Everywhere in the British Isles a visitor meets Indians—tens of thousands of people of Indian origin. They're arriving by the planeload from the Subcontinent, working in factories and brokerage houses, and serving up what has become Britain's national dish—curry, which first appeared on a London menu in 1773.

The British, in fact, may be living proof of the adage "You are what you eat." While anthropologists ponder the deeper meaning of Britain's changing tastes, it is safe to say the British crave curry. More precisely, chicken tikka masala, an Anglo-Indian concoction invented by Indian immigrants to the United Kingdom in the 1950s and described by the late Foreign Secretary Robin Cook as "a true British national dish." Much like the ubiquitousness of Indian immigrants across the British Isles, this mild tomato-based curry cooked tandoori style in a charcoal-fired oven has become a staple of domestic life, replacing fish and chips as Britain's signature dish. Indian restaurants and take-away curry shops sell some 25 million portions of chicken tikka masala every year, while the retail giant Marks & Spencer dispenses 15 tons a week to Britons of every class and color.

For centuries the colonizer, Great Britain today has been colonized in reverse by a panoply of people from its former outposts, now called the Commonwealth of Nations. And Indians are the most numerous—the largest nonwhite ethnic group in Great Britain, numbering about 1.2 million out of a total population of 60 million. Another 500,000 Indian tourists visit Britain every year. While Indians followed the Union Jack to the ends of the Empire as low-cost or indentured laborers during the nineteenth century, their immigration to the United Kingdom has been a twentieth-century phenomenon, mostly after Britain quit its colonies in Africa, Asia, and much of the Caribbean between 1947 and 1984.

The French and Portuguese, of course, had empires of their own, including small colonies in India. But since the end of World War II, no country in Europe has accepted more Indians than the United Kingdom. Often haphazardly and without a smile, Britain has taken in large numbers of immigrants from the Subcontinent, particularly after its violent division into India and Pakistan in 1947. Britain also made room for thousands of South Asians who had settled in its former African colonies and were later forced, by African nationalists and armies hungry for power, to swap their palatial homes, servants, and the hot equatorial sun for drafty resettlement camps in England.

Some of the earliest Indian immigrants were Sikhs from the fertile Punjabi plains. One of the earliest and most prominent was a Sikh prince by the name of Maharaja Duleep Singh, who moved to London in the mid-nineteenth century. Singh converted to Christianity and lived handsomely enough to join the posh Carlton Club, where he is said to have complained about the quality of the fish knives. Queen Victoria even became

the godmother to his son, notes the British author Robert Winder in his 2004 book *Bloody Foreigners*. Thousands of other Sikhs, veterans of British Army regiments that maintained order throughout the Raj and fought in some of the fiercest battles of both world wars, mustered out of uniform and settled in Britain. The violent partition of the Punjab state in 1947 — where Sikhs, Muslims, and Hindus had lived together in relative calm — helped speed the Sikh migration abroad. Many settled in Southall, a West London suburb near Heathrow Airport, where Punjabis found work in a nearby rubber factory. Even today, signs in Southall, beginning at the station on the First Great Western railroad, are in Punjabi and English, so entrenched are the Sikhs.

Word of Britain's post–World War II labor shortage quickly spread to the Subcontinent, and Indians of many faiths and ethnic groups flocked to cities like Sheffield, Manchester, Bradford, Leeds, and Leicester in the English Midlands. There they found work in the textile mills and factories, as well as affordable housing, though not always a warm welcome from working-class whites. The now defunct British Nationality Act of 1948, which for a time gave Commonwealth citizens the right to move to Britain, eased their passage.

Another wave of Indian immigrants followed in the 1960s and 70s, but this time they came not from India, but largely from Britain's former East African colonies. These Indians were political refugees — some stateless, some British subjects. On August 4, 1972, General Idi Amin of Uganda, a ruthless "Africa for the Africans" firebrand, gave the country's 74,000 South Asians a scant 90 days to leave following a dream in which, Amin claimed, God told him to expel the mostly Indian minority. But God had little to do with Amin's forced expulsion of the country's merchant and professional class or his confiscation of Indian property. Rather, Amin's actions were designed to pump money into Uganda's bankrupt economy and quiet his querulous army. Stripped of their wealth and citizenship, and unwelcome in India, the "Uganda Asians" were

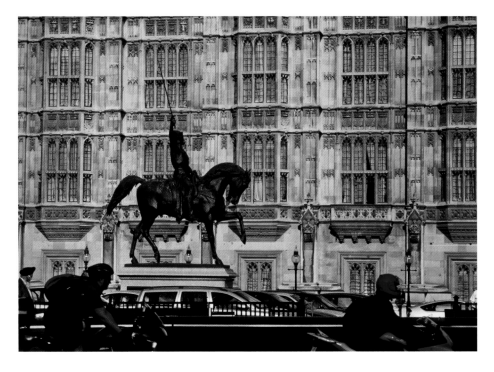

reluctantly allowed into Britain, Canada, and the United States, where many have prospered in ways that celebrate the resilience of the human spirit. Other African nationalists and corrupt politicians used more subtle methods to force Indians out of neighboring Kenya, Tanzania, Malawi, and Zambia, sending thousands to England in search of a new life at the bottom of the economic ladder.

"We knew the British and their ways," recalls Tooshar Mavani, an Indian of Gujarati descent and a retired textile factory owner in Leicester. "So the biggest thing to get used to when we came from Kenya was the weather." Mavani says his family was penniless when they pulled up roots in Kenya after his father's concrete business in neighboring Uganda was confiscated. Despite being a British subject, Mavani ended up in London's Pentonville Prison — then used as a detention center for East African Indian immigrants. "But there was plenty of work upcountry in Leicester in textiles, shoes, and printing," says this good-natured man whose son is a police officer and daughter a psychologist. "It was easy to settle down."

The changing complexion of Great Britain has been one of the kingdom's most vexing social issues of the last

A statue of King Richard I stands outside Parliament in London, where the first Indian immigrant was elected to the House of Commons in 1892. Connected by colonial ties, Indian émigrés and students, including most of the leaders of India's independence movement, have called the British Isles home for more than two centuries.

In the predominantly South Asian suburb of Southall outside London, Sikh footballers celebrate in the Glassy Junction Pub. Indians stay connected to the Subcontinent and their immigrant communities in Great Britain through a powerful ethnic media that includes nine Indian newspapers and magazines and another 11 Indian radio and television channels, plus the BBC's domestic Asian Network.

quarter century, though sometimes Britons forget their own history has been one of successive immigrations since at least the time of the Normans in 1066. Indeed, one of Britain's strengths, say some scholars, has been its ability to absorb foreigners—Jewish moneylenders from Eastern Europe, Huguenot weavers, Irish laborers, and Indian shopkeepers—and draw new strength from their stimuli. Today, ethnic minorities account for nearly 10 percent of Britain's population and have a higher birth rate than whites, putting the kingdom at the center of a global population shift from the less developed to the post-industrial world. Immigration, for example, is overwhelmingly the story of London's development—four out of ten foreign-born immigrants live in the capital, including about 450,000 people of Indian origin. When the next census is released in 2011, Leicester, where Indian refugees from East Africa settled in large numbers, is expected to be the first British city with a majority of nonwhite residents—most of them of South Asian origin. Some commentators call this somersault of history the beginning of an "Asian Raj" in the British Isles.

Great Britain's response to this influx of people of color has, in some cases, been positive, allowing immigrants access to schools, health care, social

security—or welfare benefits and public housing—and even granting newcomers voting rights if they hail from a Commonwealth country, as most Indians do. But Britain's 40-year-old policy of multiculturalism—protecting each minority's right to its distinctive languages and customs—has created gaping divisions in a society that prides itself on civility. "Being born in a particular community is not in itself an exercise of cultural liberty, since it is not an act of choice," says Amartya Sen, a Nobel Prize–winning economist and philosopher at Harvard University who, in his eighth decade, retains his Indian citizenship. In Sen's view, the government in London has wavered from its earlier and largely successful efforts to integrate immigrants and now, in the name of multiculturalism, is segregating racial and ethic groups, especially South Asian Muslims. Part of the problem has been the government's decision to deal with immigrants almost exclusively on the basis of religion rather than looking at the many other connections South Asians have to their adopted land. "Britain is currently torn between interaction and isolation," says Sen, who was once Master of Trinity College at Cambridge University.

Still, there is no denying that Hindu temples, Muslim mosques, and Sikh gurudwaras have become fixtures of every major British city, in many cases housed inside deconsecrated Christian churches. That some predominantly South Asian mosques have been breeding grounds for extremist rhetoric and terrorism, including the July 2005 attacks on the London subway system, has put further strain on British immigration policy. Nevertheless, during her Golden Jubilee Year in 2002, Britain's Queen Elizabeth II felt obliged to tip her crown, as it were, to Britain's sizable and increasingly powerful Indian minority, paying her respects at a Hindu temple. Accompanied by her husband, Prince Philip, Duke of Edinburgh, the monarch removed her shoes and padded in her stocking feet through the Highgatehill Murugan Temple, a North London landmark popular with Tamils from India, Sri Lanka, Mauritius, South Africa, and Malaysia.

The queen's visit highlighted a changing social landscape that Britons are coming to accept. Indians today are one of Great Britain's highest-earning and

best-educated ethnic groups, achieving prominence in business, information technology, health care, the news media, the arts, and entertainment.

The executive Lakshmi Mittal, head of the world's largest steel company and Britain's richest man with a fortune estimated at $25 billion, is England's most celebrated Indian entrepreneur. His takeover battles with European rivals have become a staple of the financial press. Mittal's personal life has been chronicled with equal fervor. Called the fifth richest man in the world by *Forbes*, Mittal paid $128 million in 2003—a record at the time—for a mansion in the exclusive London borough of Kensington and another $60 million for the 2004 fairytale wedding of his daughter Vanisha—the most expensive wedding in modern history. Yet there are thousands of British Indians, known mainly to readers of the financial pages, their employees, and the charities they support, who have prospered in engineering, manufacturing, hotels, pharmaceuticals, catering, and fashion. In fact, the Indian community in Great Britain accounts for some 40 percent of the retail sector, from the "corner-shop wallas," whose newsstands and convenience stores have become more ubiquitous than pubs throughout England and Scotland, to tycoons like Shrichand and Gopichand Hinduja, billionaire brothers with interests—some highly controversial—in oil, banking, telecommunications, and armaments.

Indians also make up a significant percentage of doctors in the National Health Service—a prominence in medicine they share with their compatriots in the United States. And in politics, more than a dozen politicians of Indian origin sit in both houses of Parliament at Westminister—a tradition that dates to 1892, when the British elected their first Indian MP.

Beyond the City of London financial district and Westminster on the banks of the River Thames, the contributions of Indians in the media, arts, cinema, and literature are being hailed, and indeed claimed, as part of mainstream Britain. The faces and bylines of Indians are an everyday occurrence on the BBC Television News, SkyNews, and ITV, and in the *Financial Times*,

Independent, and *Guardian*. One BBC Television hit, *The Kumars at No 42*—a sitcom about a typical, albeit comically portrayed, Indian family living in the North London suburb of Wembley—has found a worldwide audience and inspired imitations as far away as Israel and Australia. On the big screen, Anglo-Asian director Gurinder Chadha, who was born in Kenya and came to London as a child, has achieved a wide following with two hit films that examine racial prejudice: *Bend It Like Beckham* and *Bride and Prejudice*. Bollywood films and dance contests also attract audiences of every color and class, and UK music charts unfailingly top out with bhangra, originally the lively dance music of the Punjab that is now popular with young people worldwide.

Meanwhile, the immigration debate continues in Great Britain. Asylum seekers from Eastern Europe, Africa, and anyone who might be a Muslim are the latest source of alarm and grumbling in pubs, parlors, and Parliament. Perhaps the most important question to ask is why immigration policy has been so accidental and haphazard. How is it, asked the late author and journalist Anthony Samson in the *Guardian* newspaper, that Britain "admitted tens of thousands of Indians, but made no effort to attract the highly qualified mathematicians who would play a central role in Silicon Valley in California?"

If there are bright spots on the horizon, they may be in the suburbs of places like London, Leicester, or even Edinburgh in Scotland, where Hindus, Sikhs, and Muslims live side by side in upscale homes with SUVs and BMWs parked in the driveways. A second generation of born-in-Britain South Asians is on the ascent, abandoning "Little India" enclaves and heading for the suburbs in search of better schools for their children and more comforts for themselves. And according to census data, Britons are marrying outside their race at a rate higher than in any other European country—an encouraging sign that divisions are breaking down in far more fundamental ways than simply eating more curry than fish and chips. "If you have money," says Mavani, "you can live just about anywhere, can't you?"

A South Asian family enjoys the quiet of Victoria Embankment Gardens, a narrow public park that was created in the late nineteenth century along the River Thames in London. About 45 percent of the Indians in Britain are Hindu, 29 percent Sikh, and 13 percent Muslim. Most immigrants come from just three Indian States—Sikhs from Punjab and Hindus from Gujarat and West Bengal.

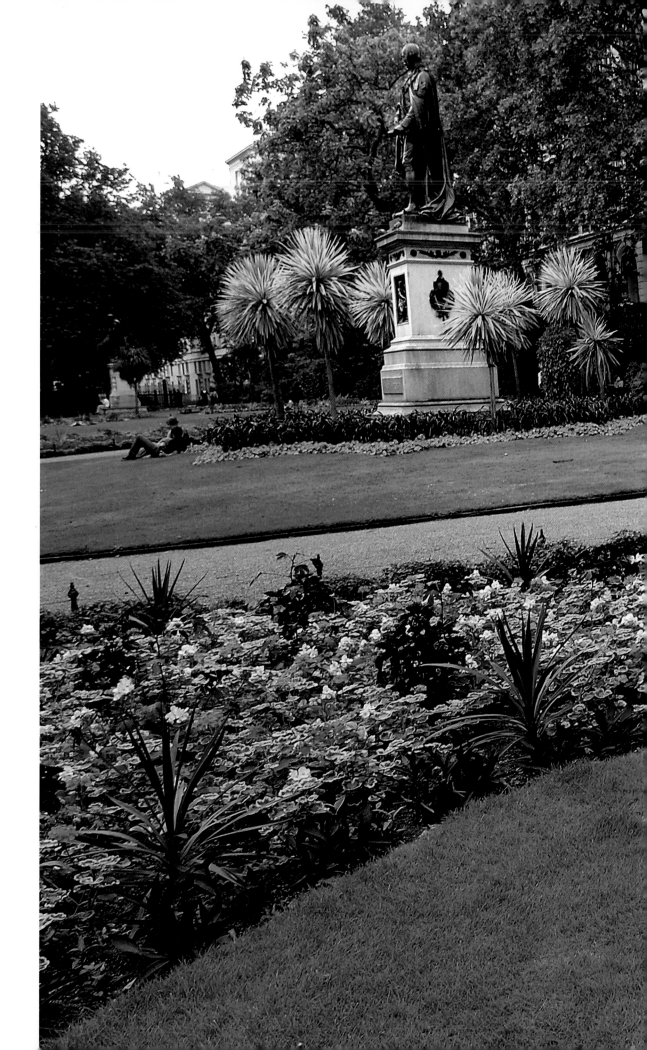

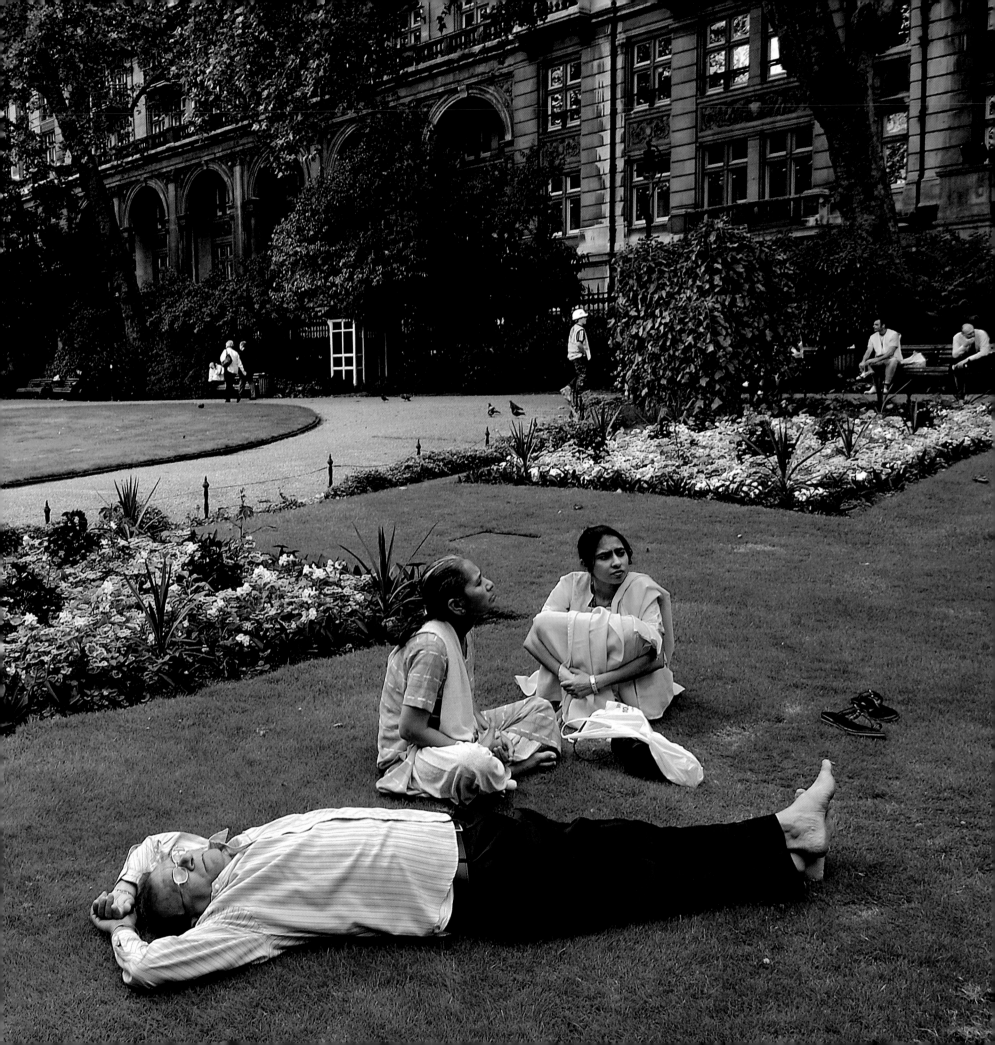

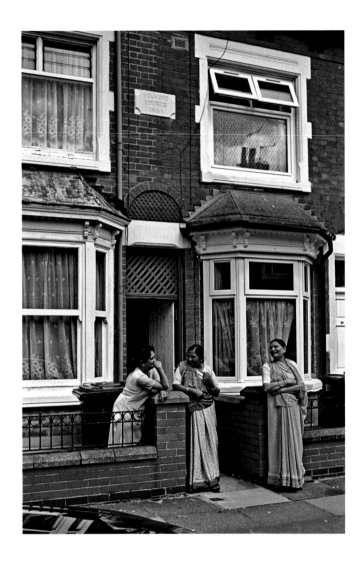

Family knows best is the message a young British-
Indian woman receives on a crowded London subway,
a preferred means of travel from the boroughs of
Ealing, Brent, and Harrow, where there are high
concentrations of South Asian immigrants. Affordable
housing and jobs in textile mills and shoe factories
brought Indians to Leicester, where women gossip
in front of late-Victorian-era houses. Indian
immigrants, many from East Africa, have helped
transform Leicester into a regional center of banking,
insurance, and education, including two universities.

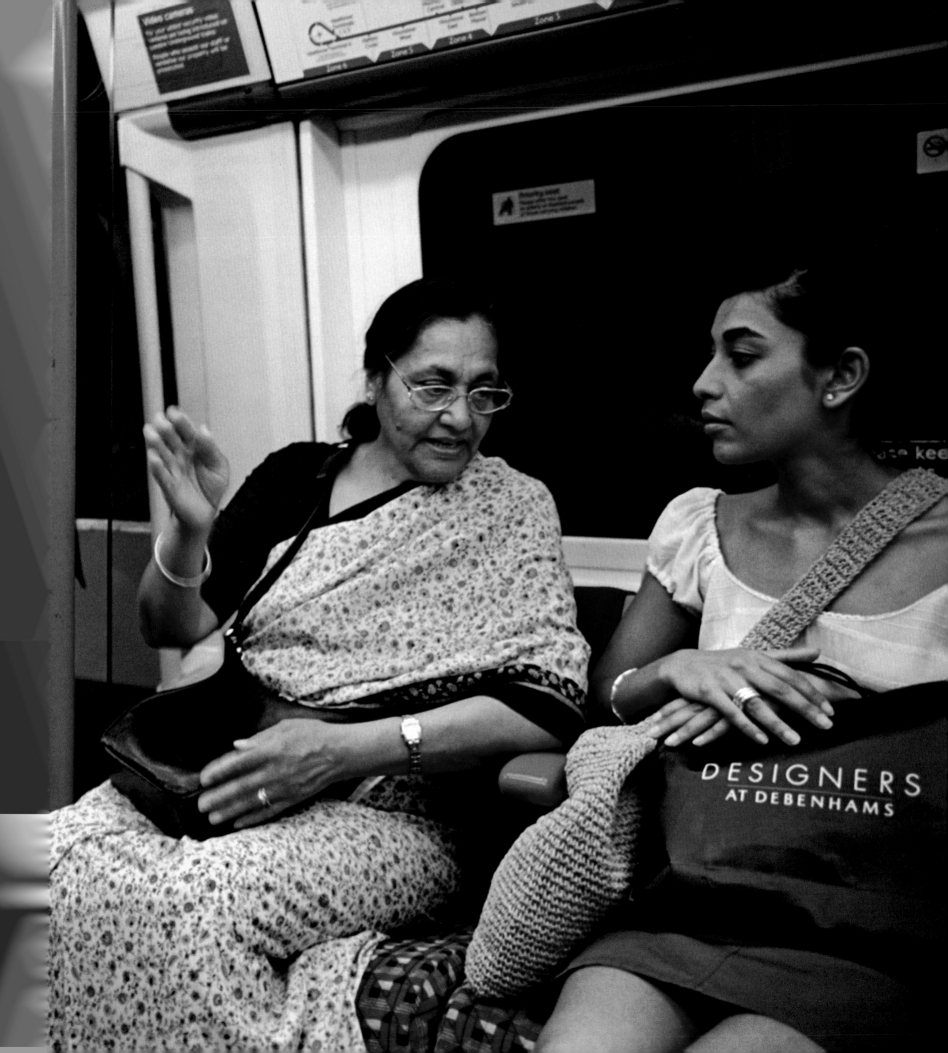

One of the largest Hindu temples outside of India, the Shri Swaminarayan Mandir in the London suburb of Neasden is often called Britain's Taj Mahal and serves a prosperous Gujarati community. Devotees in Britain largely paid for and built the temple, which is made of 26,300 pieces of hand-carved Italian marble. Scholars find a contradiction in the Swaminarayan religion, a fast-growing sect in India and abroad with temples in the United States, Canada, and East Africa, for its Gujarati-only exclusiveness despite preaching a message of universal truth for all faiths.

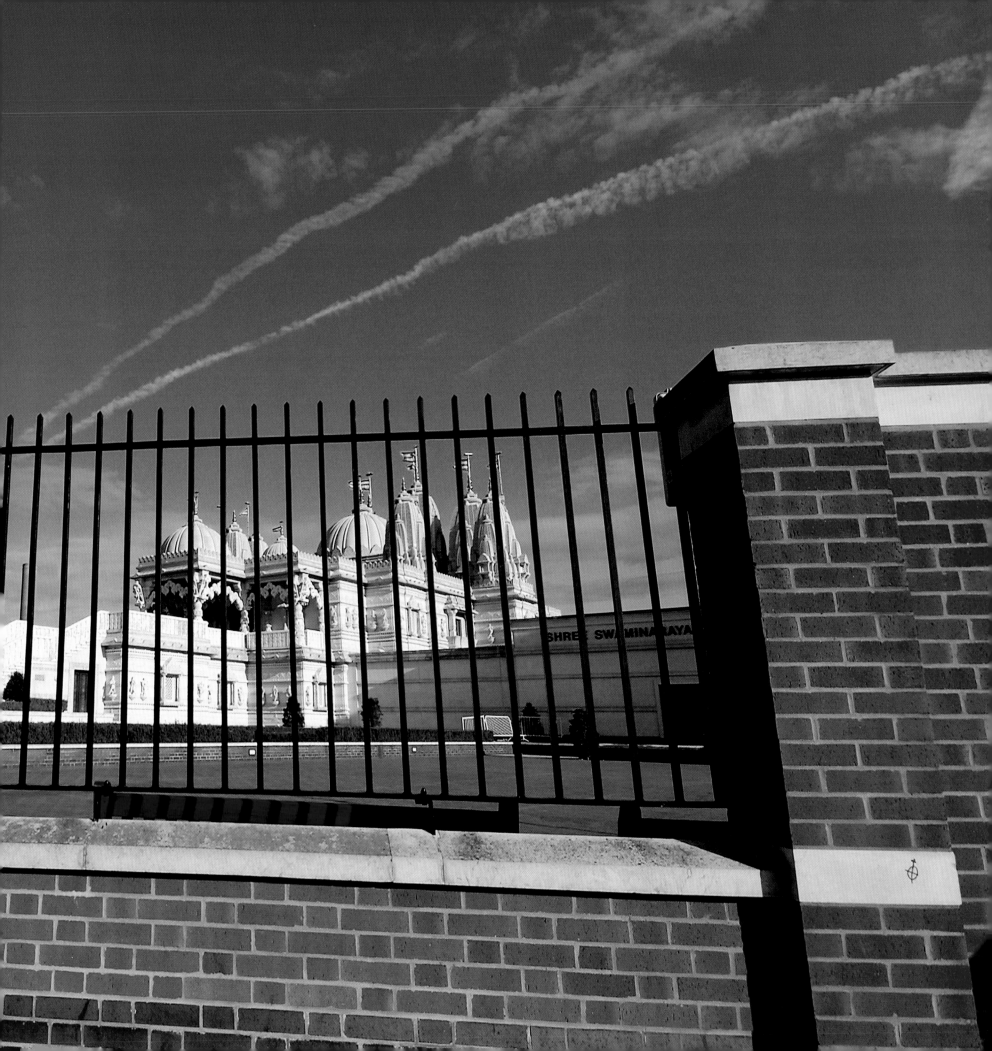

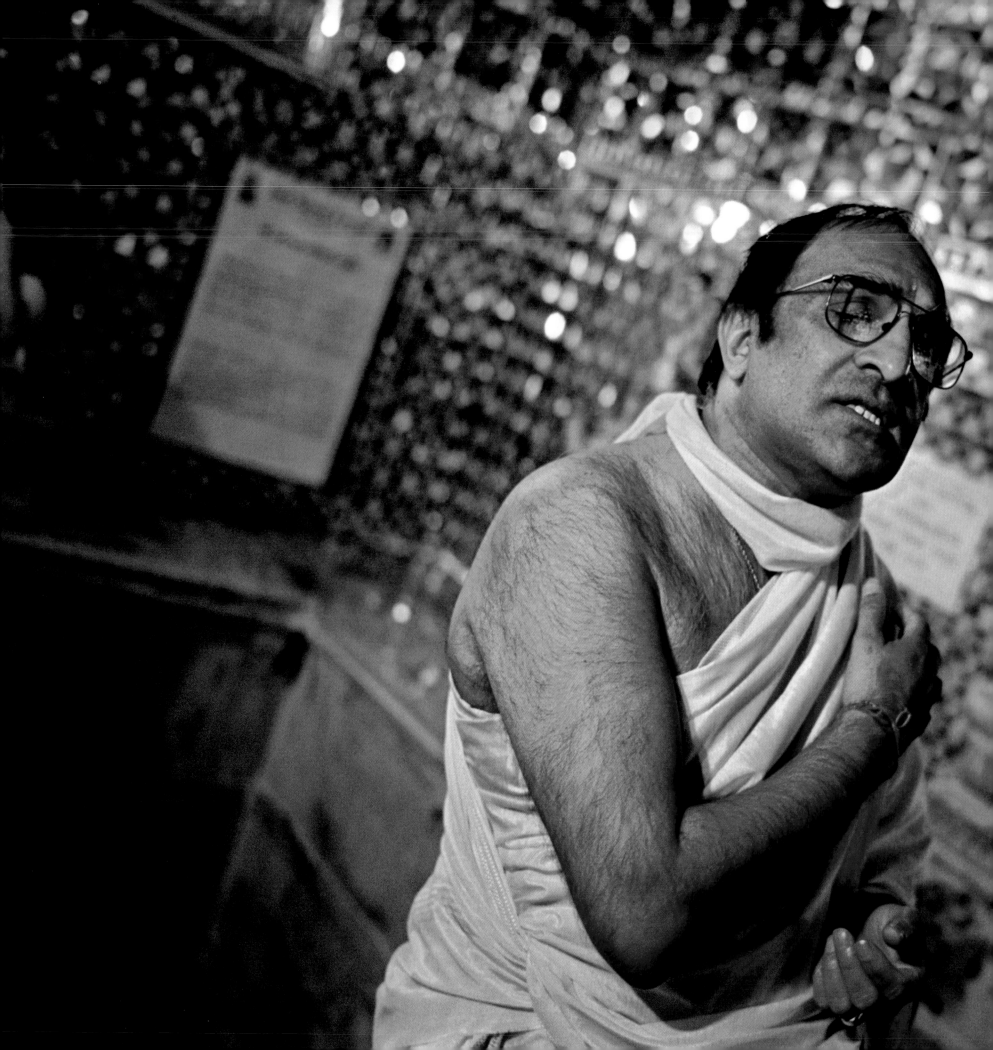

Disciple of an ancient faith, Dr. Ramesh Mehta, a physician in the English Midlands, doubles as priest and leader of the Jain Centre in Leicester, the only place in the Western world with all of Jainism's most sacred images. Gathered beneath stained-glass windows depicting their message, Jains believe that animals and plants, as well as human beings, contain living souls and that every species should be treated with respect and compassion. Vegetarians and early environmentalists, Jains advocate conserving the world's scarce resources.

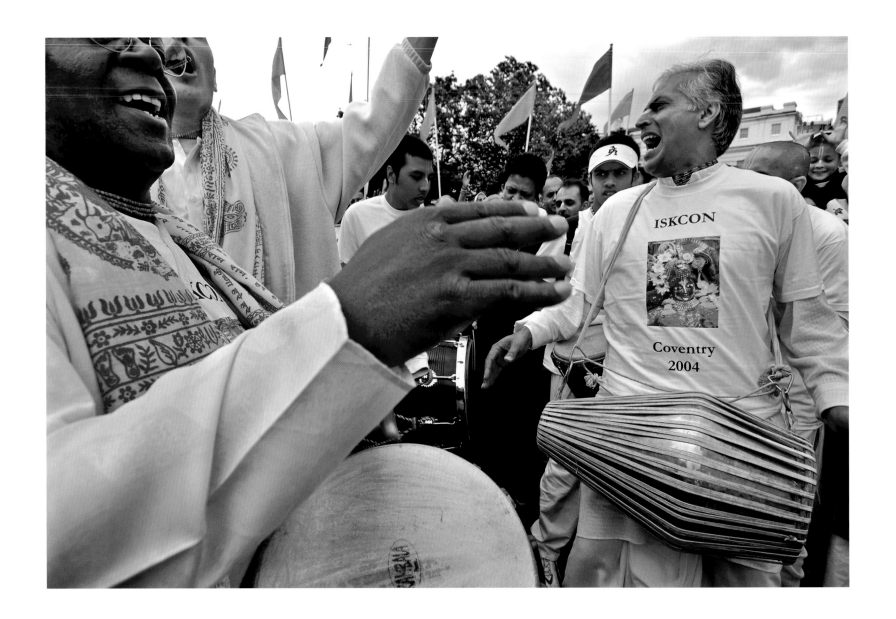

Hare Krishna devotees, like Ms. Suci Rani of London, celebrate *Rathayatra*, or the Carnival of Chariots. Introduced first in San Francisco in 1967 by followers of the Hare Krishna guru His Divine Grace A. C. Bhaktivedanta Swami Prabhupada, it is the Hindu sect's largest street festival, with drummers, chanters, dancers, and clanging cymbals—all accompanying wooden chariots pulled by hand from Hyde Park to Trafalgar Square. In Great Britain, Hare Krishna believers first celebrated Rathayatra in 1969 in London.

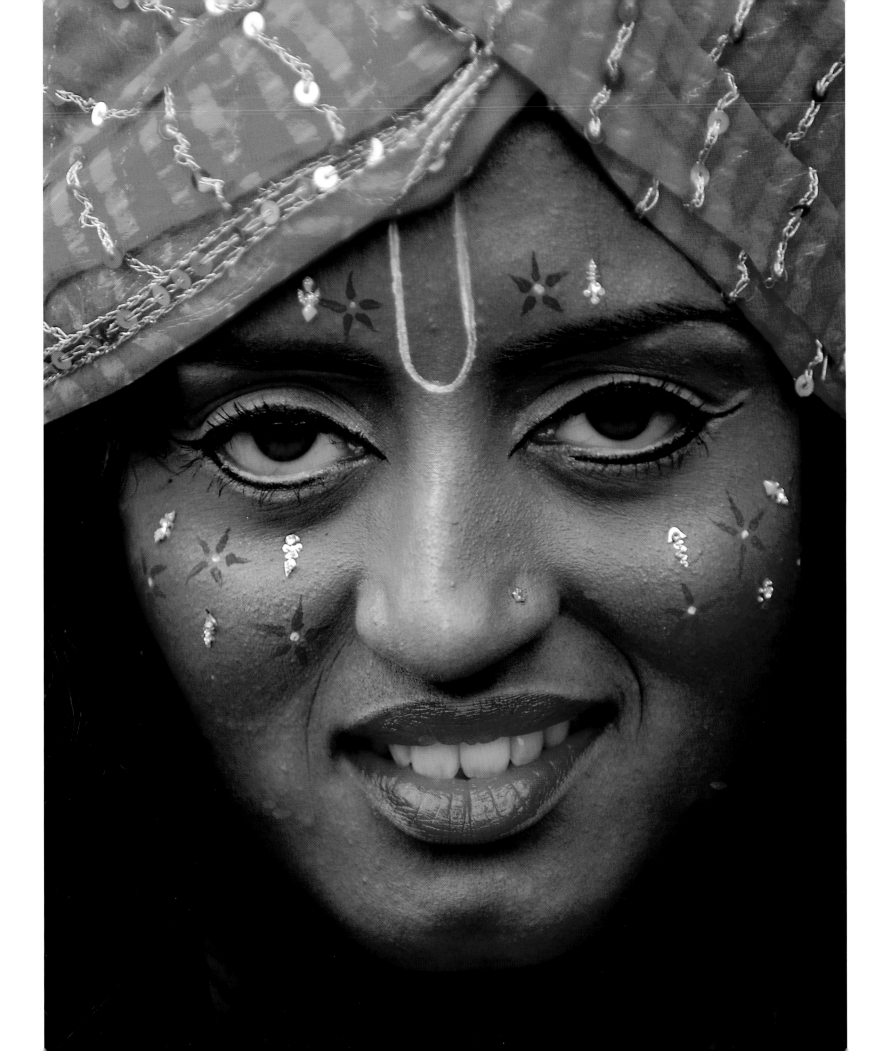

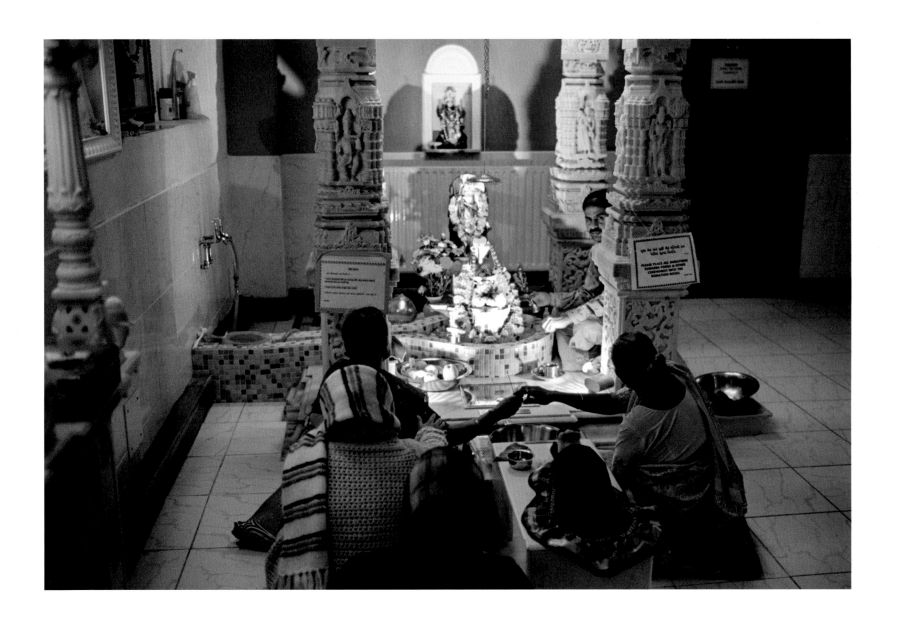

A place of worship for Hindu pilgrims, the Shree Jalaram Prarthana Mandal, or temple, in Leicester is famous for its colorful iconography. A ceiling painting includes likenesses of Jesus Christ and Buddha, though it is not uncommon to find images sacred to other faiths in modern Hindu temples, especially in countries like Great Britain where Indians have sought to fit in to a new multicultural society. The Jalaram sect prizes religious equality, and characteristically the temple has played host to an oral history project in which immigrants record their memories of coming to Britain.

Carrying Indian flags, British-born South Asians celebrate Diwali, sometimes called Deepavali, or the Hindu festival of lights, in Leicester, which for one night in late autumn may be the brightest place in all of England. For Hindus, Deepavali is a festive time that marks the victory of good over evil. The original Sanskrit word Deepavali means an array of lights that drives away darkness, but the name has been popularly modified to Diwali, especially among persons like those in Britain from northern India.

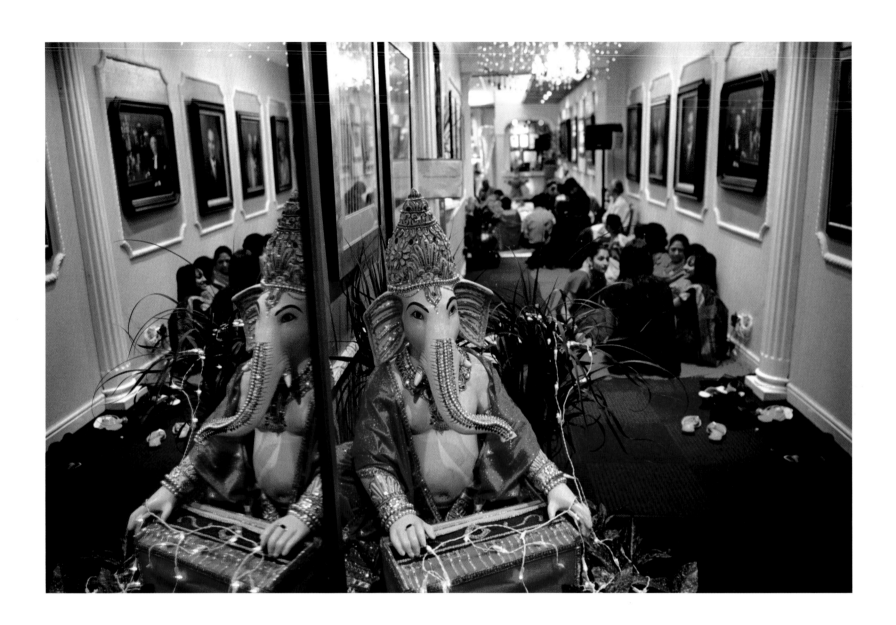

On the third evening of Diwali, families and friends, like these Hindus in Leicester, gather for prayers. Notably, Sikhs and Jains also celebrate Diwali, usually to mark the day Sikhs laid the foundation for their most important temple in India and the day on which one of the Jains' supreme holy men attained Nirvana.

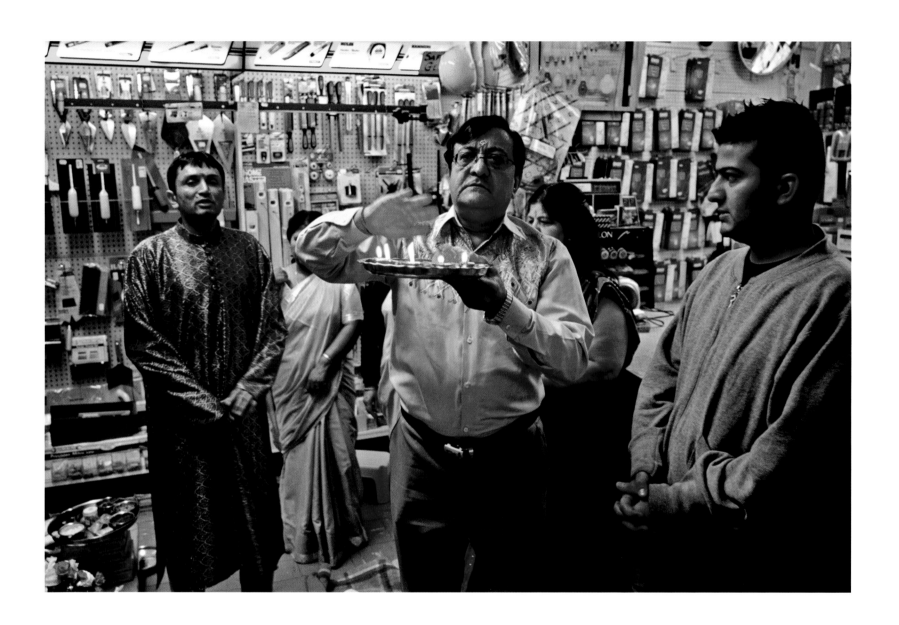

Invoking Lakshmi, the goddess of wealth, shopkeeper Chandu Pancholi (center) marks
Diwali by closing the books on his hardware business in Leicester and, with the help of
a Hindu priest and his son, begins a new fiscal year. Born in Uganda, Pancholi says his
ironmonger shop offers customers "everything from the vintage to the latest gadgets."

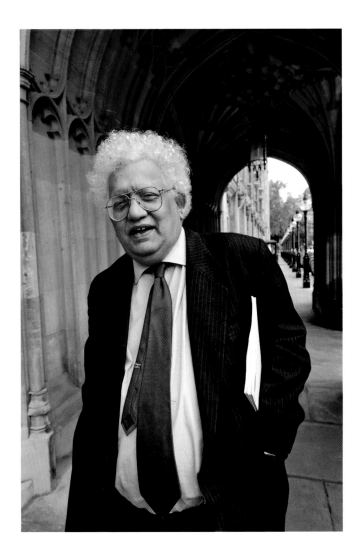

Critic of multiculturalism, Lord Meghnad Desai enters the House of Lords in London. "Access to public housing and other government assistance was based on South Asians maintaining their identity," says Desai, an emeritus professor at London School of Economics. "But young people are adapting to the knowledge-based economy, assimilating along the lines of the Jews through education." More separate than assimilated, South Asians in Leicester bank and shop along Belgrave Road. By the year 2011, Leicester—founded by the Romans—will become the first British city with a majority nonwhite population.

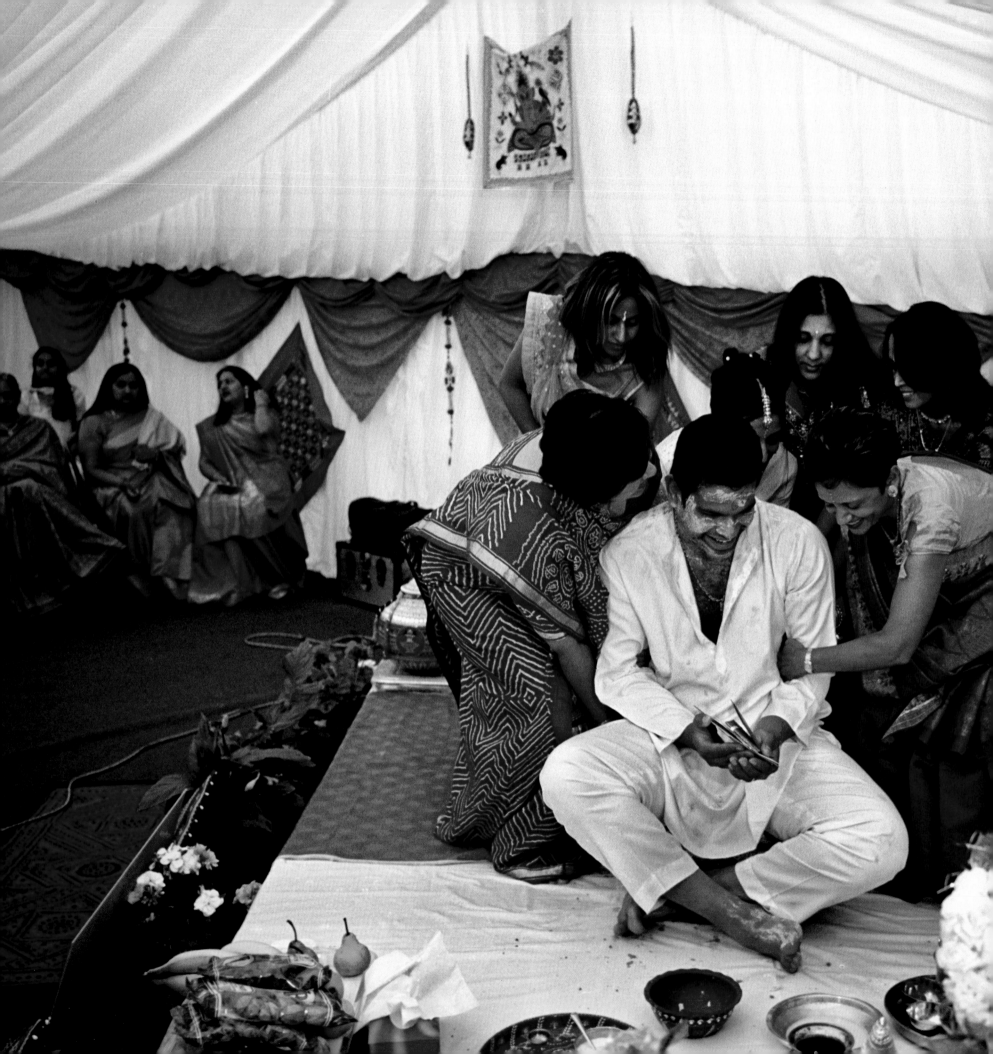

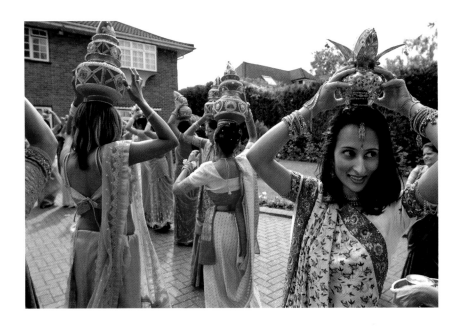

Hindu bridegroom Mitesh Patel is the object of Gujarati cultural traditions that range from the elegant to the raucous before his wedding in rural Hertfordshire outside London. Outfitted in their best saris, relatives of the groom carry specially decorated pots on their heads in a religious ceremony called *Ghari Puja*. Less solemn is the *Pithi* ritual, which calls for female relatives to rub a paste made out of chickpea flour, turmeric, and rose water on the bridegroom's skin to enhance its tone—an event blessed by a Hindu holy man.

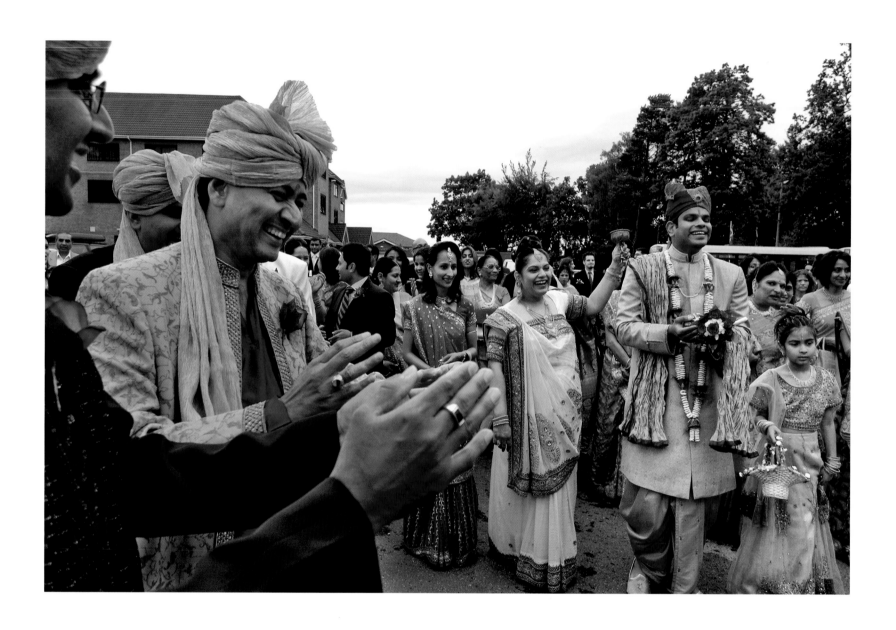

Bridegroom Mitesh Patel wears a super-sized smile for the Vara Satkaarah, or honoring-the-groom ceremony—a lively wedding-day ritual held at a country club near Windsor Castle that ends with Patel's family parading to the wedding hall to be blessed by the mother of the bride.

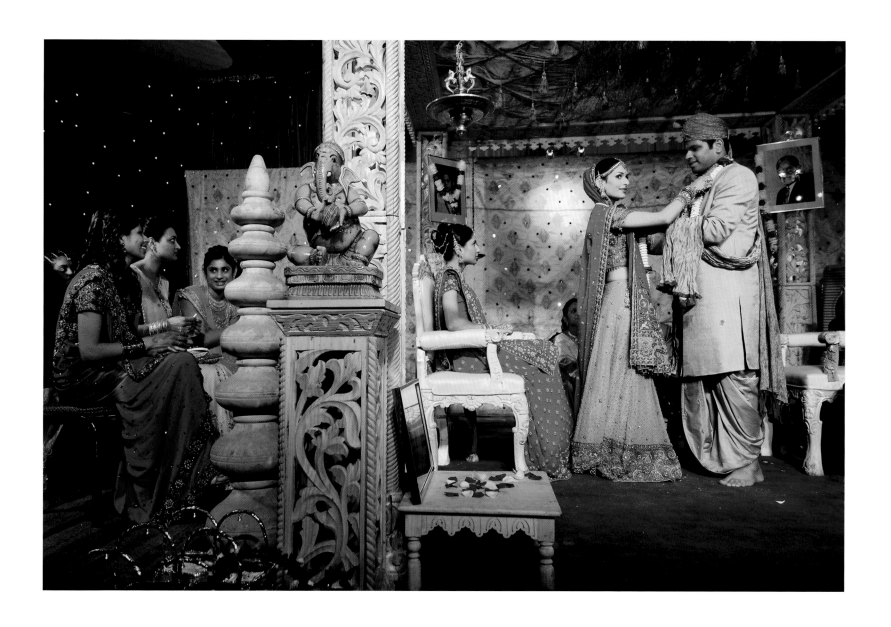

Far more somber is the actual wedding ceremony, which is conducted over several
hours with clockwork precision. The ceremony ends with a recitation of the
traditional wedding vows in English—required under British law—and an exchange
of garlands by the groom and his bride, Nital Patel.

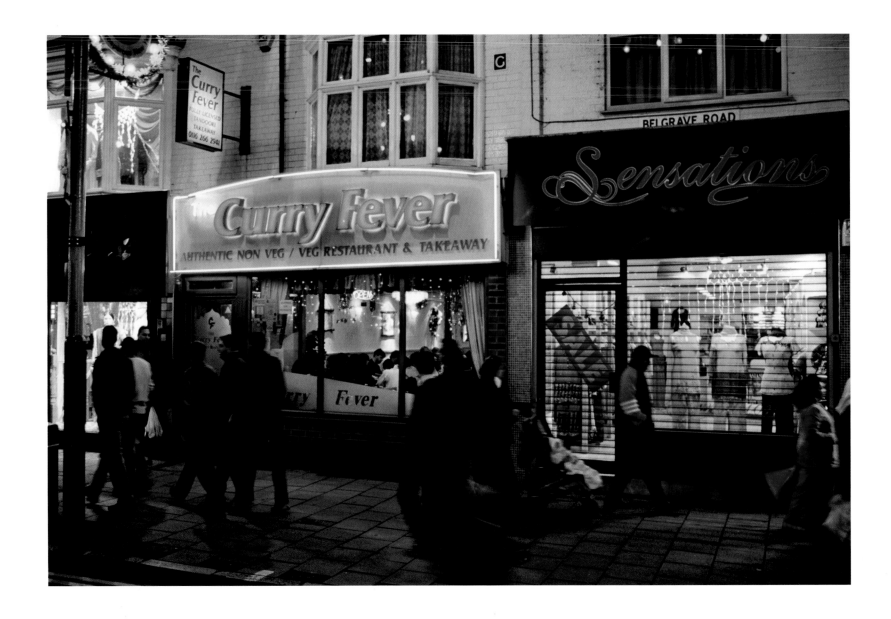

Curry, one of the most admired legacies of the British Raj, is served up at a dozen or more South Asian restaurants in Leicester, largest city in the East Midlands. Strictly speaking, curry is a British invention—a catchall term used to describe rice, vegetable, and meat dishes jazzed up with a variety of Indian sauces of butter, crushed nuts, spices, and fruit.

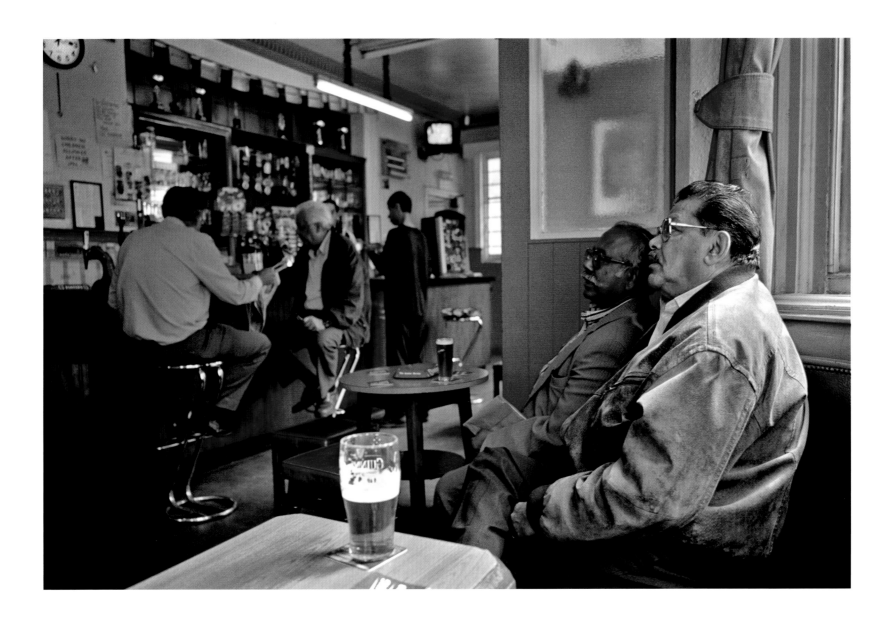

Bangladeshis run many of the 8,000 so-called Indian restaurants in England, but pubs are another story. Several pubs along Belgrave Road in Leicester cater almost exclusively to Indians, who enjoy a pint of Kingfisher or Carling lager before lunch. British researchers say Sikhs drink more alcohol than Hindus or Muslims and that alcohol-related psychiatric admissions to hospitals are especially high for Sikh men.

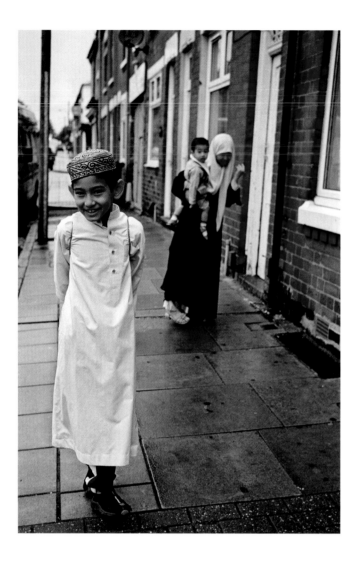

The call to Muslim prayer draws children to the windows and onto the gritty streets of Leicester's Highfields neighborhood. Along Melbourne Road, where the bulk of the city's 30,000 Muslims live, the fear is that some of Britain's 1.8 million Muslims are embracing a violent, radicalized version of Islam. Many of the city's first Indian Muslim immigrants came from British East Africa with entrepreneurial zeal and money, and quickly moved into the economic mainstream. But England's shift from manufacturing to a service-based economy has been less welcoming of newcomers, who remain segregated and look to religion—especially Islam—for their identity.

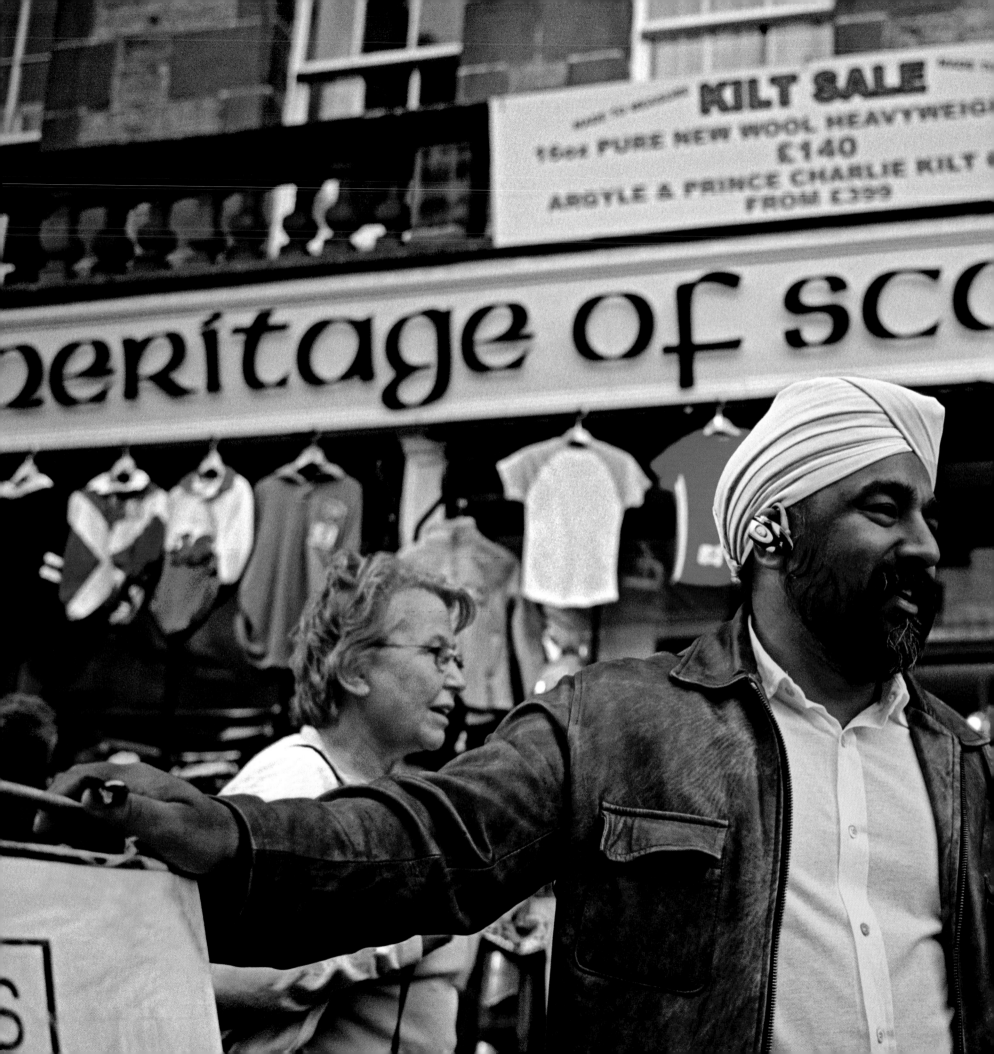

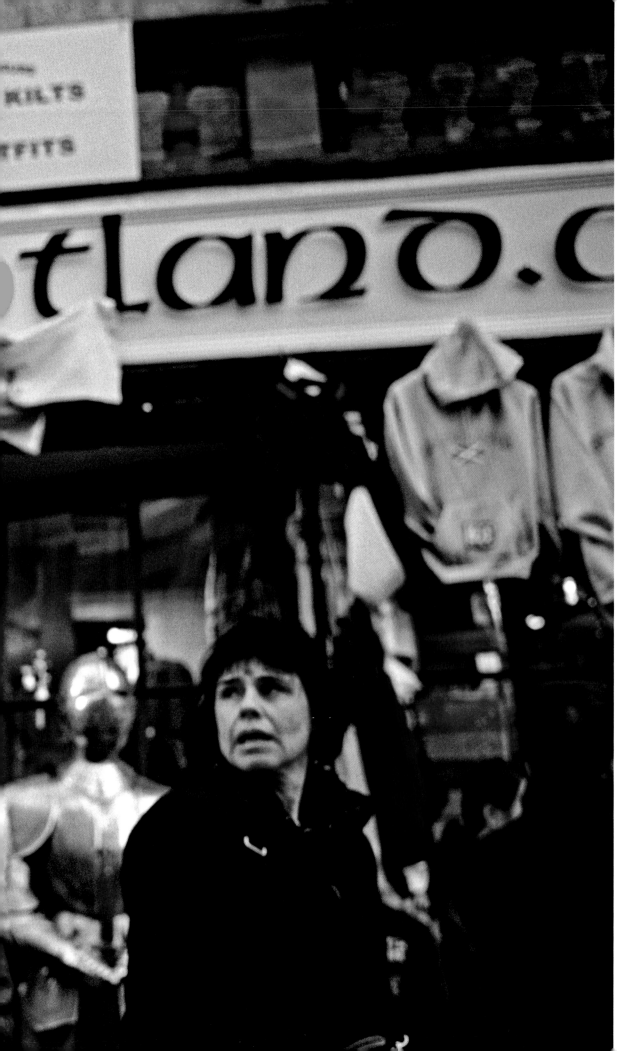

Using a wireless earpiece, Scottish Sikh businessman Surinder Singh chats on a mobile phone outside his store in Edinburgh. The first Sikhs to settle in Edinburgh, in about 1920, were traders and peddlers, most members of the Bhatras caste. Today, the influence of South Asian culture on the Scots is apparent with two official Indian-Scottish tartan plaids—the Leith Sikh tartan, which includes blue from the Scottish flag, green from the Indian flag, and the saffron of the Sikh community, and the Laird of Lesmahagow tartan, which is named after a Glasgow Sikh landowner who has had the works of poet Robert Burns translated into Punjabi.

Sikhs worship in the Guru Nanak Gurdawara Singh Sabha Sikh Temple in Leith, a district of Edinburgh, the Scottish capital, where several thousand Punjabi merchants and their families have lived in a tight-knit community for more than 60 years. As their numbers grew over the generations, Sikhs took over a vacant Anglican church in 1976 to use as their holy place, usually called a *gurudwara*, or "doorway to the guru." The former St. Thomas church was built in 1843 by Sir John Gladstone, father of Victorian-era Prime Minister William Gladstone, and is now divided by gender during prayers and festivals.

The Middle East, Africa, and the Indian Ocean
Oil, Politics, and the Legacy of Gandhi

Indian merchants in wooden dhows and sailing ships traded with parts of the Middle East, Africa, and the islands of the Indian Ocean for hundreds of years before Dutch merchants changed everything in 1653 and began selling Indians as slaves in the Dutch Cape Colony, now the fetching city of Cape Town. Yet Indians didn't arrive on Africa's shores in substantial numbers until the nineteenth century—the result of British colonial policies that encouraged the importation of laborers from India after slavery was abolished throughout the Empire in 1834. Tens of thousands of Indians sailed across the Indian Ocean to the rugged volcanic islands of La Reunion and Mauritius, as well as to work the plantations of the fertile Natal coast and build a railroad through the savannah and high plains in East Africa. According to newspaper accounts, the greatest threats in the early days came from the occasional lion that would greedily eat a railway worker or two, or from diseases that killed Indian laborers by the hundreds.

Indian professionals, or fare-paying "passenger Indians," as they were called, followed in a second wave of immigration to Africa in the late nineteenth and early twentieth centuries, working the railways, dockyards, coalmines, and municipal offices from Kampala to Cape Town. Among them was a young lawyer, recently called to the bar in London, named Mohandas Karamchand Gandhi, whose struggle against injustice and racial discrimination would inspire generations of South Africans hungry for freedom and human dignity.

Perhaps the most unlikely place to discover Indians in the Middle East and Africa is Israel and the occupied Palestinian Territories. But unlike Indian communities in, say, Great Britain or Southeast Asia, these 60,000 voluntary, faith-based immigrants and their offspring are quietly assimilating the dominant culture and ethos of Israel, with many marrying Jews of European origin. Still, Indian émigrés in Israel occasionally travel back to India on so-called "roots tours" with their Israeli-born children to visit places like Mumbai and Kerala on the Malabar Coast, where there were once thriving communities of Indian Jews.

If colonialism was responsible for millions of Indians immigrating to Africa and the islands of the Indian Ocean, the world's demand for oil and natural gas, coupled with an acute labor shortage, has motivated tens of thousands more to take up work in the states of the Persian Gulf. Since the 1970s, Indians have been arriving by the planeload in places like Iraq, Kuwait, Saudi Arabia, Qatar, and Dubai, a futuristic city-state where blue-collar workers live in overcrowded labor camps, work for low pay, and more than occasionally resort to suicide rather than return home empty-handed.

By all accounts Dubai, the most flamboyant of the seven states that make up the United Arab Emirates, has reinvented itself as one of the most globalized corners of the world, banking on education, a favorable business climate, and tourism to offset its dwindling reserves of oil and gas. But the men and women giving Dubai an extreme makeover are largely hidden from public view. Of Dubai's 1.5 million residents, perhaps a million are

immigrants—the majority of them construction workers from South Asia and the Philippines. Beyond the glitz and the glamour, the mall-hopping shoppers, and developers who have built a ski resort in the middle of the desert, hundreds of thousands of unskilled Indian workers toil in the hope that their labor will benefit home and family. Thanks to their sacrifice, now into its fourth decade, the effects of globalization have been trickling down to places like Kerala, a tiny Indian state on the Arabian Sea, where remittances from workers in the Middle East account for more than 20 percent of the state income.

But the price has been high.

Blue-collar Indian workers in the UAE, including Dubai, amount to an exploited underclass with no rights, no unions, and no stake in the country's burgeoning wealth, say human rights groups. And a recent Human Rights Watch report says that in neighboring Saudi Arabia, many of the country's more than one million Indian migrants live in "conditions of slavery." Even the U.S. State Department has repeatedly criticized the UAE and other Gulf states for labor abuses that amount to "involuntary servitude."

Arab employers often confiscate the passports and residence permits of workers when they arrive, making it virtually impossible for laborers to look for better jobs or quit and go home. Human Rights Watch says migrants typically cannot obtain exit visas without the approval of their sponsor or employer, "sometimes placing them in situations that amounts to forced labor." But the story of these largely anonymous Indians, who live in Dickensian labor camps and crowded apartments, is gaining attention in the usually self-censored UAE press, which now regularly reports on worker protests over delayed pay and substandard living conditions.

Since the flush 1970s, when global energy prices began to soar, the earnings of these foot soldiers of globalization have financed much of India's trade deficit, according to a recent study by the British Department for International Development and the University of Dhaka in Bangladesh. While Indians

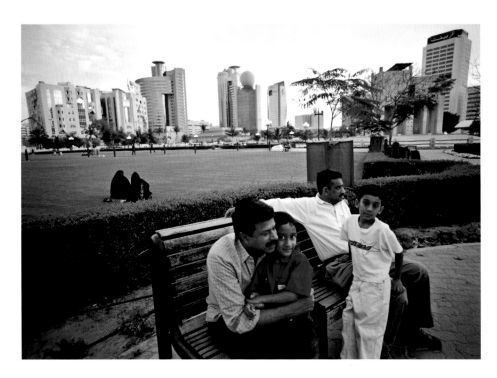

working in the Middle East amount to only 1 percent of the India's total labor force, the remittances they send home have had a considerable impact on the regional economies of poorer states like Tamil Nadu, Andhra Pradesh, and Kerala. The some 3.1 million Indians working in the Persian Gulf send home about $7 billion a year, according to the Indian Bureau of Foreign Employment. Overall, the Reserve Bank of India says Indians worldwide are sending home about $15 billion a year, accounting for slightly more than 3 percent of the country's gross national product in recent years.

In Kerala, the exodus of workers to the Gulf has resulted in smaller families and more families headed by women, giving these de facto heads-of-household newfound power and authority. Gulf remittances also have contributed to a 6 percent decline for Muslims living below the poverty line and a 3 percent decline among Hindus, according to a recent study by the Center for Development Studies in the state capital, Thiruvananthapuram. Kerala workers at a high-rise construction site in Dubai say the money they send home pays for new houses; better schools, uniforms, and textbooks for their children; and dowries for their daughters. Others tell of having to repay sizable loans,

Against a backdrop of glass, steel, and stone, fathers and sons enjoy the calm of early evening in Dubai, one of seven largely self-governing city-states that make up the United Arab Emirates. About a million Indian professionals, some accompanied by their families, work in the oil- and gas-rich Persian Gulf states.

Far from Dubai's futuristic skyline, a South Asian merchant takes a tea break outside his shop on Al Fahidi Street, a maze of alleyways and wind towers in the heart of the Bur Dubai souk, or ancient bazaar. Indian merchants from the coastal states of Gujarat and Tamil Nadu set up shop in Persian Gulf ports of Bahrain and Muscat at the beginning of the eighteenth century and established a thriving gold trade with Dubai by the mid-1800s.

some at nearly 100 percent interest, to secure jobs and visas for the UAE. Meanwhile, the poorest Kerala villages are getting new mosques, temples, and satellite dishes, thanks to Gulf remittances, as well as outdoor advertising for all manner of consumer goods, especially flush toilets.

The UAE's substantial investment in fiber optic networks means that remittances move from the rich to the less developed world at the speed of light, though the practice of carrying gold jewelry or ingots back to India hasn't disappeared—to the chagrin of UAE and Indian government economists. In Dubai, where there are no personal income taxes, banks compete to send remittances anywhere in India inside 24 hours. Some workers send home as much as half of their earnings. But unskilled workers worry about their ability to keep the remittances going home. "There are too many South Asians here now and many are going home, not to return," says a Pakistani taxi driver. "You have to work 365 days a year, no days off."

UAE policies seem to bear out the driver's comments, despite a building boom that has made Dubai the second largest construction site in the world after Shanghai. While South Asian professionals are

still welcome, the UAE is accepting fewer visa applications from Indians for unskilled jobs, turning instead to Filipinos, Indonesians, and even Romanians, who are less likely to protest working conditions. "I recently placed an advertisement in the local newspaper for 50 jobs and 700 Indians showed up," says P. K. Girish, general manager of one of Dubai's 400-plus hotels and an Indian by birth. "There's no doubt Dubai needs to finetune its labor market." Thousands of illegal South Asian immigrants are said to live in slums in the neighboring Emirate of Sharjah, he says.

While professionals like Girish live as comfortably in Dubai as anywhere else in the developed world, they say the welcome mat is a bit less welcoming these days. Throughout the Gulf, indigenous Arabs are being hired for managerial jobs once reserved for Indians in what amounts to an affirmative action policy to fight local unemployment. Indians of every social class gripe about discrimination and a lack of rights, such as citizenship for Indian children born in the UAE, but few seem anxious to return to India. "Life is so harsh in India," says Trevor Rose, a native of India who earned a Canadian passport only to return to Dubai. "This is still better."

Indians in South Africa, professional and otherwise, might disagree with Rose. Despite their numbers—at least a million today—Indians have never really been welcome in South Africa.

British settlers in Natal may have needed their labor, but colonial governors and Afrikaner politicians from the beginning saw Indian immigrants as "coolies" or chattel. Their racism made no distinctions between, say, indentured laborers and teachers, accountants, or lawyers like the troublesome Mr. Gandhi, who forced the British to abolish a poll tax; recognize Hindu, Muslim, and Parsi marriages; and ultimately encouraged future generations to resist injustice and discrimination. Between 1885 and 1941, white South Africans enacted 61 pieces of anti-Indian legislation. By 1948, the leader of the self-governing British dominion known as the Union of South Africa, D. F. Malan, had declared, "Indians are a foreign and outlandish element which is inassimilable." As the apartheid system of racial separation became more entrenched, more laws

followed, culminating with the notorious 1950 Group Areas Act, which sent blacks to "homelands" in some of the most inhospitable parts of the country and uprooted Indians in the coastal metropolis of Durban, dispatching them to distant ghettos.

The "divide and rule" apartheid policies of successive white South African governments allowed Indians more economic opportunities and political freedoms than blacks, fostering hostility against Indians—and some of their business practices—that lingers today. No one disputes that in the worst of times, some prosperous Indians established themselves along "Millionaires Row" in the Reservoir Hills neighborhood of Durban and the wealthy suburb of Seal Crescent not far from Johannesburg. But it would be a mistake to think that Indians in South Africa are better off than most blacks. Thousands of Indians still live in rural ghettos carved out in the 1960s, in some cases without plumbing or electricity. A 2003 Indian government study of the diaspora in South Africa found that "65 to 70 percent of persons of Indian origin are still living under the poverty line" and between 10,000 and 20,000 Indians are HIV positive.

Racial politics continue to divide South Africans today, with Indians, who fought against apartheid since the days of Gandhi, feeling betrayed by the affirmative action policies of the black-dominated government. Indians with skills are migrating to any developed country that will take them, mostly New Zealand and Australia, in a "brown brain drain" that shows no sign of letting up. "There is really no future here," says Narinsamy "Cass" Moodley, a taxi driver. "We're living on borrowed time."

One person who hasn't given up on South Africa, and indeed considers herself a patriot, is Ela Gandhi, former social worker and journalist who served seven years in parliament and is perhaps best known as a granddaughter of Mahatma Gandhi. Now in her sixties, Ela Gandhi tells visitors to her cozy twelfth floor condominium overlooking one of Durban's better neighborhoods that she is proud of her South African heritage and citizenship—hard-earned in the anti-

apartheid struggle when she was under house arrest from 1975 to 1983. "We used to have a lot of African friends," Ela Gandhi recalls of her schoolgirl days in a mixed Indian and black ghetto outside Durban. "We didn't have to go to school to understand our neighbors." Dedicated to promoting her famous grandfather's message of *satyagraha,* or steadfastness in the pursuit of truth and nonviolence, she says, "There is hardly any politician in South Africa who wasn't influenced by the struggle of Gandhi."

Ela Gandhi is a leader who recognizes that Indians must become part of the turbulent melting pot that is today's South Africa, however much resentment there may be on all sides—Indian, black, and white. For better or worse—and there is a lot of "worse" with rampant crime directed at Indians in every major city—Indians must, in the words of an Indian government report, "accept with grace the inevitable process of increasing Africanization." The report continues, Gandhi's message of "non-racialism, for which so much has been sacrificed, will not be adequately advanced without the integration of Indians into the mainstream of South African society."

Of course, South Africa is not the only place in Africa where Indians have suffered and prospered, only to face a fresh round of hardships. The expulsion of much of East Africa's merchant and professional class forced tens of thousands of Indians to start life anew at the bottom of the economic ladder. Ironically, Indians are now being wooed to return to Uganda by Kampala's pro-business government. And while many black Ugandans still resent South Asians years after independence, confiscated property has been returned and Indians are again running banks, foreign exchange bureaus, hotels, pharmacies, insurance companies, and some of the sugar industry. About 15,000 South Asians live in Uganda today, far fewer than the 74,000-plus in the time of General Idi Amin. But by many accounts, Indians have invested about $1 billion in Uganda over the past decade. That some Indians again feel at home in Uganda is perhaps a sign that better days are ahead for Indians throughout Africa.

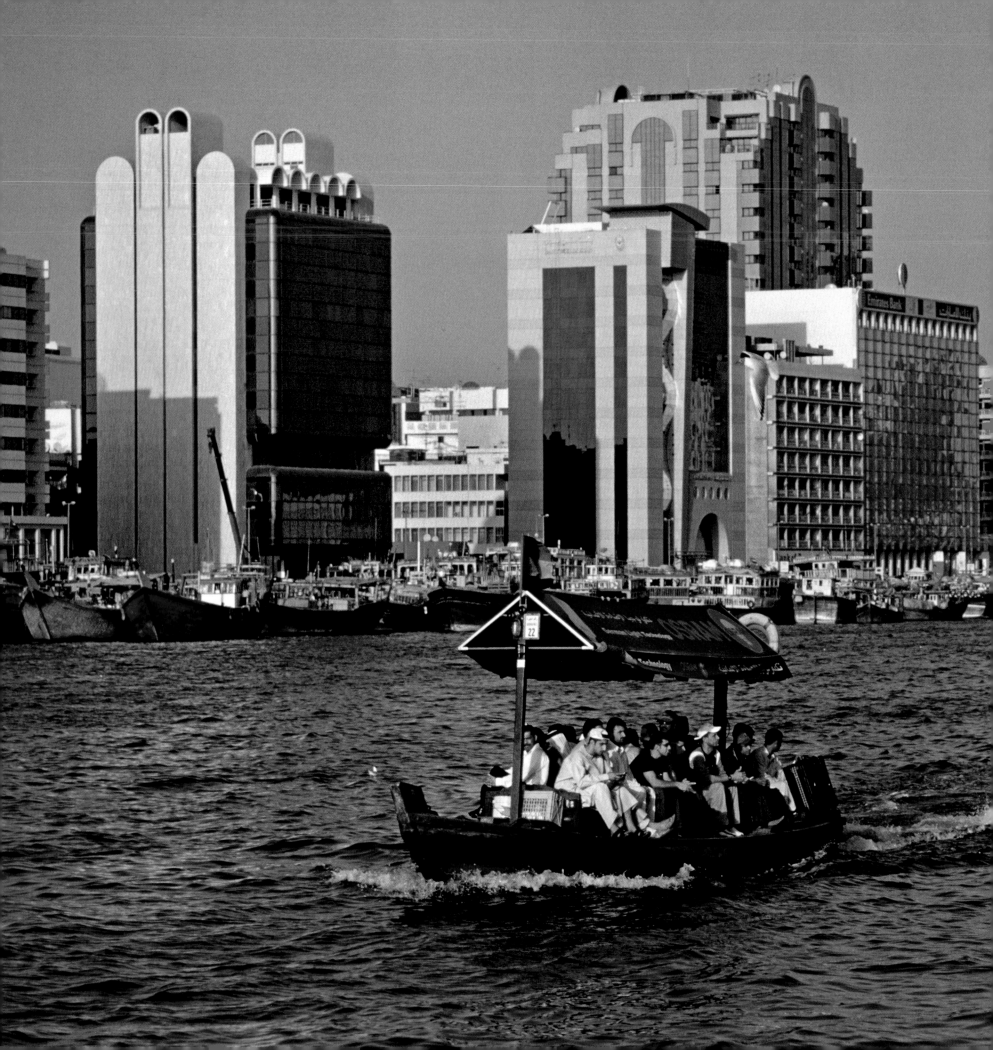

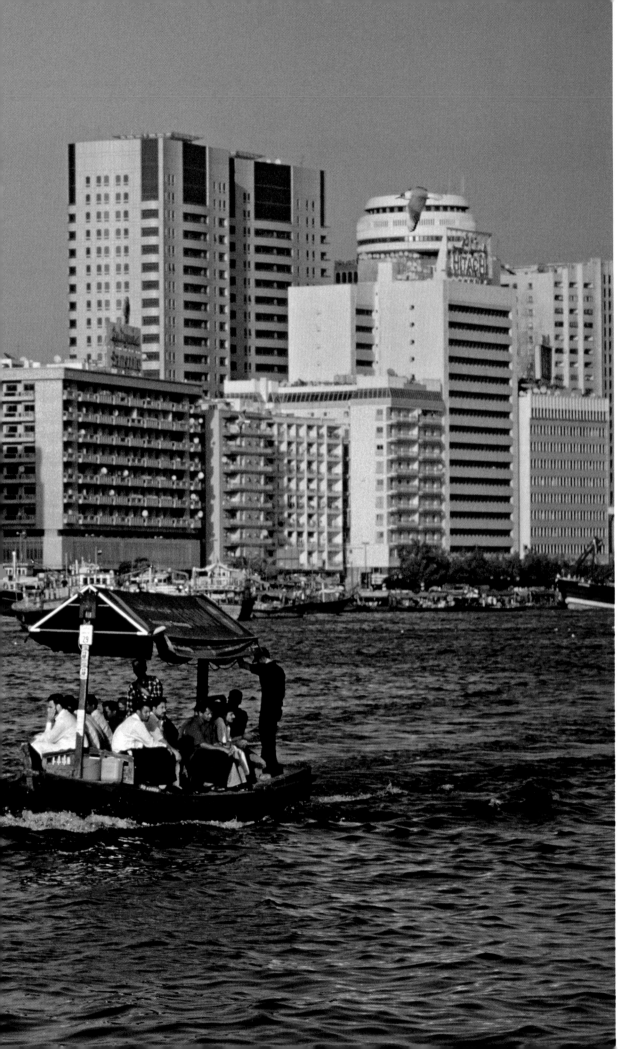

Growing faster than any other place on earth, except perhaps Shanghai, the city-state of Dubai began as a trading settlement along the Persian Gulf. Unlike its neighbors, Dubai was never blessed with much oil, instead attracting world attention through trade, investments, colossal real estate projects, sports events, conferences, air shows, and a string of superlatives in the Guinness record books.

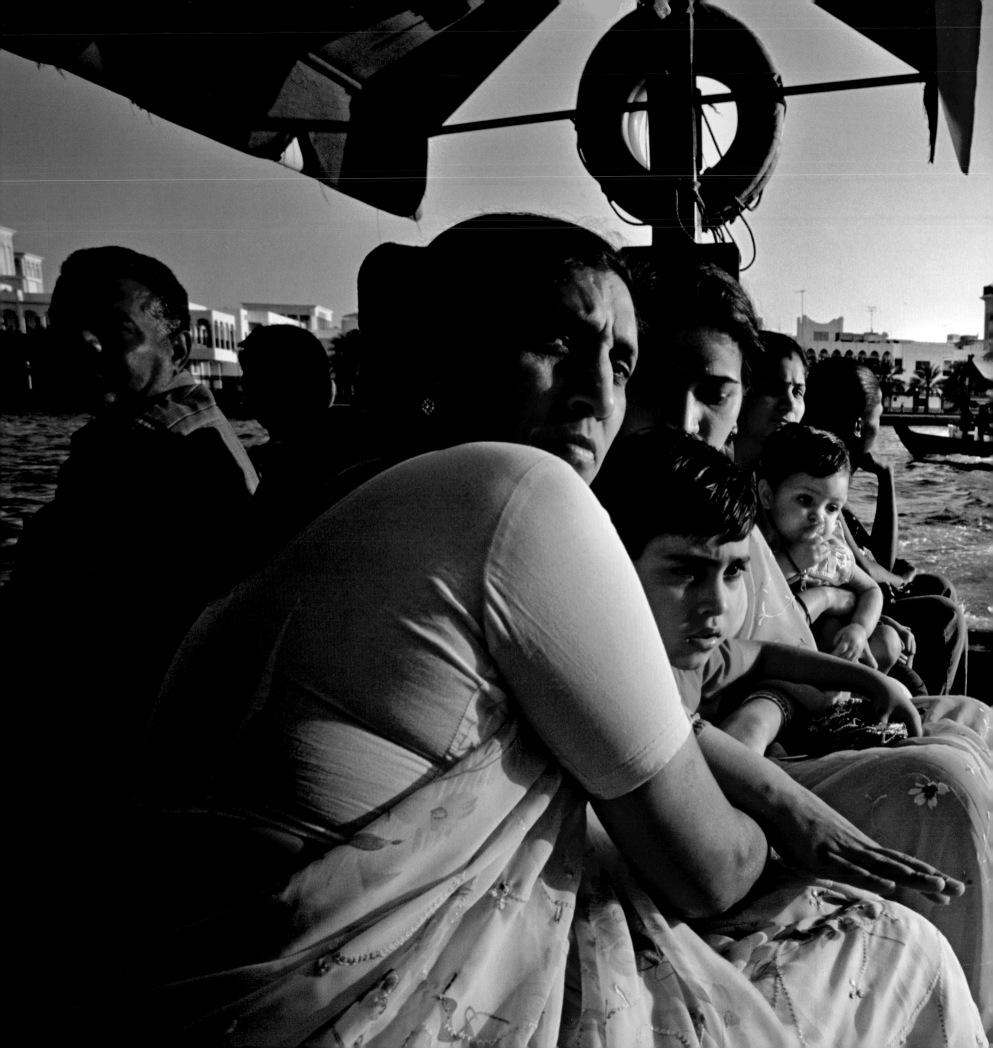

Indian families join the rush hour procession of water taxis, called *abras* in Arabic, crossing Dubai Creek, a traditional seaport crowded with traditional wooden ships, or *dhows*, that trade with Iraq, Iran, Yemen, Somalia, and India. Strategically located between Europe and Asia, Dubai boasts several modern commercial seaports that together rank thirteenth in the world in container traffic and that depend heavily on South Asian workers, both professional and blue-collar, to operate them.

South Asian laborers and taxi drivers—many from impoverished rural communities in the Indian states of Kerala, Andhra Pradesh, Goa, Karnataka, and Tamil Nadu—sleep ten to a room in an apartment in al Quoz, a rundown industrial section of Dubai. Most of the three million Indian workers in the Persian Gulf states are unskilled or semi-skilled, including those at this construction site in Dubai. About 550,000 South Asians work at construction sites in the United Arab Emirates, where labor unrest over workers' rights and safety has triggered demonstrations and strikes.

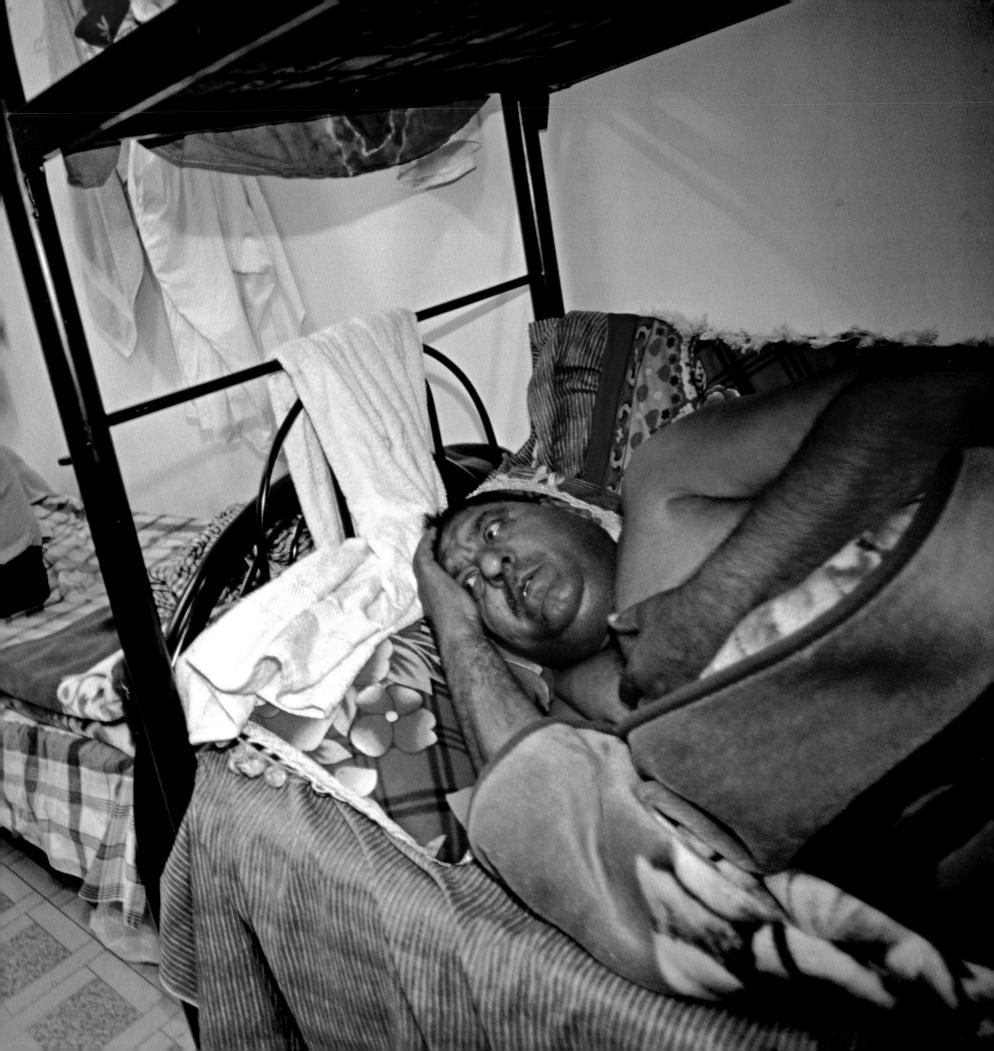

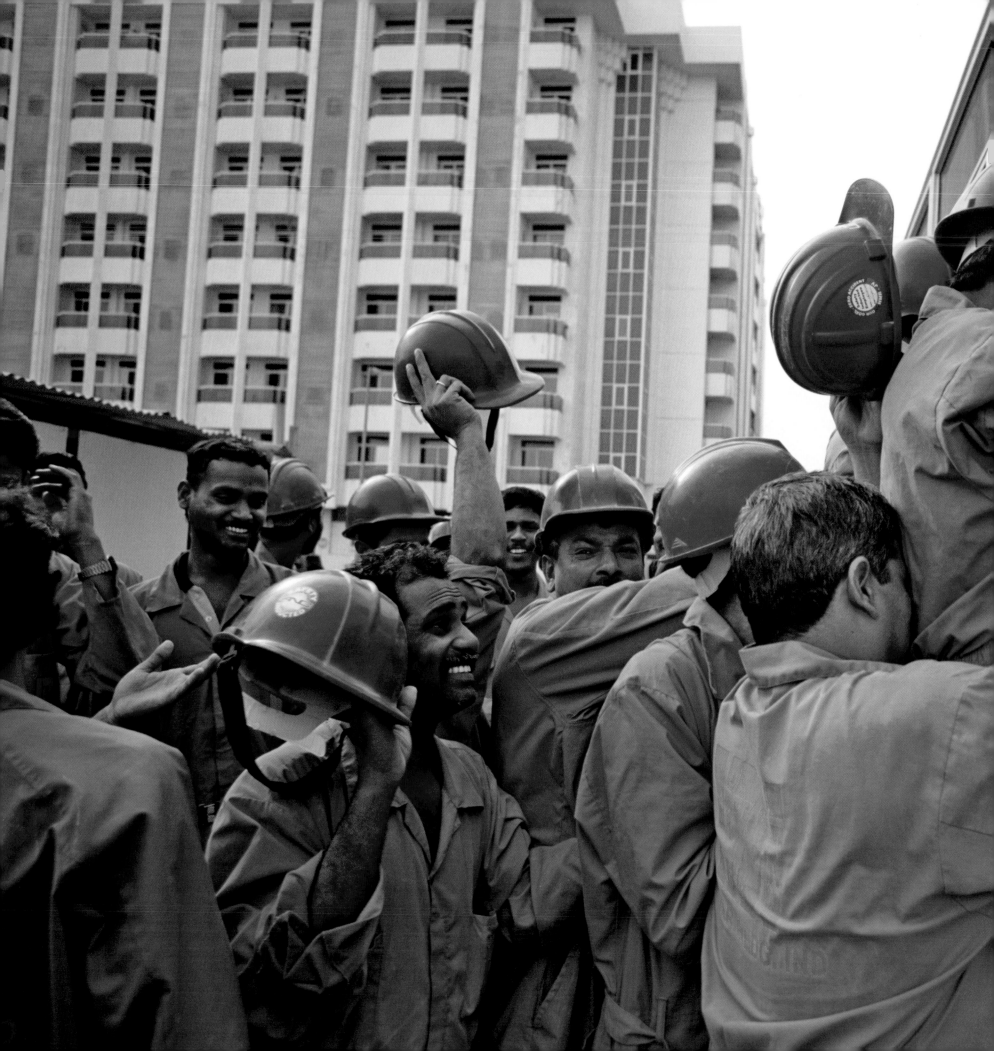

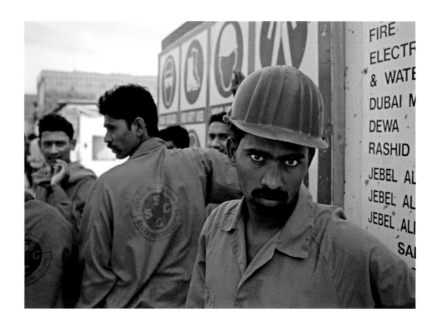

Exhausted Indian workers at a high-rise construction site in Dubai scramble onto buses for a ride through the desert to Labor Camp, an enclave for foreign workers that resembles barracks for a Third World army. Stripped of their passports, sometimes unpaid for months, and preyed upon by recruitment agencies in India that charge as much as $3,000 for an employment visa, workers like this man from Kerala state earn between $175 and $300 a month—about the same as the cost of staying a single night in one of the luxury hotels he and coworkers help build.

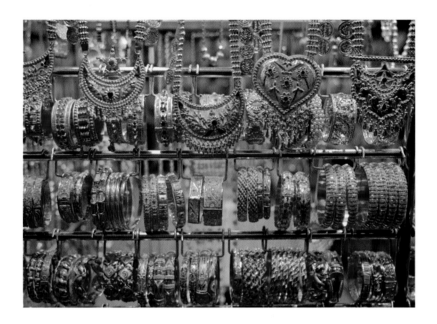

Gold shops and nightclubs with names like Anthakshari, Ashiana, and the Bollywood Café cater to a subcontinental elite in Dubai, a sought-after destination of the diaspora. Indian professionals say they are willing to sacrifice democracy, which doesn't exist in the Gulf states, for the good pay, luxury shopping malls, private schools, and low crime. But Dubai and its neighbors have been roundly condemned by human rights groups for aiding in the exploitation of some of the 600,000 to 800,000 women and children, who are trafficked across international borders each year, most for commercial sex.

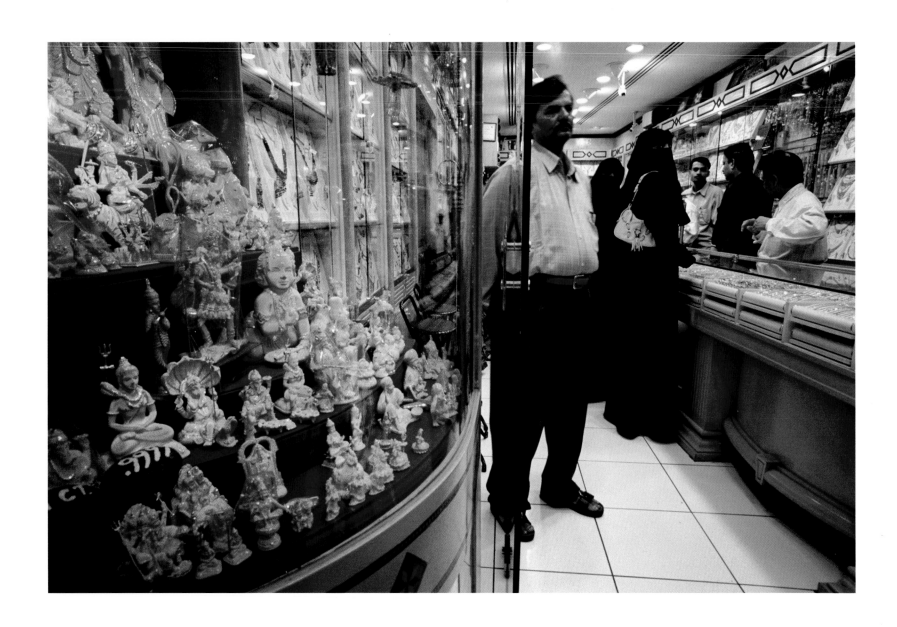

Small statues of Hindu deities greet visitors to a jewelry shop in the Dubai Gold Souk. Fishing and the pearl trade anchored the city-state's economy until they were replaced by gold and natural gas in the 1940s. Since 1997, when Dubai imported a record 660 tons of gold bullion and re-exported around 600 tons, the market for gold bullion—chiefly in Egypt and India—has diminished. Today, making gold jewelry for tourists and residents alike is big business.

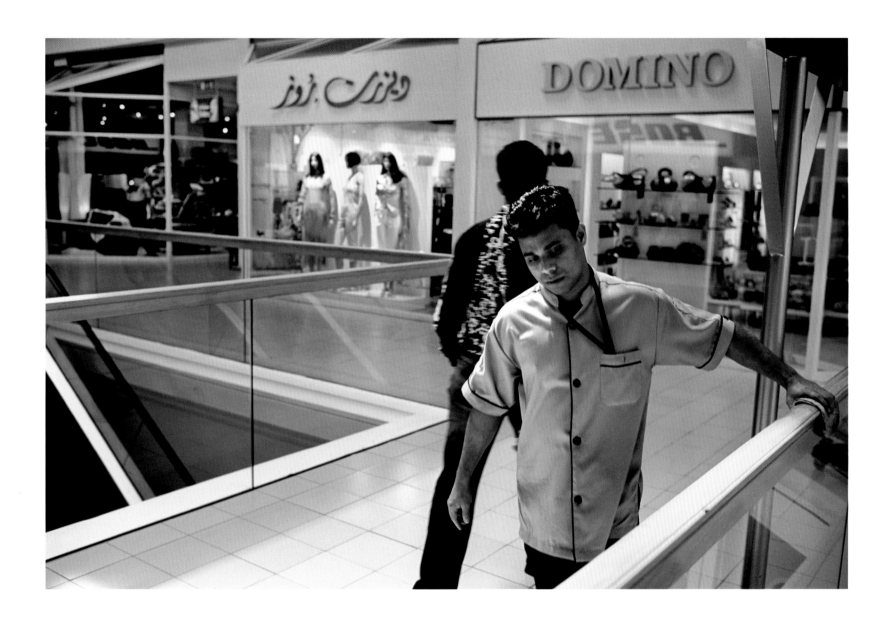

An Indian laborer adds luster to the already highly polished Wafi Mall, one of Dubai's most elegant shopping complexes with more than 200 stores. Authorities in the United Arab Emirates worry that only 15 to 20 percent of the population of about 4 million people are Emirati citizens. And citizens increasingly want well-paid government jobs, not blue-collar work. Thus, the Emirates will continue to rely on imported laborers from as far away as Thailand and the Philippines for menial jobs.

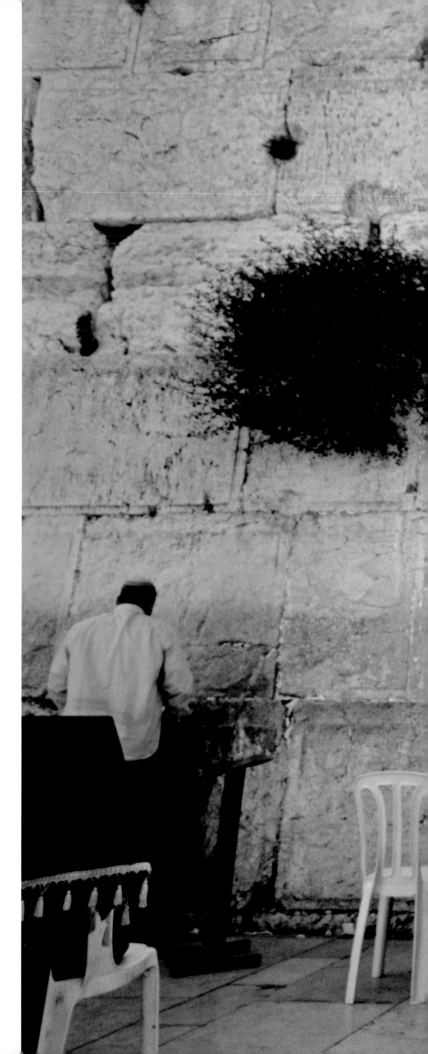

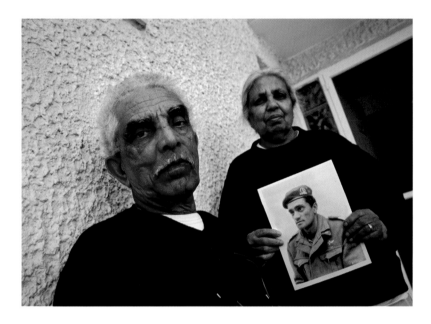

One of the most unforgiving outposts of the diaspora is Israel, home to about 60,000 Indian Jews. In Jerusalem, Private First Class Tamir Baite, an Israeli Army sniper and recent immigrant from Manipur in northeast India, scans the Wailing Wall, one of the most holy places in Judaism and Islam. In the settlement of Nevatim at the edge of the Negev Desert, Yefret and Shoshanna Chiam, Indian immigrants from Cochin, continue to mourn their son Salomon, an Israeli paratrooper killed in the final hours of the 1973 Yom Kippur War.

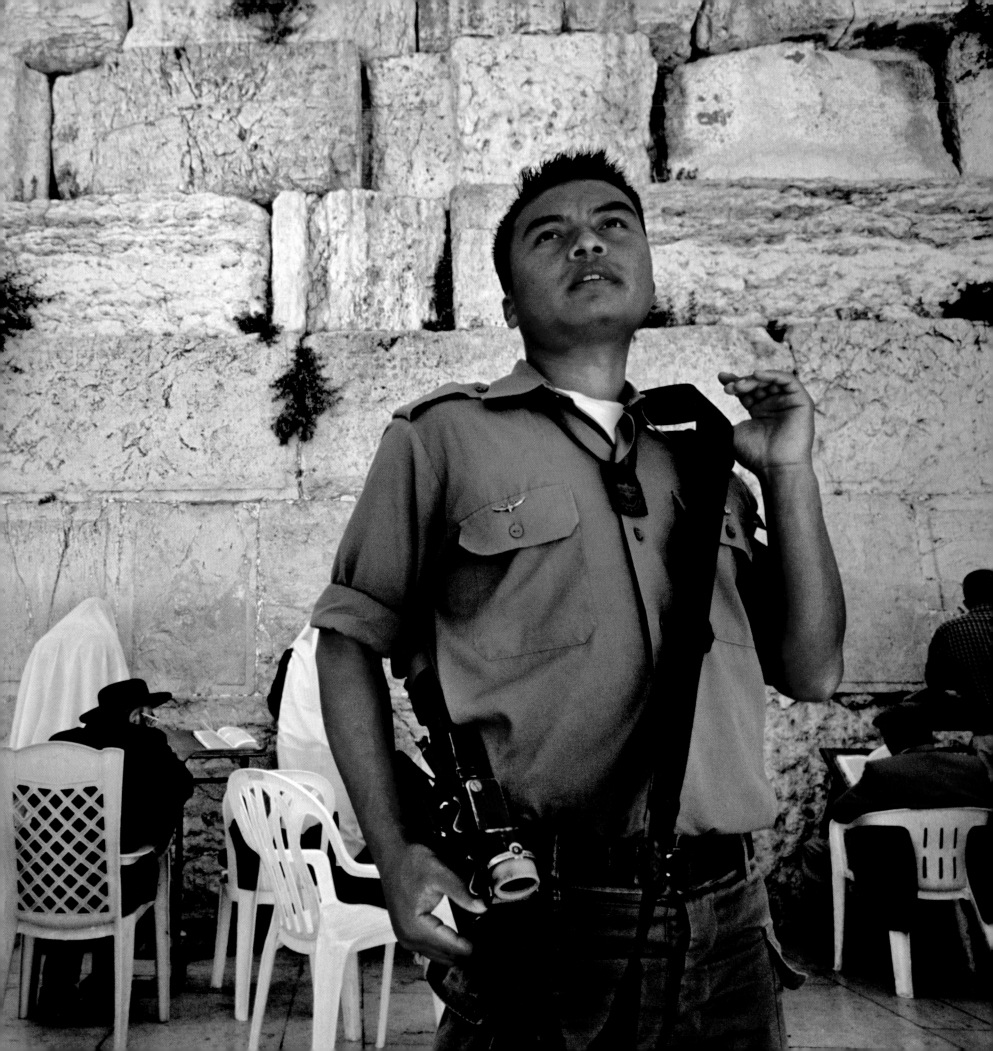

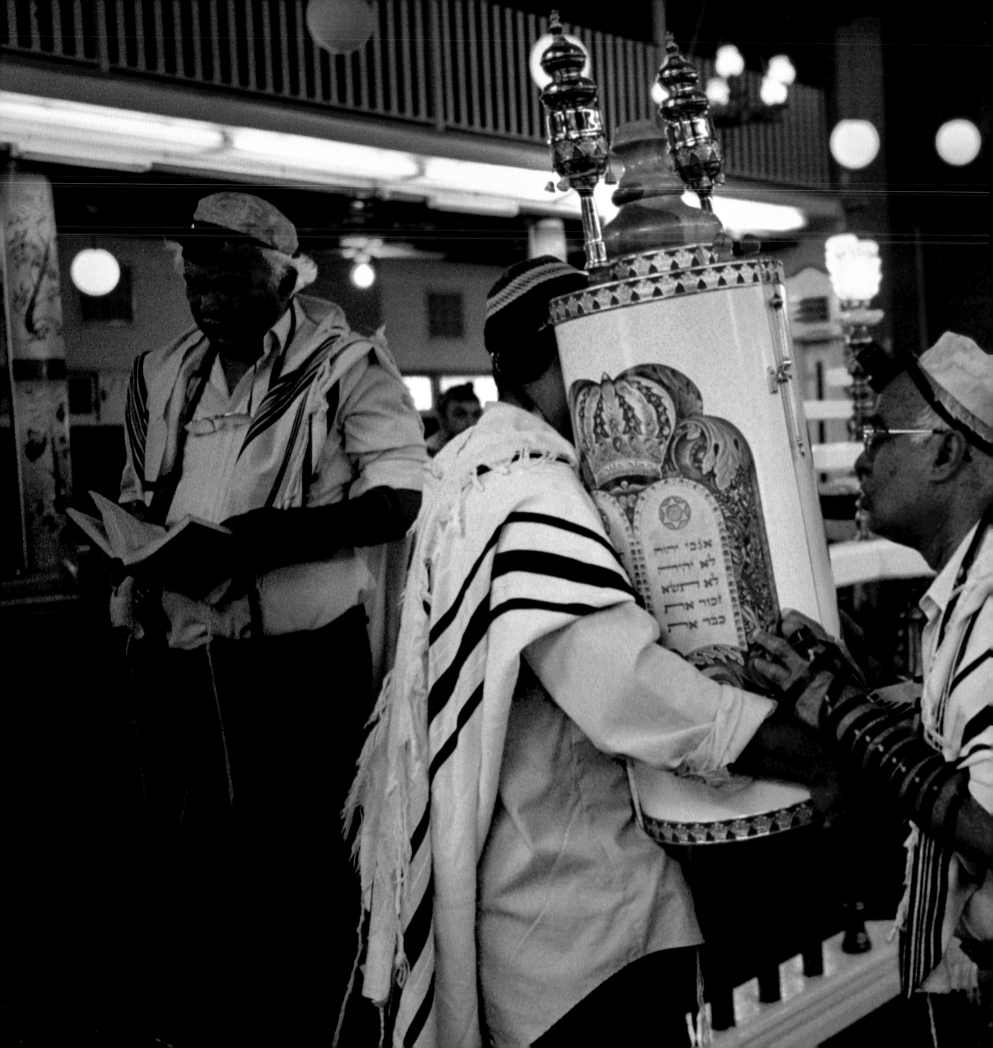

Indian Jews in Nevatim gather in the Cochin Synagogue to read from the Torah, the sacred Jewish scriptures customarily kissed by the faithful. The Cochin Jews—originally merchants and shopkeepers who lived along India's Malabar seacoast for more than 1,000 years—are one of the smallest of several groups of Indian Jews that have migrated to Israel. Most of Israel's 60,000 Indian Jews are called the Bene-Israel, descendants of the Cohanim, an ancient Israelite priestly class—a lineage that was confirmed by DNA testing in 2002.

Hebrew, English, and Malayalam, the language of the south Indian state of Kerala, mix easily on the playing fields of Navatim, a Cochin Jewish settlement where soccer has taken the place of cricket for a new generation of Indians born in Israel. While rabbinical authorities were quick to embrace mainstream Indian Jews, a more controversial group of Indian immigrants are the Bnei Menashe, a Sino-Burmese group from India's remote northeast who claim to be descendants of the lost Tribe of Menashe. About 1,000 Bnei Menashe have settled in Israel, most in the West Bank and near Gaza.

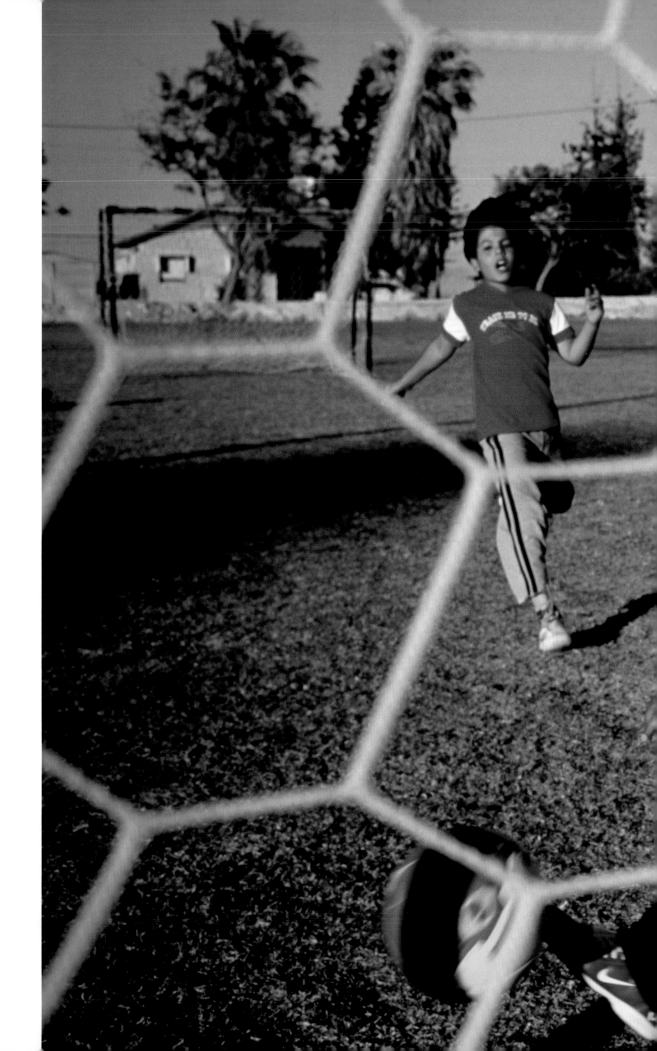

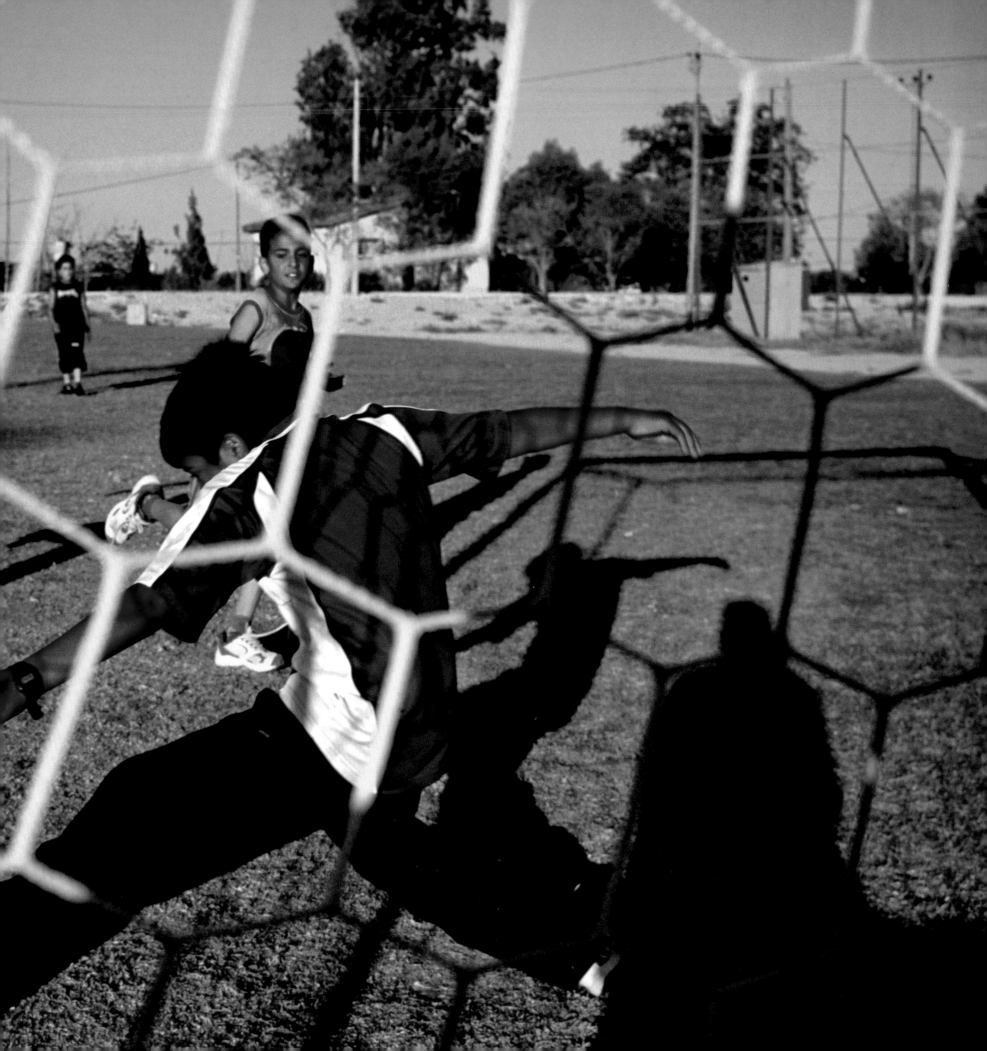

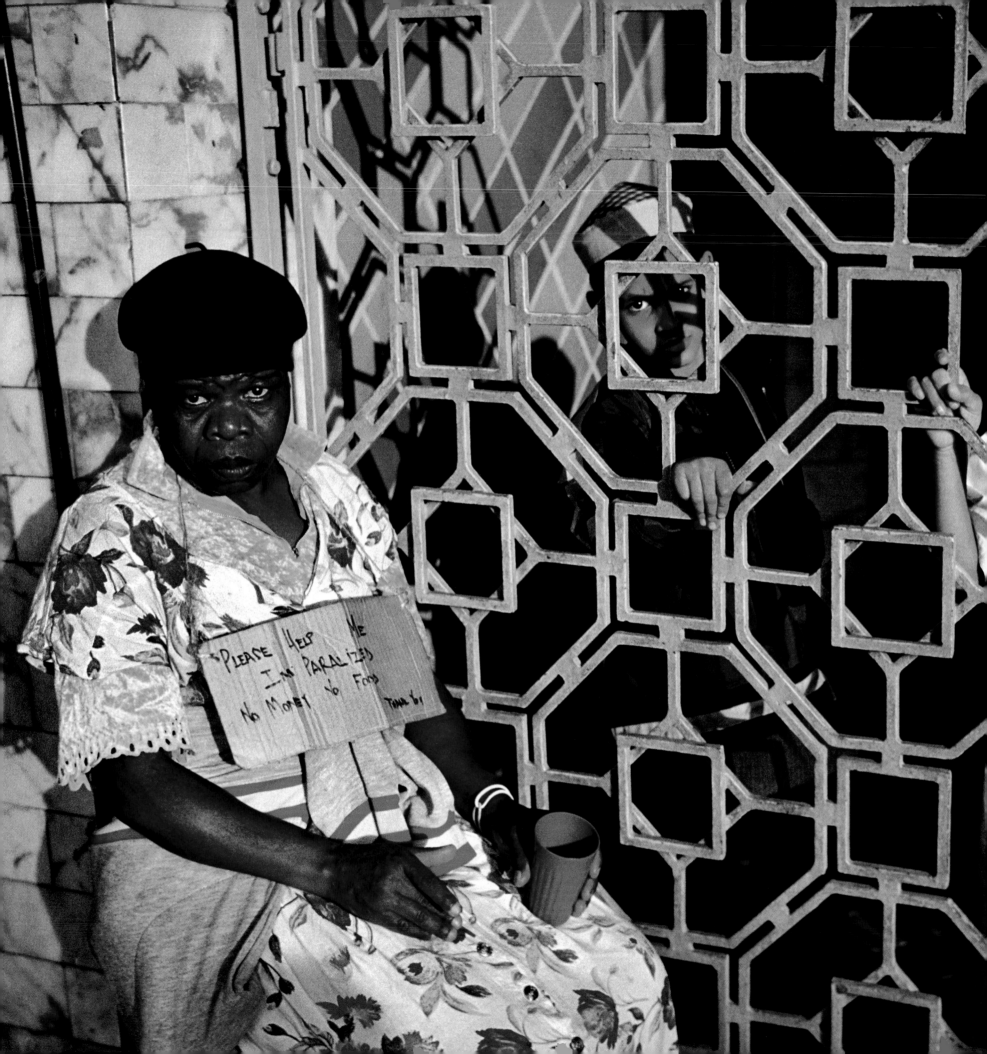

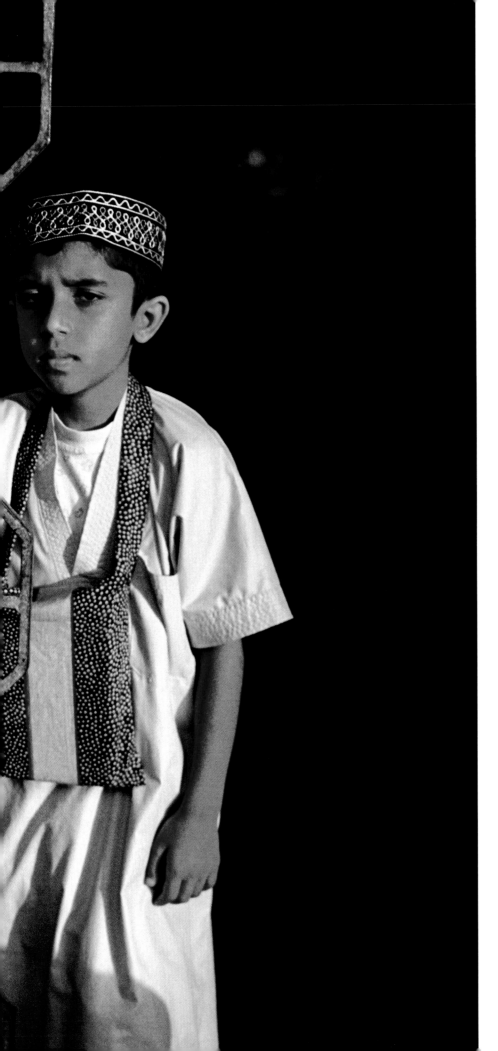

Juma Masjid is the largest mosque in the Southern Hemisphere and dominates Grey Street in Durban, South Africa's second-largest city with more than 600,000 people of Indian ancestry among its 3.2 million residents. Outside Juma Masjid, boys of Indian origin linger before prayers with a paralyzed woman begging for food—a stark reminder of the economic divide between many black South Africans and the Indian merchant class that owns many of the shops and markets in downtown Durban.

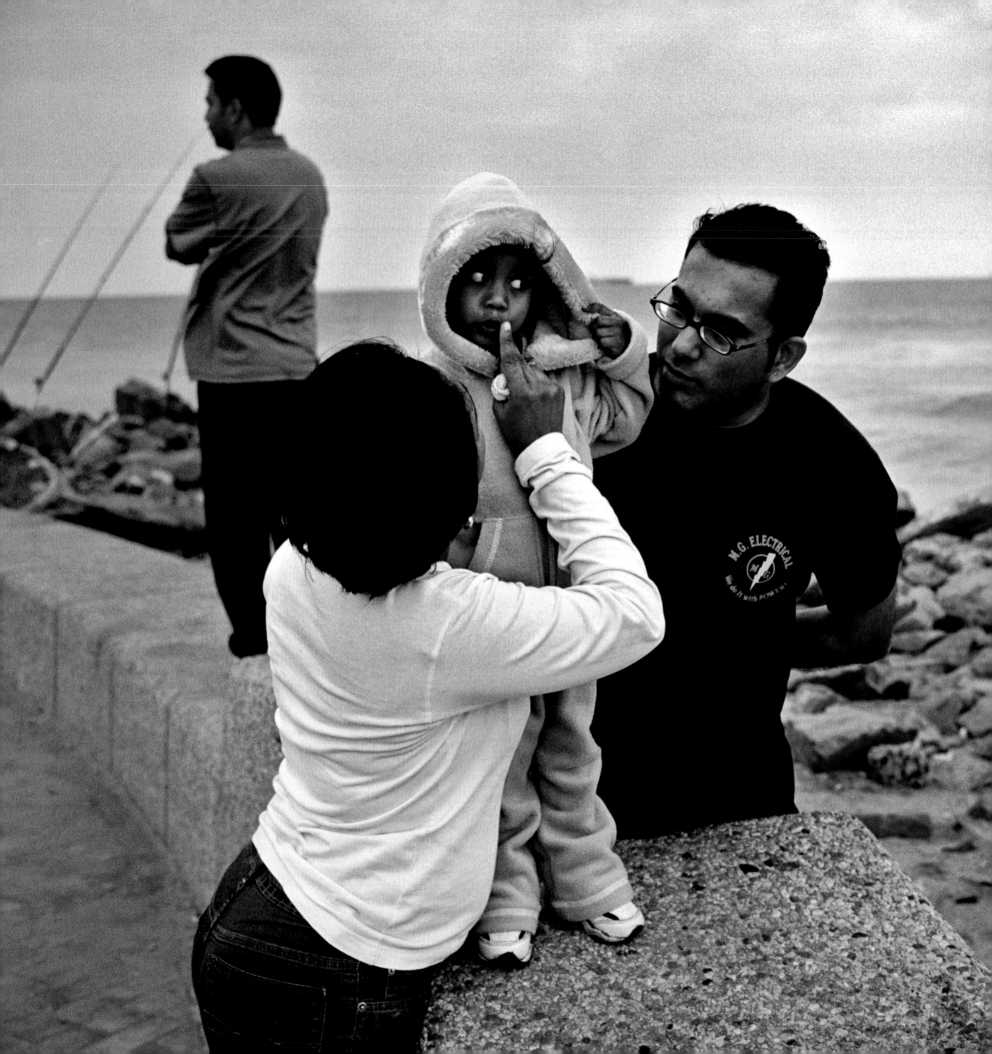

Brisk winter winds sweep across Blue Lagoon on Durban's Indian Ocean seafront, where Indian families gather to stroll or fish on weekends. Durban started as a small British settlement on Natal Bay, but by 1860, nearby sugar plantations employed more than 150,000 Indian laborers. Today, the Port of Durban is the busiest seaport in South Africa and the busiest container port in the Southern Hemisphere.

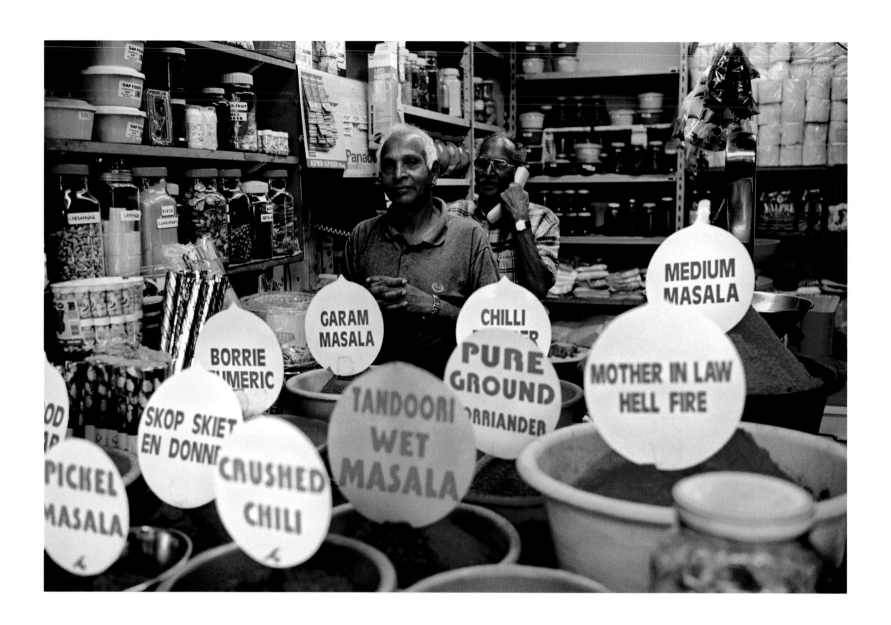

Durban is called the Curry Capital of Africa and for good reason, judging by the ingredients on sale in the Victoria Street Market. The market's main attractions are exotic spices and dried beans imported from India, some given names in Afrikaans such as skop skiet en donnder, meaning "kick, shoot, and thunder." Nearby is the Madrassa Arcade bazaar, where Indian fast food outlets sell a uniquely Durban dish called "bunnychow"—half a loaf of bread scooped out and filled with curry.

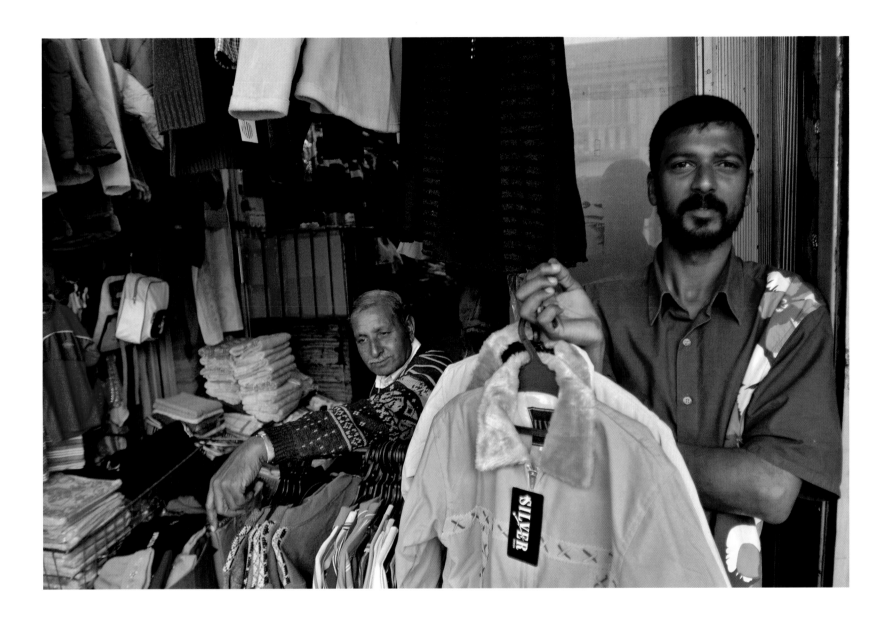

Reminiscent of shops in New Delhi's Chandi Chowk, Indian merchants, both Hindu
and Muslim, populate the bazaars of Durban's old Indian Quarter along Grey Street.
But a century and a half of living in South Africa has diluted the allegiance most
Indians feel toward the country of their ancestors, according to an authoritative
Indian government report. Most of South Africa's one million Indian citizens say
they are South Africans first and foremost, reflecting their deep-seated involvement
in the struggle for equal rights.

A passion for horse racing begins at an
early age for South African Indians,
who turn out by the thousands in early
August for the running of the Canon
Gold Cup at the Greyville Turf Club in
Durban—the ultimate test of stamina
for thoroughbreds in South Africa and
the final race of the KwaZulu-Natal
winter season. In the parade circle
before race time, a largely Indian
crowd, including some children,
gives the horses a careful look.

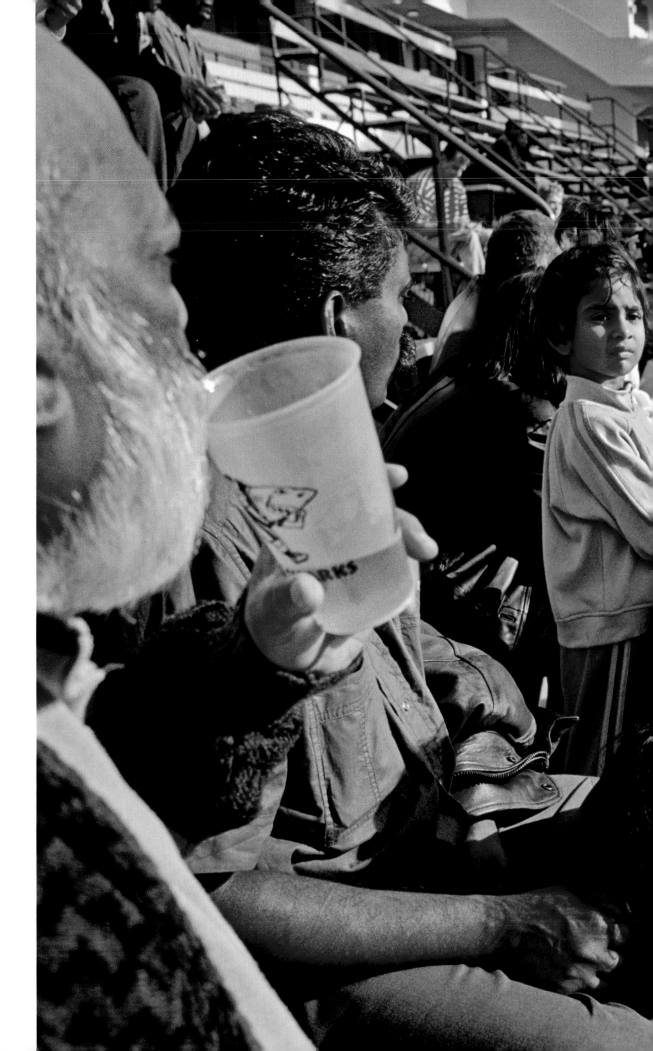

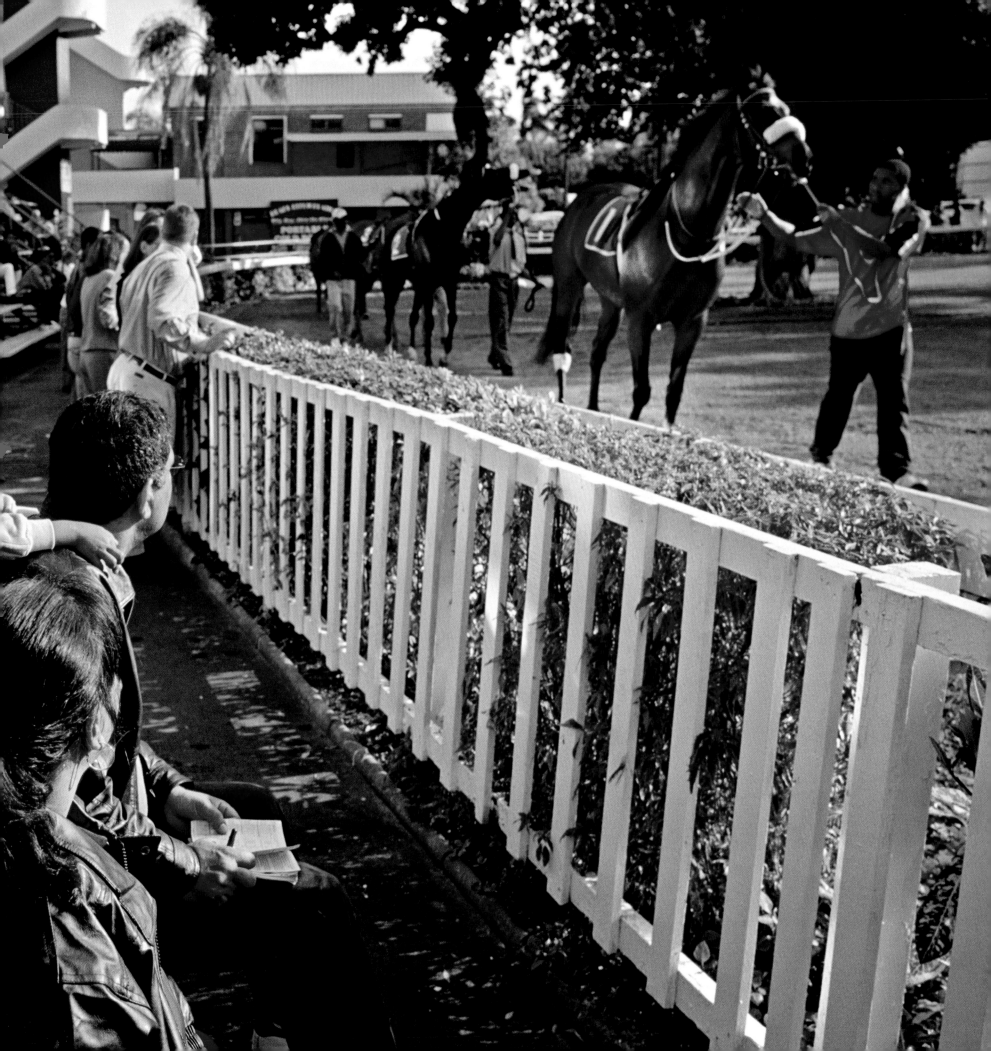

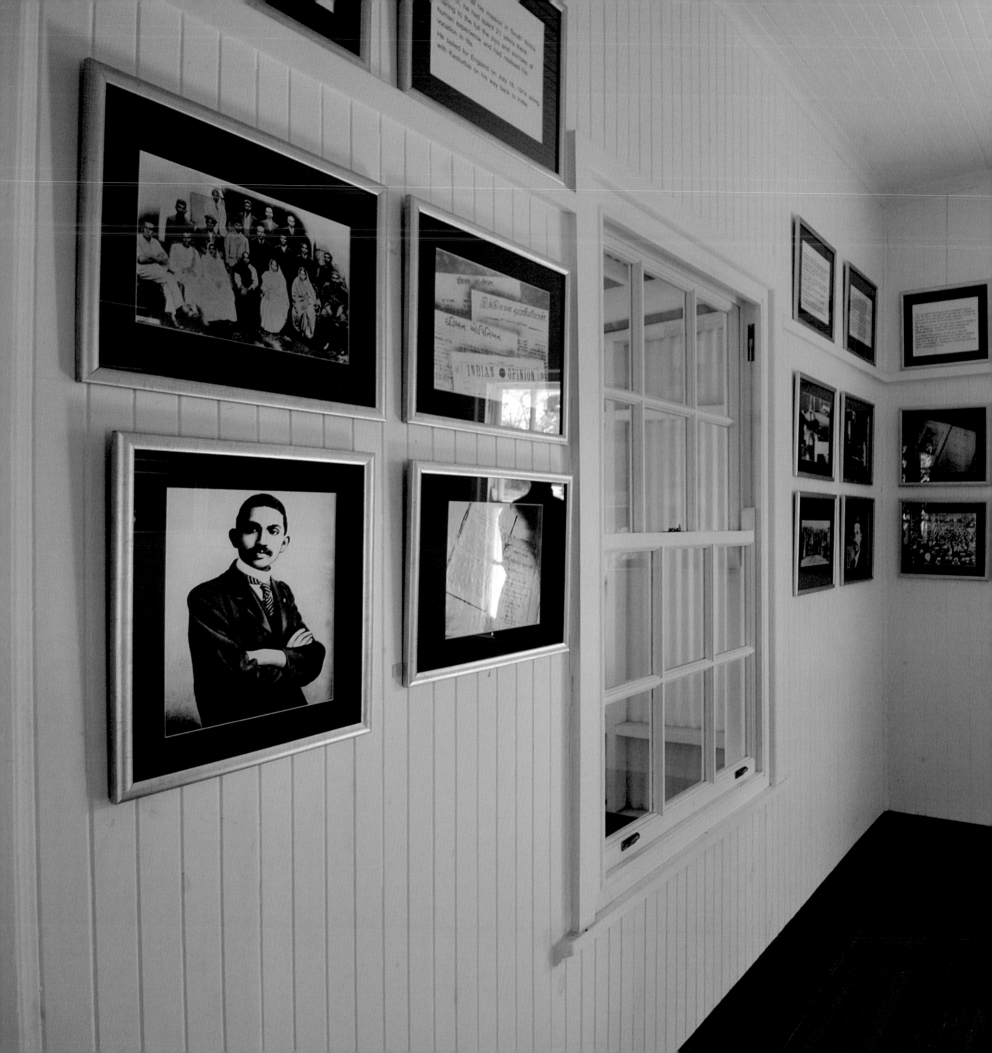

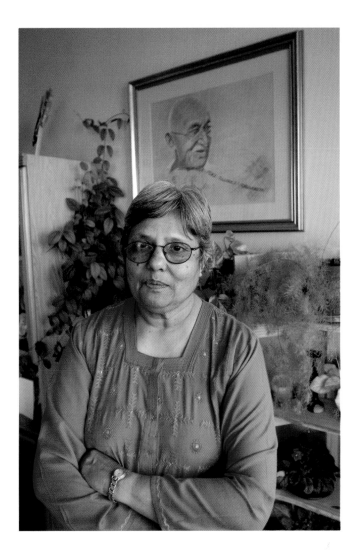

Ela Gandhi has carried on the work of her famous grandfather, Mohandas K. Gandhi, working as a human rights activist, social worker, and journalist in Durban. She endured eight and a half years of house arrest under the former apartheid government, only to be elected to the new South African Parliament, representing her birthplace—Phoenix Township, which her grandfather established in 1904 as a center of resistance to colonial oppression. M. K. Gandhi's original Phoenix settlement north of Durban was rebuilt in 2000, complete with rooms showing where he published the newspaper *Indian Opinion* in four languages.

Safe behind bars, children in Phoenix Township cast a wary eye toward strangers of all races. South Africa—one of the most dangerous countries in the world not fighting a war—has seen a dramatic increase in robbery, rape, and murder since the end of apartheid and is ranked second in the world by the United Nations for assaults and murders per capita. Nearly every home in South Africa, including modest working-class bungalows, is protected by some sort of private security firm—many with orders to shoot suspects on sight.

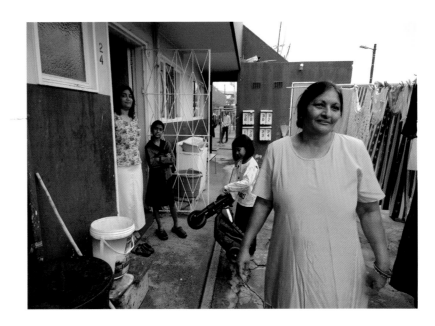

Pastel bungalows and ramshackle apartments stretch
to the horizon in Phoenix Township outside Durban,
home to about 300,000 South Africans, most of
Indian origin. The 1950 Group Areas Act that
established apartheid required Indians, as well as
blacks, to move to segregated "townships"—a
euphemism for rural ghettos far from the cities'
centers. Later, the South African government adopted
a policy of "divide and rule," giving Indians and
people of mixed race limited rights, but bitterly
splitting black South Africans from their longtime
allies in the struggle against apartheid. Outside
their Phoenix apartments, three generations of the
Gopichund family testify to the poverty that
diminishes the lives of many Indians long after
the abolition of apartheid.

A Hare Krishna devotee lays prostrate in front of the altar at the opulent Temple of Understanding, or Sri Sri Radhanath, in Chatsworth outside Durban. Architects designed the temple, built in the 1980s, to look like a giant lotus plant. With its gold-tinted windows, floors made of Italian marble, and Chinese chandeliers, the temple is the largest Hare Krishna shrine in Africa. Recent census data shows that about 40 percent of Indian South Africans are Hindu, 20 percent Muslim, and 13 percent Christian with the remainder belonging to smaller sects.

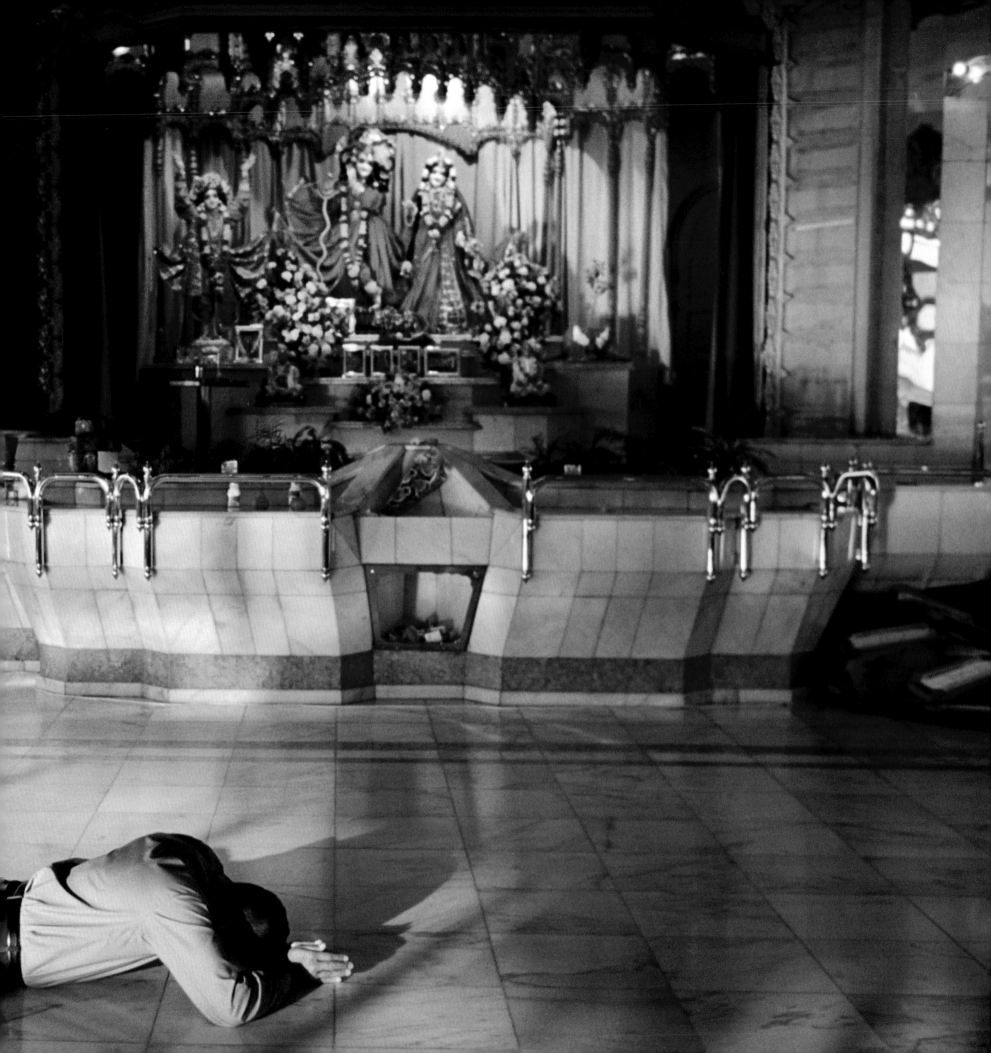

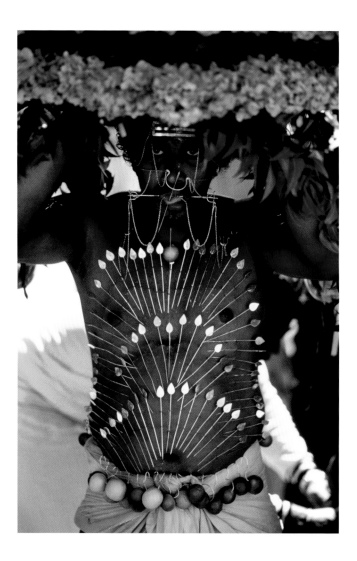

Oldest of the Mascarene Islands, Mauritius is the only country in the world outside of India where Indians are a majority—68 percent of the island's 1.2 million people. Indian workers were first brought to the volcanic island from Pondichery, then a French possession in India, as early as 1729, though most arrived during British colonial times to work the island's sugar plantations. In an impressive display of religious fervor, Tamil devotees celebrate Cavadee by piercing their tongues and bodies with needles and skewers as an expression of devotion to Lord Subramanya Swamy, the son of Shiva. The devotees' silence is usually said to signify a victory of good over evil.

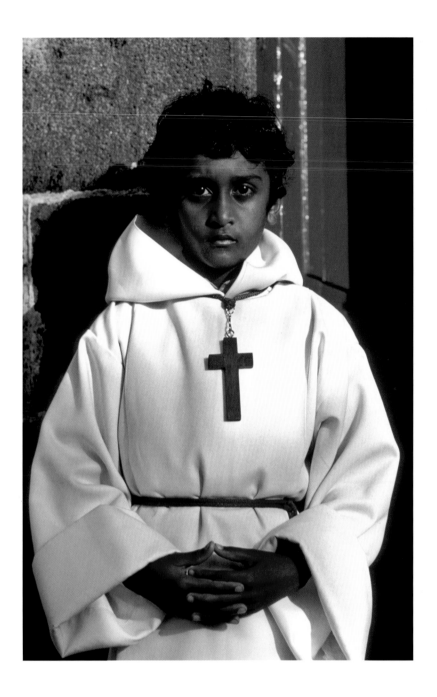

An Indo-Mauritian altar boy waits for Mass to begin outside a Roman Catholic church at Curepipe. Christians in Mauritius make up about 24 percent of the island's population, many descendants of eighteenth-century immigrants from French colonies in India. About 85 percent of Mauritian Christians are Roman Catholic.

At a Hindu temple in Mauritius, a worshipper rings a bell to ward off evil spirits and distracting sounds during *puja*, or prayers. While Mauritius has embraced globalization, becoming a major garment exporter, its Indo-Mauritian majority remains fiercely attached to Indian culture, including the Bhojpuri and Telugu languages.

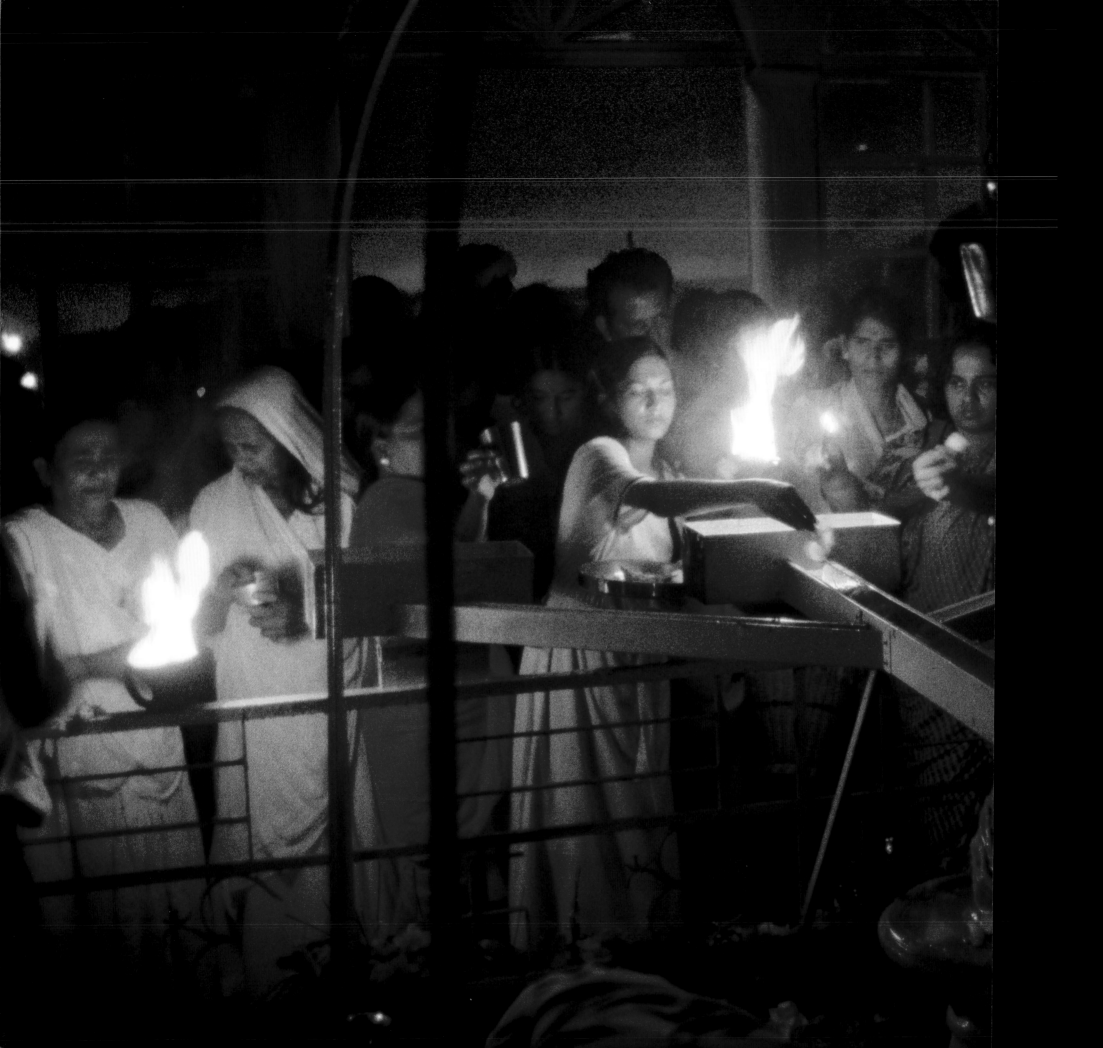

Hindu worshippers in the central Mauritius city of Curepipe celebrate Maha Shivratri, a festival honoring the deity Lord Shiva. Following an all-night vigil, devotees carry the *kanwar*—wooden arches covered with flowers—across the island to the lake at Grand Bassin to fetch holy water in a scene reminiscent of great rituals on the banks of the River Ganges. Despite their overwhelming numbers, Indo-Mauritians remain at the lowest rung of the economic ladder, owning barely 10 percent of the island's big companies.

The Caribbean
From Indentured Labor to Chutney Music

owered by sail and steam, cargo ships out of Calcutta and Madras brought more than 147,000 Indian immigrants to the British colony of Trinidad between 1845 and 1917. But unlike the tens of thousands of Indian professionals who have poured into the United States over the past three decades in search of well-paying jobs and suburban comfort, the Indian immigrants who were deposited in Trinidad and other Caribbean colonies came as indentured laborers to work British, Dutch, and French plantations after the European Powers abolished the slave trade. Trinidad's Indian laborers were called "coolies" by their overseers and became the backbone of the sugar and rice industries. Over the generations, only a handful of Indian immigrants returned to India—the British offered free passage home after five years of indentured servitude. However, most opted for their freedom, ten acres of land, and the promise of a better life in the New World.

East Indians, as they are called in the Caribbean, still work Trinidad's sugar plantations, now in decline, and grow much of the island's food. Indeed, Indians run the island's fruit and vegetable markets, and own its supermarkets. Others dominate the island's cocoa and coffee industries—a *petite bourgeoisie* of small businessmen and women, shopkeepers, and craft workers. But Indians are also the doctors, lawyers, and professors on an island rich in crude oil and natural gas but deeply divided by race, class, and culture. Officially, East Indians and blacks of African descent each constitute about 40 percent of Trinidad and

Tobago's 1.1 million citizens. But more than a century and a half after arriving in the Caribbean, East Indians live in a world apart from black Trinidadians, mostly along the coastal lowlands called the "sugar belt" south of the capital, Port-of-Spain. South Asian culture has been frozen in time here, half a world away from Mother India—an enclave of hot *roti* breads, pungent spices, Bollywood movie theaters, Indian satellite television channels, Hindu temples and private Hindu schools, and mosques for the Muslim minority. Hindu holidays like Diwali, Holi, and Ganga Dhara are celebrated with the same passion with which the rest of the Caribbean celebrates Carnival. As recently as 25 years ago, Hindi was spoken in many homes, though today it is largely relegated to Hindu schools and temples.

Over the generations, East Indians have embraced the wider Caribbean culture in at least one area—music, specifically Chutney Music that started in the early 1970s, bringing together elements of Hindi film and Afro-Caribbean calypso. The word *chutney* comes from the Hindi word that describes a hot peppery mix, which goes a long way to explaining Chutney's up-tempo lyrics superimposed over a driving calypso beat. Today Chutney Music is heard throughout the Caribbean and the northeast coast of South America, where there are large East Indian populations, as well as in the Trinidadian neighborhoods of New York and Toronto.

Yet most scholars say what makes Trinidad's East Indians distinct is the way they have resisted

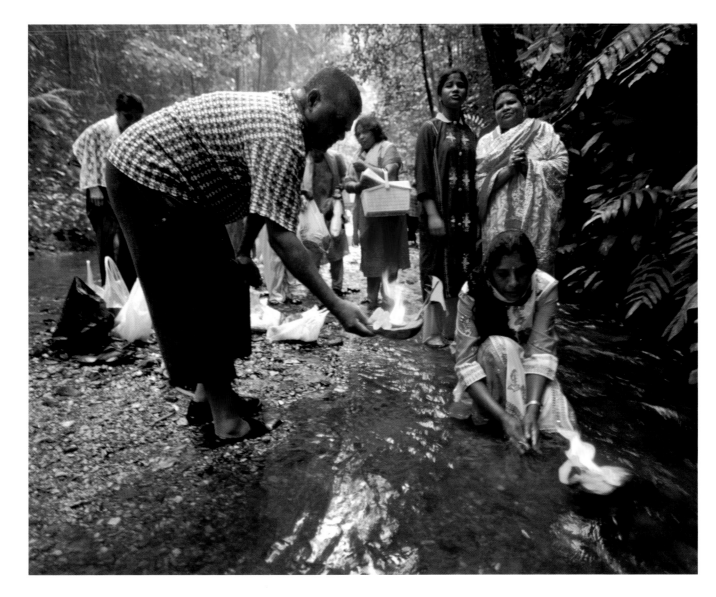

Beneath a canopy of mahogany trees, Trinidadian Hindus send oil lamps in coconut shells down the Marianne River, giving thanks to Lord Shiva for food, water, and shelter in a recently revived celebration called *Ganga Dhara*. Other Hindu festivals like Diwali and Holi are national holidays in Trinidad and Tobago, as is Indian Arrivals Day—a celebration that marks the landing of the first Indian indentured laborers in May 1845.

"creolization"—becoming part of a hybrid mix of British, French, Dutch, Spanish, and indigenous native cultures common to so many Caribbean islands. Instead, they have preserved and, in many cases, revived a Hindu culture that is largely free of the most egregious caste distinctions. Anthropologists think the Hinduism of Trinidad is more homogenized or "universal" than in India, with its richly diverse traditions, because immigrants from widely separated parts of the Indian Subcontinent were thrown together on plantations and in villages half a world away from their Brahmin leaders and local customs. Oxford University professor Judith M. Brown

suggests that Christian missionaries and reformist Hindu movements like Arya Samaj—a late-nineteenth-century sect that advanced the idea of direct communion with God, bypassing savior, prophet, or priest—influenced the evolution of a more standardized set of Hindu beliefs and rituals. "Hindu temples were even built on the pattern of churches," writes Brown, "and designed for congregational worship."

Over the generations, this close-knit Hindu culture has allowed East Indians to survive the vicious racial politics of the post-independence period and prosper, especially as entrepreneurs and farmers.

Indians dominate the central plains of Trinidad, a swath called the "Sugar Belt," where cane plantations were once the mainstay of the island's economy. Thanks to oil and natural gas, Trinidad and Tobago today boast one of the highest per capita incomes in the Caribbean. But the petroleum industry employs comparatively few people and unemployment is high—about 10 percent of the islands' labor force.

In fact, when a London-educated lawyer and trade union organizer named Basdeo Panday became the first Indian prime minister in 1995, East Indians saw his elevation as their coming of age. But Panday failed to unite Trinidad and Tobago's deeply divided people and was forced from power in 2000, though not before he paid an official visit to India and the village of his forefathers in the Indian state of Uttar Pradesh.

About 10 percent of the Indian immigrants to Trinidad were Muslims from the plains of North India in Uttar Pradesh and today Hindus and Muslims can be found living side by side in a sort of harmony unknown in many parts of India itself. One of them is Nazir Mohammad, who traveled in 1912 with his indentured mother from a village in northeast India to Calcutta to make the six-week steamship voyage to Trinidad. One of only six or seven living indentured immigrants, Mr. Mohammad never went to school, in part because he had to go to work in the cane fields as soon as he came of age. "I can't read or write but I know that's my name," says Mr. Mohammad, holding a photocopy of his "Infant Boy's Emigration Pass" stamped on the Calcutta docks by colonial officials. "Education wasn't so much then and that was my downfall."

Mr. Mohammad was, however, invited to join the Trinidadian delegation at a conference in New Delhi several years ago, when the worldwide Indian diaspora of the last two centuries was celebrated as one of the most successful migrations in human history and some of the 30 million Indians living abroad were urged, not for the first time, to invest in India. For Mr. Mohammad, not a wealthy man, it was enough to set foot in his country of birth—certainly one of the last living Trinidadian Indian immigrants to do so—and visit the village of Hallaun in Uttar Pradesh where he was born. "I don't like so much the modern life," says Mr. Mohammad. "But I still speak plenty, plenty Hindi."

A son of Trinidad who has focused his scathing eye on India and the disarray of the postcolonial world is Sir Vidiadhar Suraiprasad Naipaul, one of Great Britain's two living Nobel laureates in literature. Naipaul was born in Chaguanas in the "sugar belt" and educated at Oxford University, and has roamed the world for a half-century gathering material for more than 25 works of fiction and nonfiction. For all his fame, Naipaul is a literary giant who seems to be living in a permanent state of exile, even in his adopted home of Great Britain. Naipaul's Brahmin grandfather emigrated from India as an indentured laborer and his father was a newspaperman and writer who became the model for what many critics think is Naipaul's greatest novel, *A House for Mr. Biswas*. The story of a poor Trinidadian journalist who dreams of literary glory, *Mr. Biswas* is a tale of misfortune and humiliation that draws on Naipaul's childhood as an Indian Hindu growing up in what was still a British Crown Colony.

Years later, in a collection of essays titled *The Writer and the World*, Naipaul recalls: "The adaptation of my own family and the Trinidad Indian community to colonial Trinidad and, through that, to the twentieth century hadn't been easy. It had been painful for us, an Asian people, living instinctive, ritualized lives, to awaken to an idea of our history and to learn to live with the idea of our political helplessness." Naipaul, whose often blunt and incendiary opinions rankle politicians and professors of English literature alike, might well have been writing about Indian immigrants in Burma, Malaysia, and Fiji—all countries where Indians have been marginalized, or worse.

Indians who came to the Caribbean called themselves the *Jahan*, a variant of *jahaz*, or "ship," referring to the crowded vessels that brought them to the New World. Today they are the majority in Suriname, a former Dutch colony on the northeast coast of South America, and in Guyana, where race and ideology violently divided one of the poorest countries in the Western Hemisphere. Yet for all their economic success in places like Trinidad and their strength of numbers across the region, East Indians face a long list of vexing social and political problems in relations with their black neighbors, writes Mahin Gosine, a professor of sociology and anthropology at Suffolk Community College in New York and an authority on the diaspora in the Caribbean. Racial discrimination, job inequality, income imbalance, underemployment, and labor unrest have sent Indians packing over the past 40 years. By Gosine's count, several hundred thousand East Indians from Trinidad and Guyana have migrated to the United States in search of a better life and more equal treatment, while others, in smaller numbers, have gone to Great Britain and Canada. Most have settled in New York's thriving Richmond Hill neighborhood, or in Miami, Fort Lauderdale, and Hollywood, Florida, buying homes, sending their children to universities, and becoming solid members of America's middle class. Today, a third generation of East Indian immigrants—young people far removed and transformed from the world of their grandparents—are asking questions about their roots. "In fact," writes Gosine, "there is a concerted attempt on their part to find out about 'Grandma' and 'Grandpa' and the ways of life of the old societies."

A Hindu woman dressed in a colorful *shalwar kamiz*, a traditional northern Indian costume, leaves a small shrine attached to a private home in Princes Town, a city of more than 90,000 persons—many descendants of indentured laborers who bought land from the British Crown after their labor contracts expired. Home temples allow Trinidadian Hindus to perform daily *pujas*, or the act of showing reverence to a god through prayers, songs, and lighting incense and lamps.

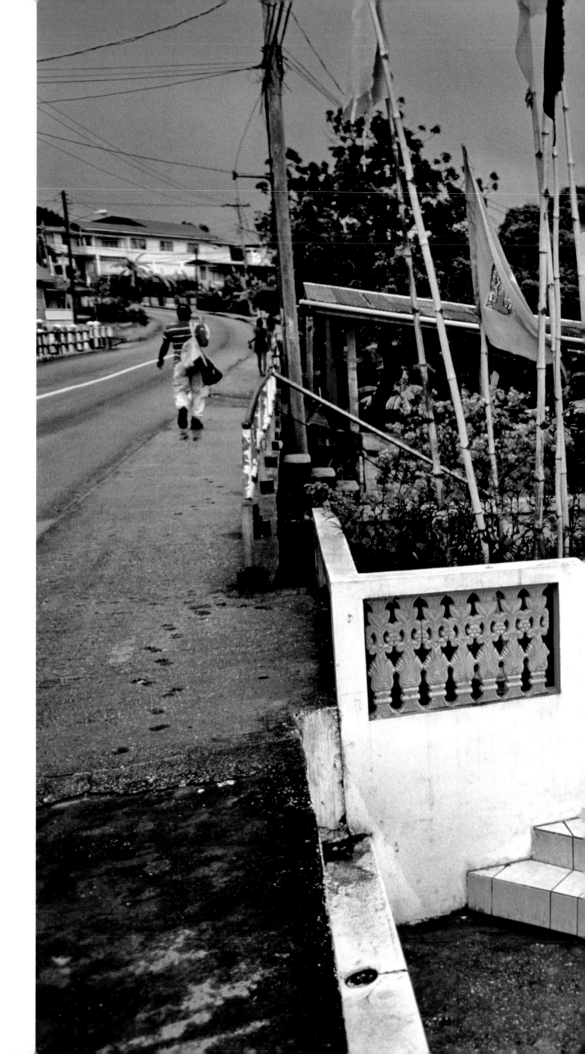

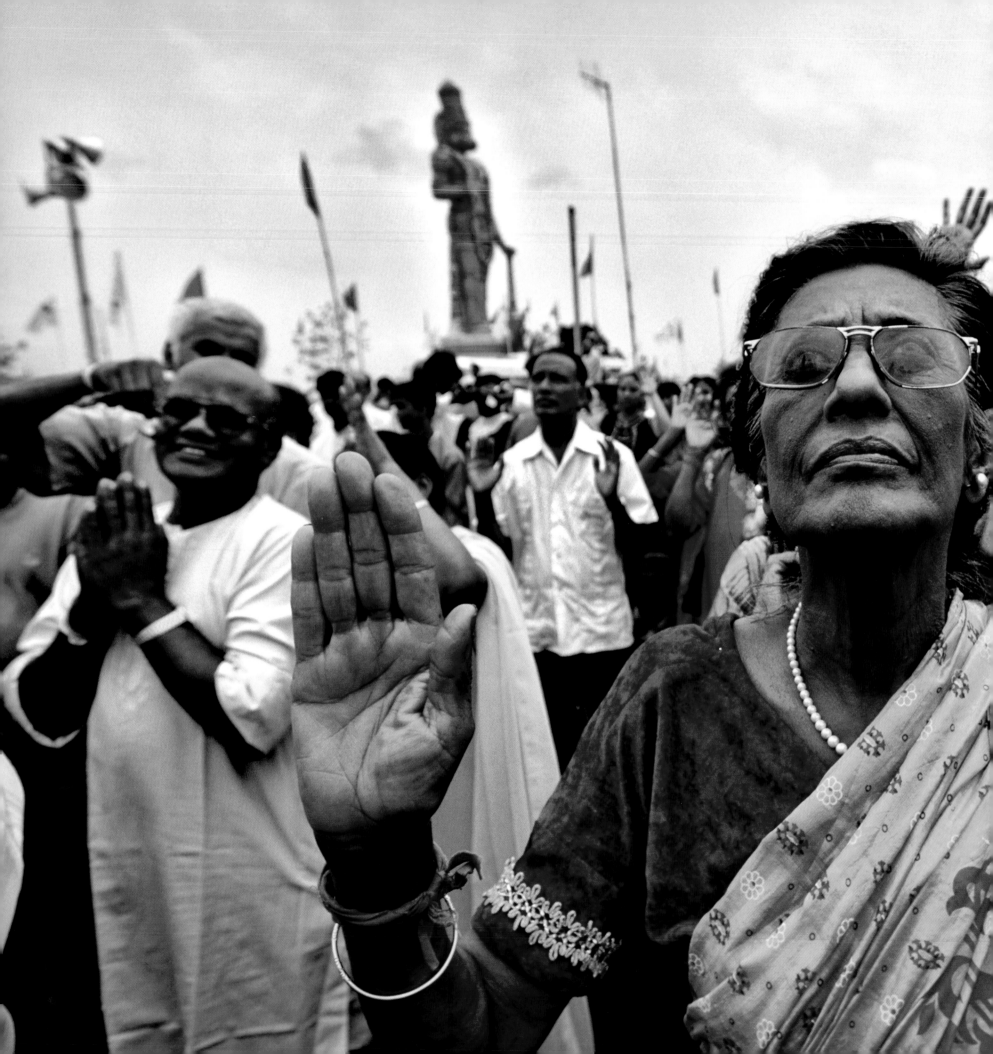

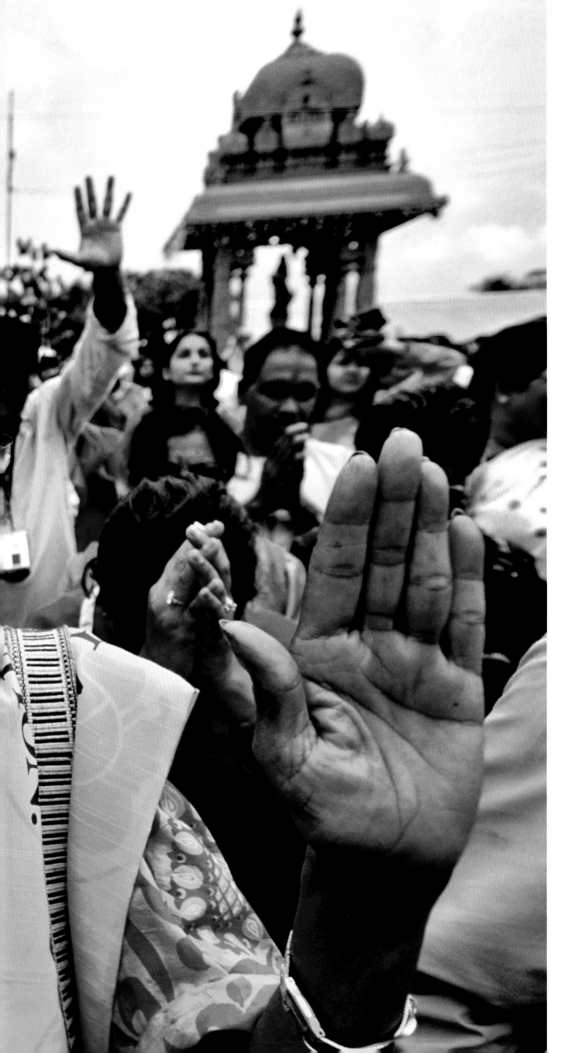

Devotees of the Sri Ganapati Sachchidananda Swamiji, a charismatic Hindu holy man based in Mysore, India, respond to his preaching at the dedication of an 85-foot (26 meter) high statue of Lord Hanuman—the tallest of its kind outside India—at the Dattatreya Yoga Center in Carapichaima. Often called the monkey god, Hanuman is one of Hinduism's most popular deities, renowned for his courage, righteousness, and selfless service. The statue (*left rear*) rises out of the cane fields of Central Trinidad and has attracted Hindu worshippers from across the Caribbean, the United States, and Europe.

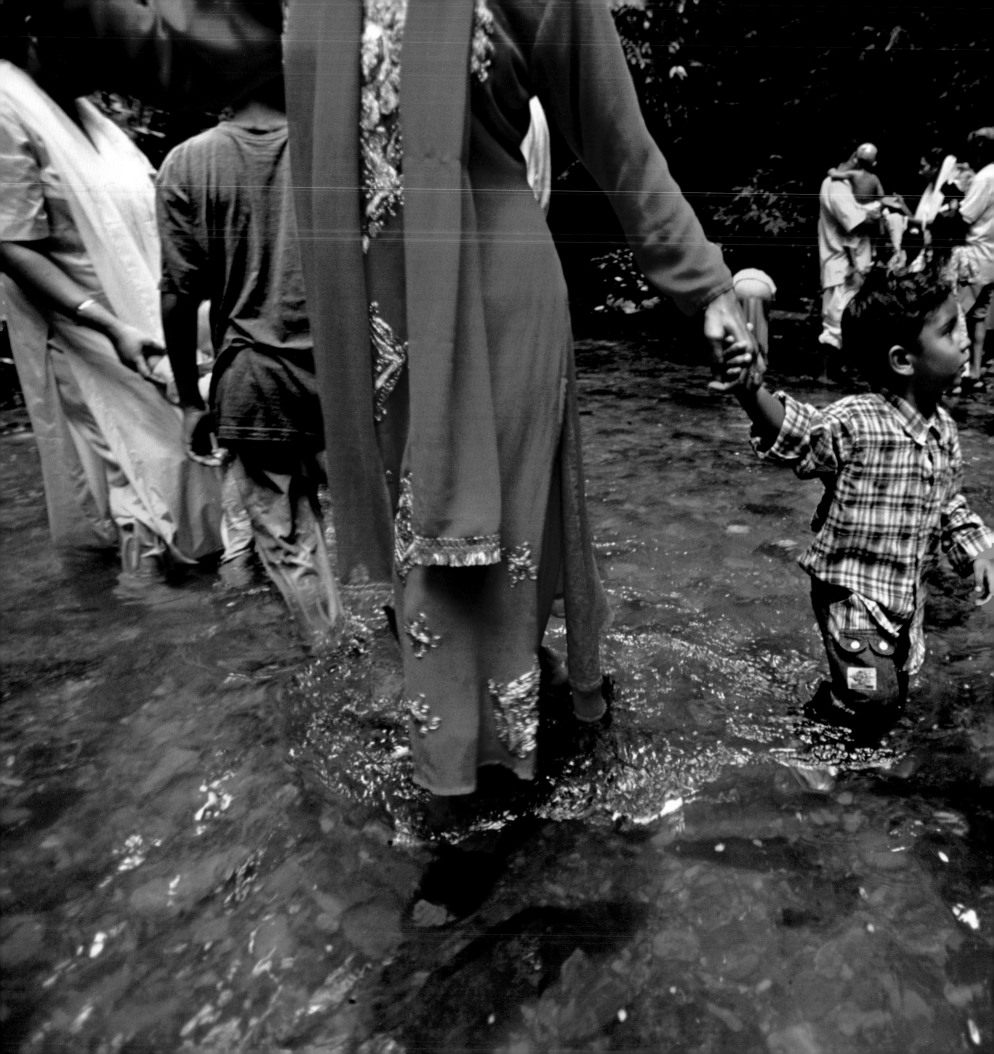

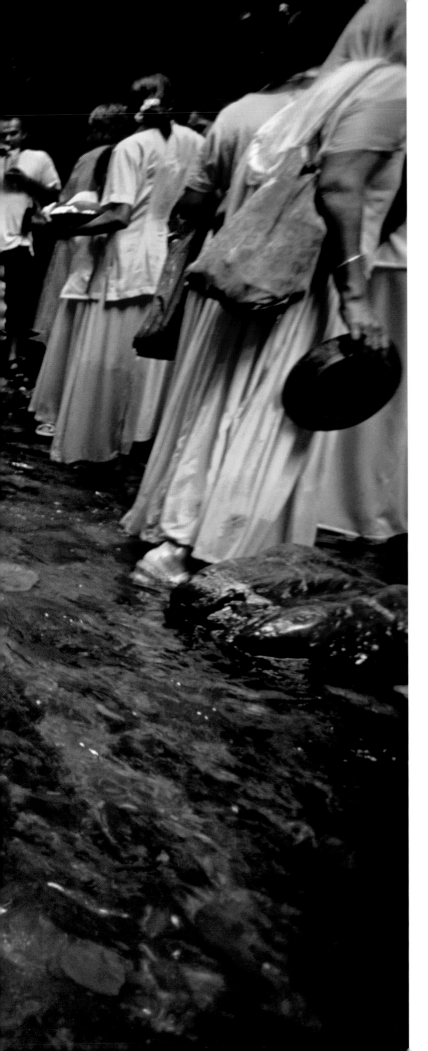

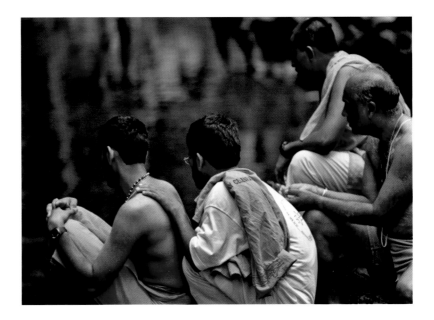

Hindus of all ages wade along the Marianne River to celebrate Ganga Dhara, a widely observed pilgrimage to the River Ganges in India, but a rite new to Trinidad. Finding their Indian roots through ritual, followers of Ganapati Sachchidananda Swamiji watch from the banks of the Aripo River in mountainous northern Trinidad as the Indian holy man sings self-composed *bhajans,* or devotional songs, in Sanskrit, Hindi, Telugu, Kannada, and English.

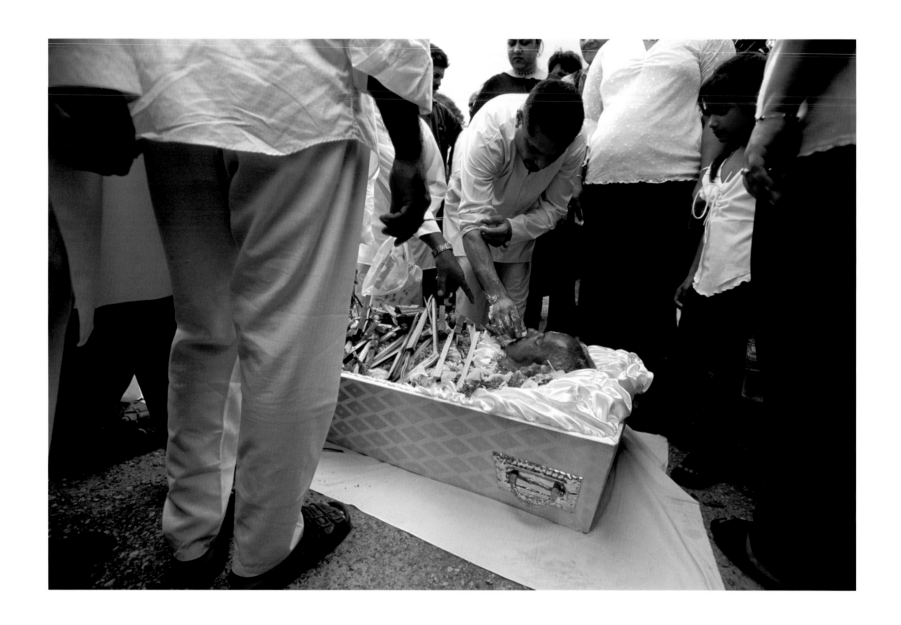

With sandalwood and ghee, a form of clarified butter, mourners prepare the body of a Trinidadian at one of the island's two outdoor cremation centers. In this most public of Hindu purification ceremonies, the feet of the body are positioned to point south in the direction of the realm of Yama, the Hindu god of death, while the head must point north toward the realm of Kubera, the god who guards the treasures of other Hindu gods.

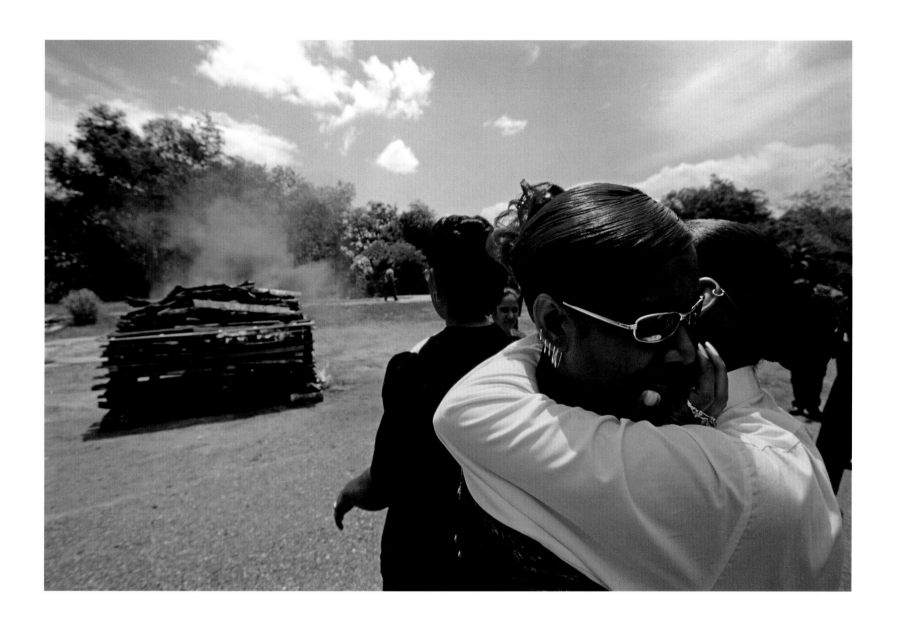

Flames leap from a pyre at the Caroni Cremation Center, as mourners of both Indian and African descent console one another. Hindus believe cremation moderates or cleanses the pollution created by death, allows the family to quickly put the separation of death behind them, and releases the soul for its journey to the next life. Sometimes a final sacrament called *Shraddha* is performed for the dead— offerings of food for the passage of the departed.

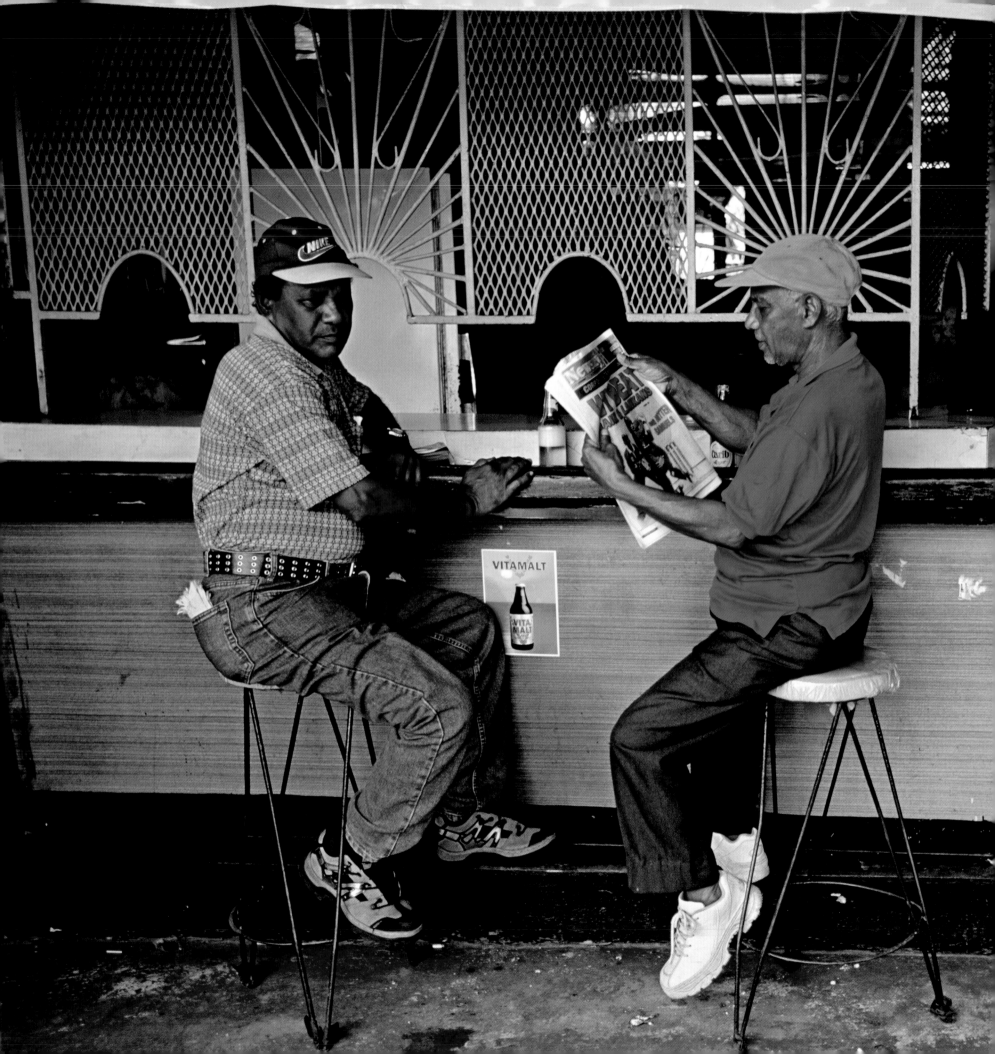

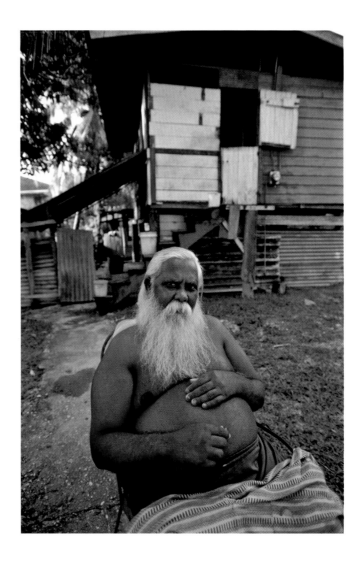

Long-simmering racial tensions between Trinidadians of Indian and African heritage take a backseat to cold beer at a bar in Siparia. Except in the largest cities, East Indian and black Trinidadians generally lead segregated lives, wrangling over jobs and political influence, including control of the government in Port-of-Spain. In neighboring Guyana, where East Indians are a majority, racial tensions have accelerated a downward economic spiral, making it one of the poorest countries in the hemisphere. Retired with health problems, Ramlakan Ramroop sits in front of his home in Williamsville.

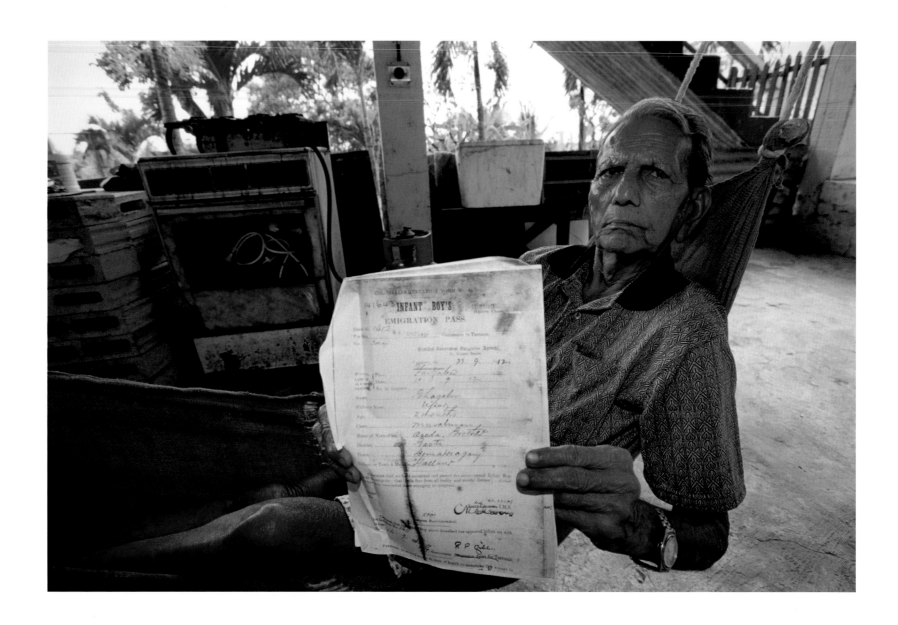

A photocopy of an "Infant Boy's Emigration Pass" stamped in 1912 on the Calcutta docks identifies Nazir Mohammad as one of Trinidad's oldest living immigrants. Mr. Mohammad came to Trinidad on a six-week voyage by steamship and later worked in the cane fields and on a dairy farm before retiring to his home and hammock. In 2003, he returned to India to attend a conference on the Indian diaspora—one of a handful of Trinidadian East Indians to visit their ancestral land.

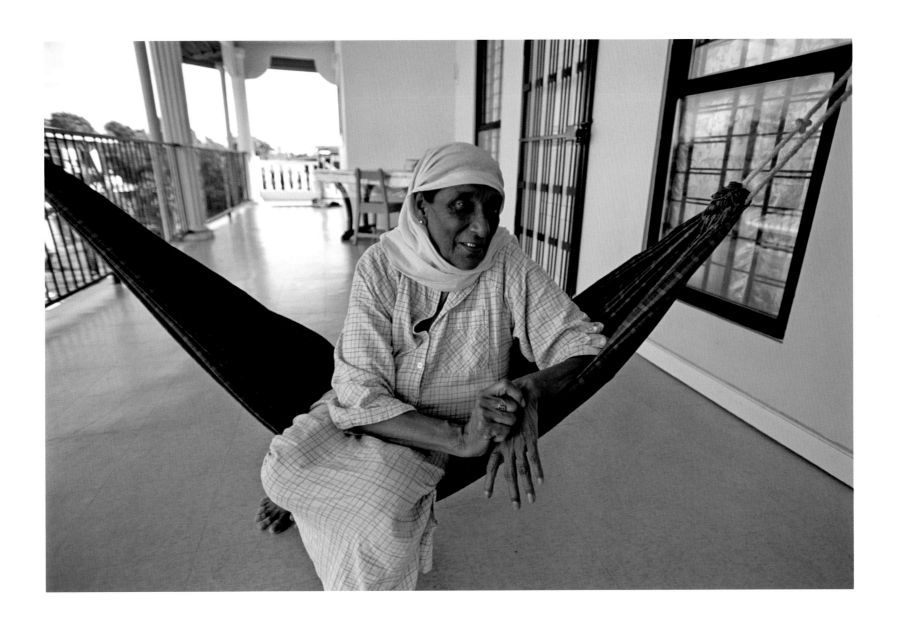

Many Trinidadian Muslims, like Mrs. Silman Mohammed of Katwaroo Trace, live in relative prosperity, as do Indian Muslims on at least a dozen Caribbean islands, including Barbados, Grenada, Dominica, Puerto Rico, the U.S. Virgin Islands, and Jamaica. Mrs. Mohammed has four children living in the United States and another three in Trinidad—all professionals. Thanks to oil and gas, a major employer, Trinidad's estimated 100,000 Muslims live at the top of the economic ladder, in contrast to East Indian Muslims in Suriname and Guyana.

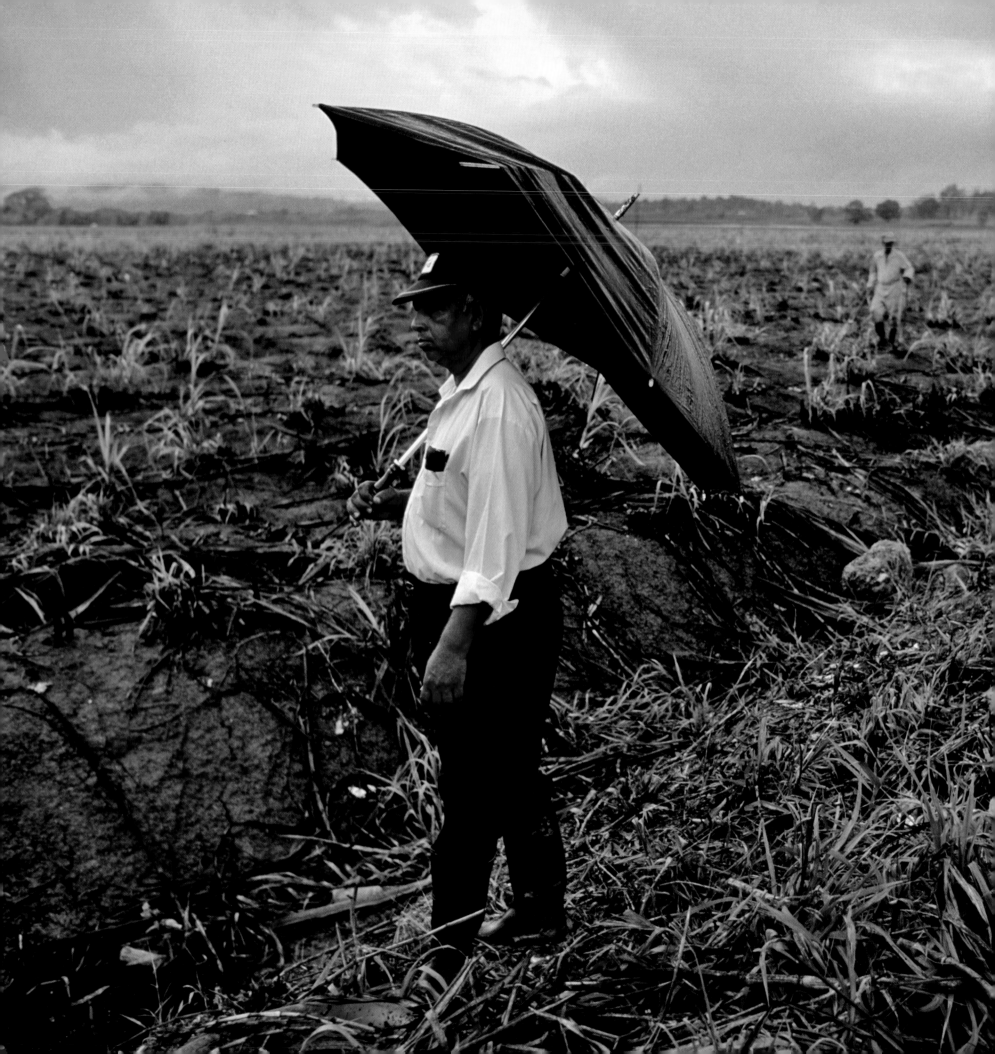

Sugar is no longer king in Trinidad, but an Indian foreman must still ensure that workers clear the remaining cane fields of debris after the harvest. Sugarcane produced by small farmers remains an agricultural staple, but gone are the days of the big plantations with tens of thousands of Indian workers. Today, Trinidad and Tobago is the world's fifth-largest exporter of liquefied natural gas and the single largest supplier of LNG to the United States.

It matters little to Trinidadians whether the venue is a village green or a gleaming stadium that seats 25,000 like Queen's Park Oval in Port-of-Spain, the largest cricket ground in the West Indies. Cricket is the top sport in Trinidad and most other islands colonized by Great Britain. East Indians first made their mark in cricket with Trinidadian Sonny Ramadhin, who played for the West Indies team in the 1950s. He was followed by the likes of Rohan Kahnai, Alvin Kallicharan, and in recent years by players like Shivnarine Chanderpaul, Ramnaresh Sarwan, and Mahendra Nagamooto—all household names in the Caribbean islands and much of the British Commonwealth.

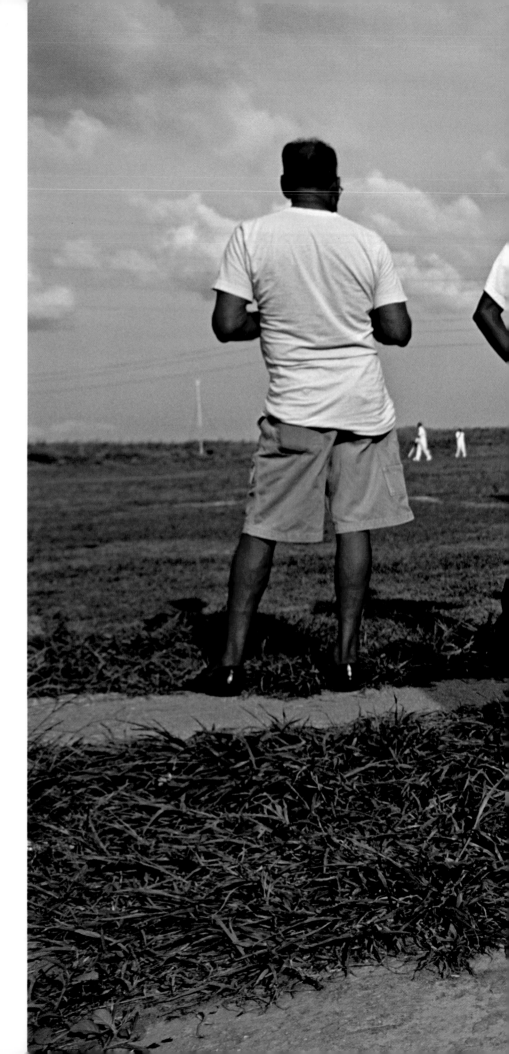

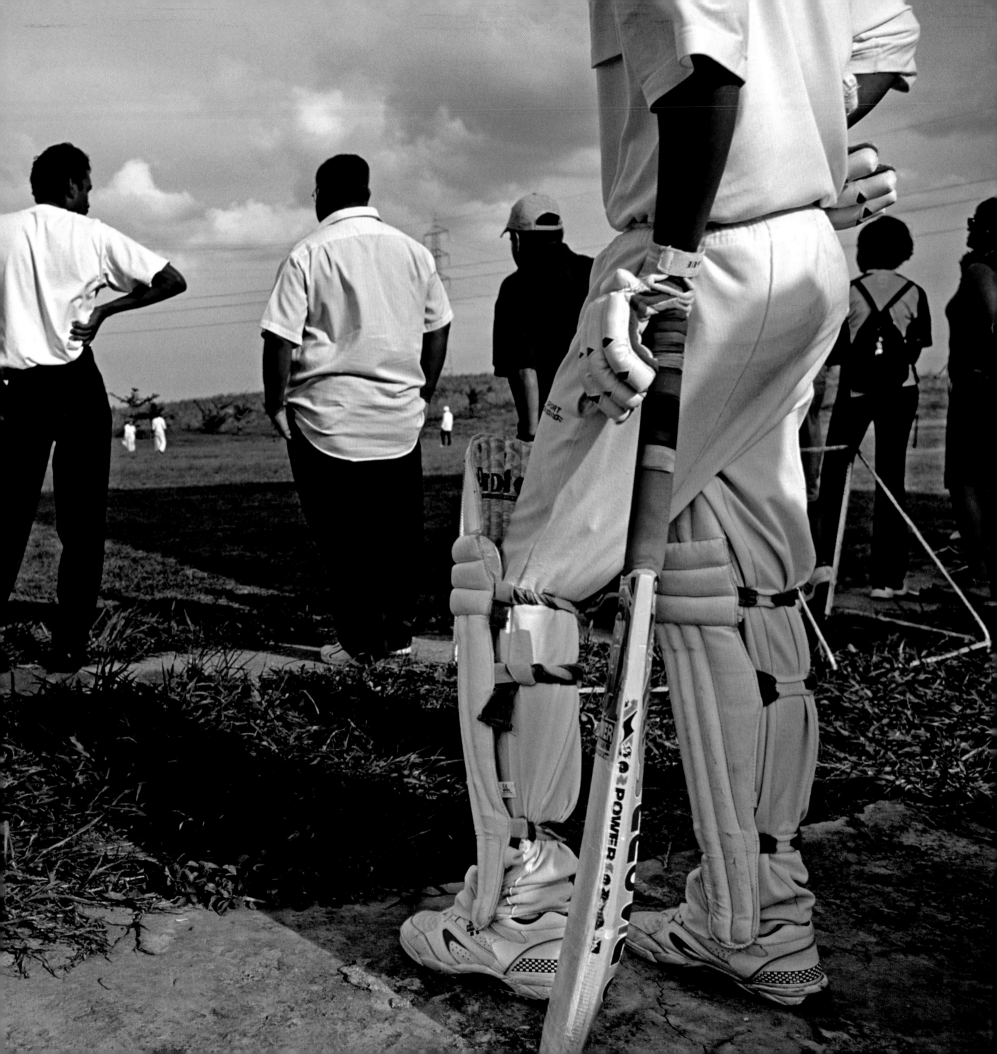

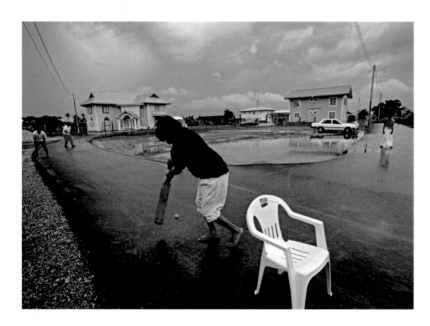

Nurse Ann Marie Copie Chansingh watches the leisurely passing of
pedestrians and vehicles from her balcony in Princes Town, where the
talk of the street is frequently about cricket. On even the rainiest of
days, young Indians take to the newly paved streets of Carapichaima
with leather ball and bat to play Trinidad's national sport. Many
young sportsmen are inspired by the story of Trinidadian cricketer
Robin Singh, a local legend, who earned a top spot on the
powerhouse Indian national cricket team before retiring to
coach teams in India and Hong Kong.

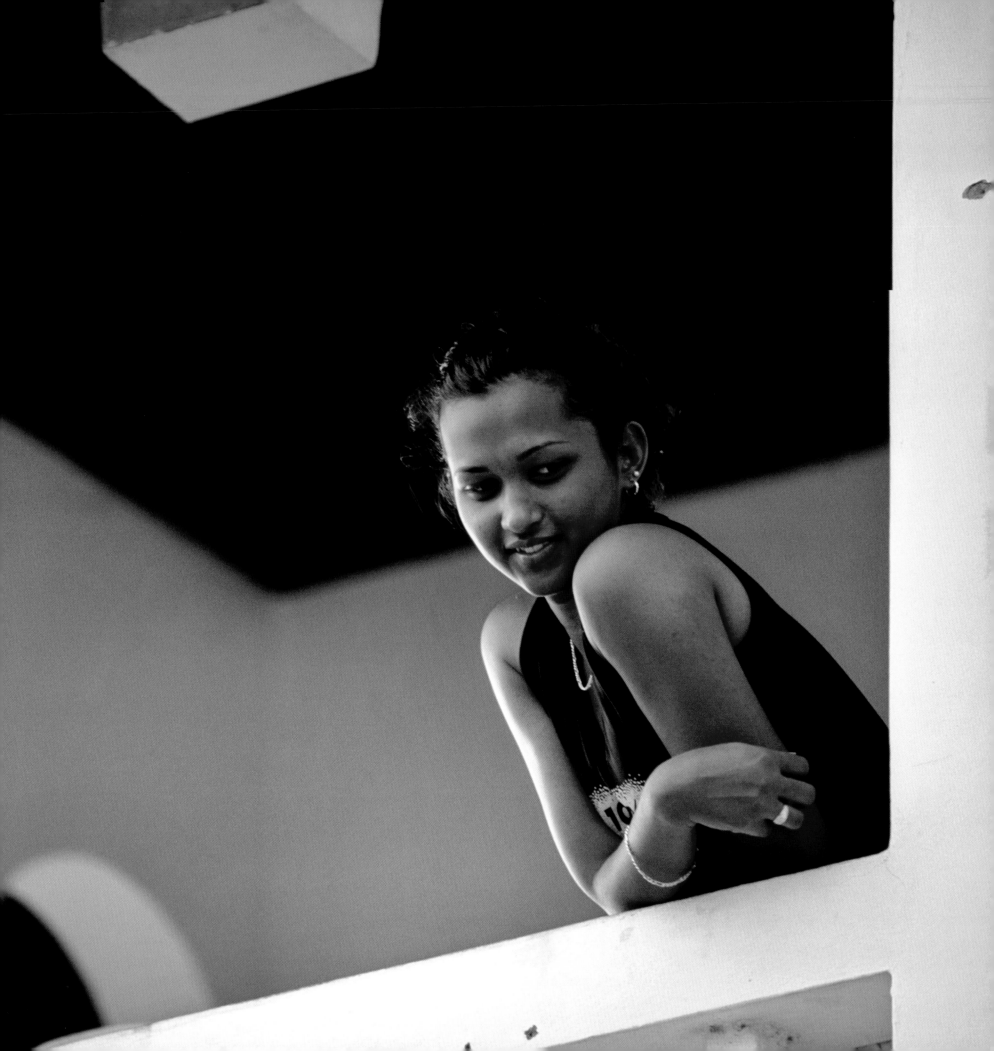

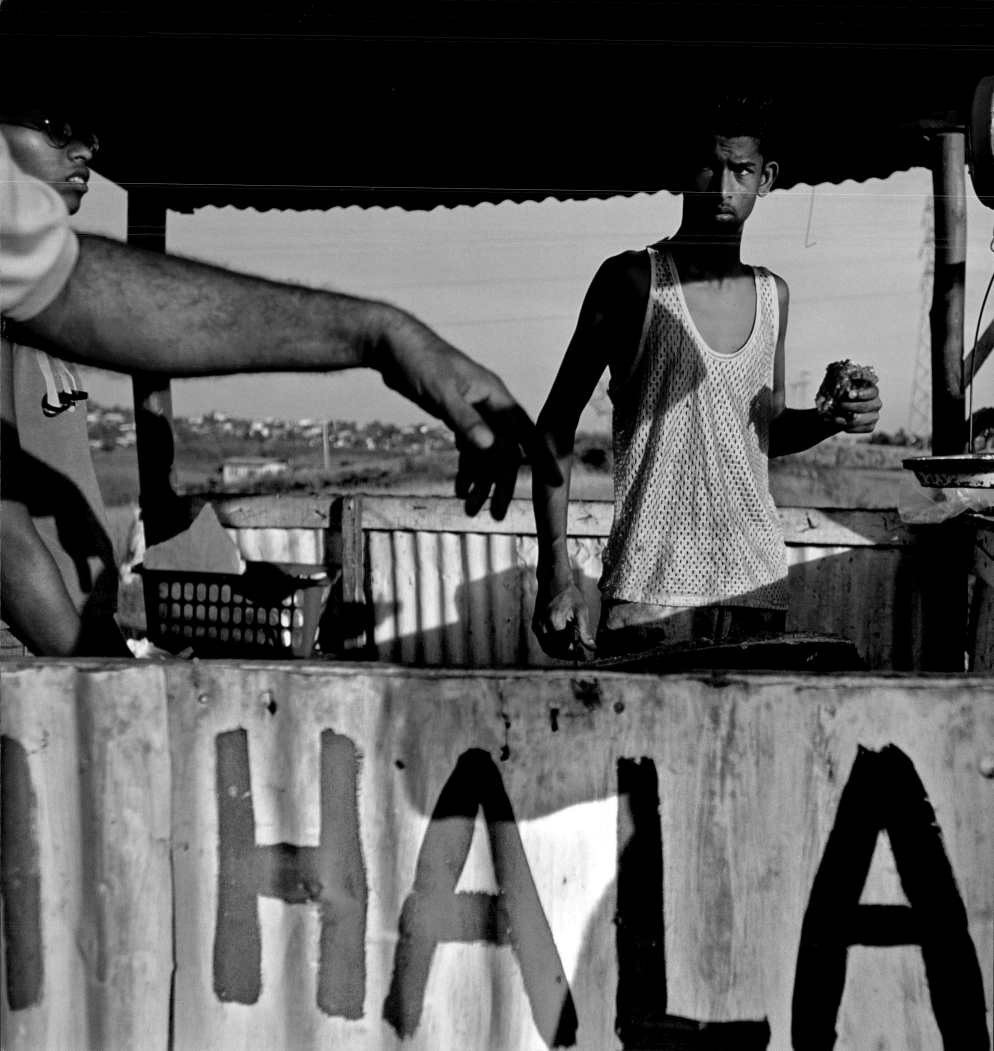

Goat meat that has been butchered according to the dictates of *Sharia* or Muslim law—and hence the certification *halal*—is sold at a roadside stand outside Williamstown in Trinidad's central island "Sugar Belt." Smaller than the U.S. state of Delaware or the Islamic sultanate of Brunei, Trinidad boasts the Western Hemisphere's highest concentration of mosques, more than 100 at last count. Trinidadian East Indians also cultivate red peppers for spicy Indian dishes, as well as cocoa, rice, citrus, vegetables, and coffee.

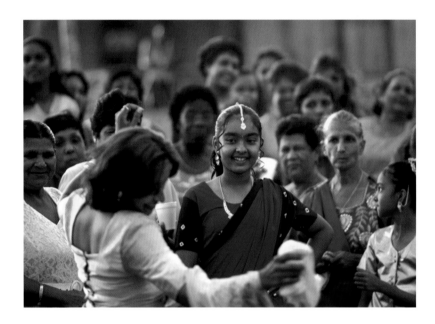

A family celebration to mark the induction of a young man into the ranks of part-time Hindu preachers called *pundits* becomes a village fête near Williamsville with dancing and a procession led by musicians with goatskin drums. Traditionally pundits come from the Brahmin, the highest Hindu caste, and serve the East Indian community in Trinidad much as Christian ministers do. They conduct Sunday prayers, lead discussions about faith, values, and current events, and counsel the troubled.

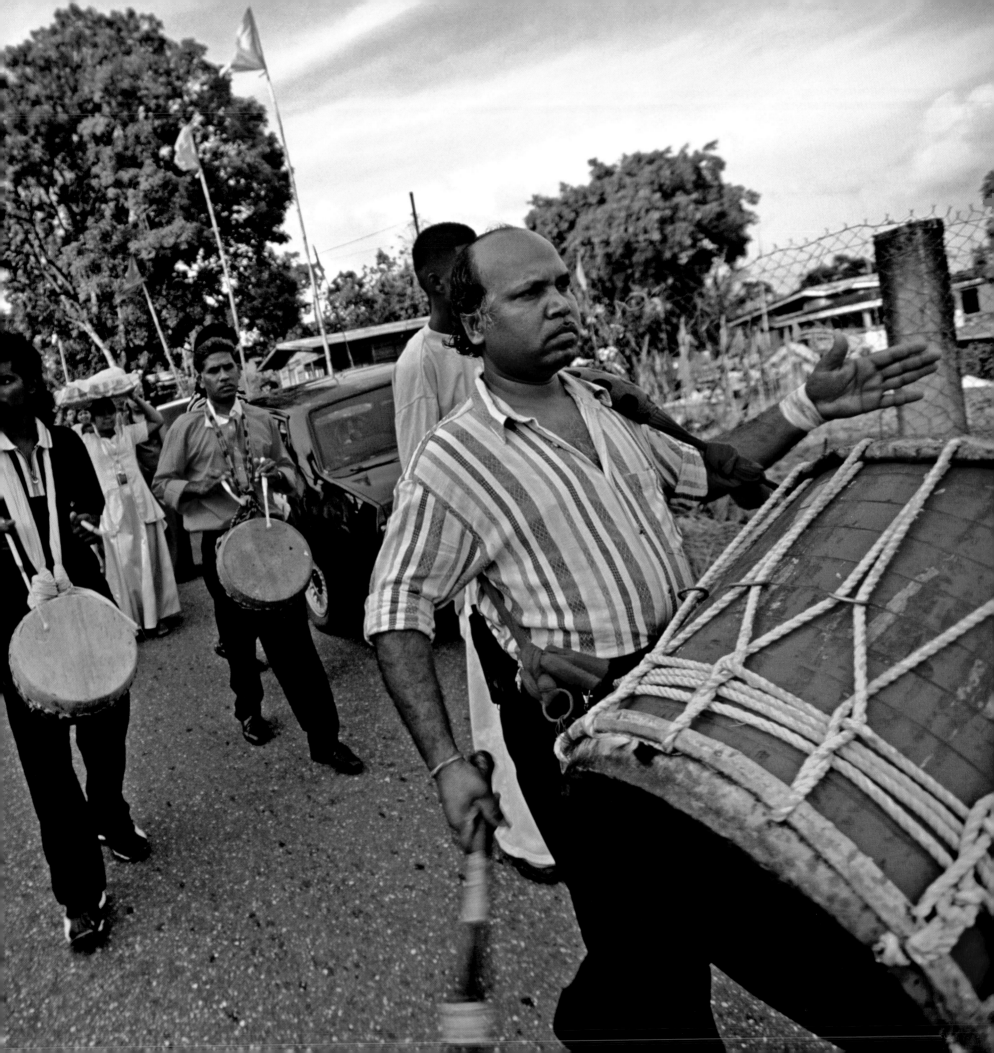

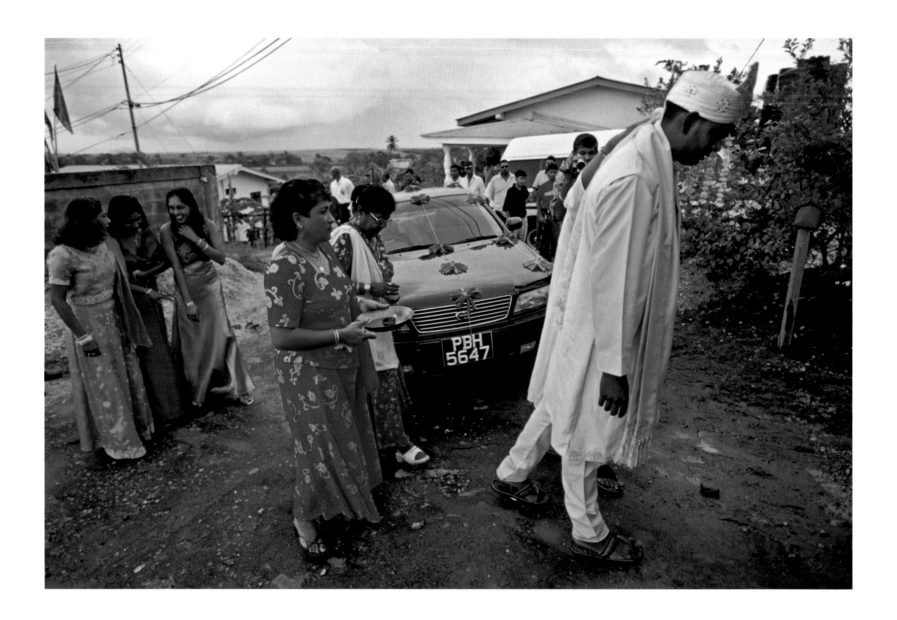

Arriving in style as a Hindu groom should, Randy Sampath, an oil company worker, receives the traditional greeting of a lighted oil lamp called a diya from his bride's family in a Trinidad village. In Hindu belief, the aarti ceremony—a greeting with a lamp—carries with it the family's prayer that the mind of the bride and groom be illuminated by wisdom.

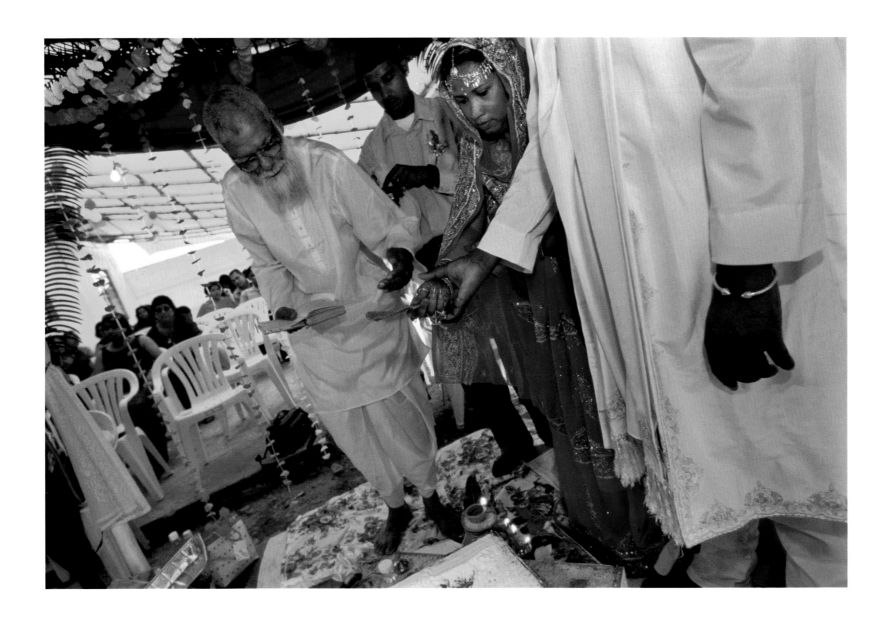

Over the traditional marriage fire, a Hindu pundit helps the couple make an offering of parched rice, or laya homa, a sacrifice of food in the hope of prosperity. The vows of love, duty, and fidelity that the couple takes in front of the fire are considered sacred and unbreakable since they are repeated in the presence of Agnidev, the Hindu god of fire.

Students line up for lunch at Parvati Girls Hindu College in Debé, one of several private schools that teach Hindi, the national language of India, along with an intensive curriculum in South Asian art and culture. Outside Queen's Royal College, Trinidad and Tobago's preeminent secondary school, an East Indian student laughs with classmates. Queen's Royal College counts among its alumni Sir V. S. Naipaul and Deryck Murray, the former captain of the West Indies cricket team, as well as presidents, prime ministers, and jurists.

At the entrance to a home in Princes Town, a census worker checking voter rolls is flanked by images of Lakshmi, the Hindu goddess of wealth (far left), and Lord Shiva, one of the three main gods of Hinduism. The artwork shows Shiva at home in the Himalayas, probably atop Mount Kailas in Tibet, and reflects the strong emotional pull of Mother India on many Trinidadians of Indian origin. Many East Indians adhere to age-old Hindu customs and religious practices, such as displaying homemade shrines dedicated to one of the many deities of the Indian pantheon.

Southeast Asia
An Ancient Passage

Unlike other parts of the world where Indians have settled in substantial numbers, Southeast Asia has embraced Indians and their culture since humankind first started keeping written records. In the first century BC, small numbers of Indian traders and holy men looked south and east to the islands, archipelagos, and peninsulas bounded by China to the north and the Pacific Ocean at the far horizon. Over the millennia, Indians left their imprint on the faiths, languages, scripts, laws, calendars, art, science, and commerce of Southeast Asia, a region now inhabited by more than half a billion people. The influence of India even extends to the current moniker "Southeast Asia," which only became popular after World War II, replacing such well-established usages as "Further India" and "the East Indies." Today, the region comprises ten countries—Brunei, Cambodia, Indonesia, Laos, Malaysia, Myanmar, the Philippines, Singapore, Thailand, and Vietnam—and Indians are at home in all of them.

To Indians of antiquity, Southeast Asia was known as *Suvarnadvipa*—the Land of Gold or, more practically, a passage to the spice markets of the Malay Archipelago and the wealth of China. Legend holds that some of the first Indians lured across the Bay of Bengal by Suvarnadvipa landed not in China but on the Malay Peninsula, arriving in Kedah, in what is today Malaysia, about 100 BC. Soon, gold, aromatic wood, and spices were not the only items exchanged in the ports of Malaya, as Malaysia was called until 1957. For Indians brought with them Hinduism and

Buddhism—faiths that struck a responsive cord throughout Southeast Asia. Over the next millennium, a gradual and uneven process of "Indianization" produced an imposing array of architectural glories— temples like Borobudur on Java, Palembang in southern Sumatra, and My Son in Vietnam—that reflected a blending of Indian and local cultural traditions. Scholars write that these early encounters between Indians and the indigenous peoples were peaceful and free of any notion of conquest. The relatively small numbers of Indian traders and scholar-priests meant that Indian culture was at best borrowed and adapted, but never imposed.

Some Southeast Asian kings who sent emissaries to India started calling themselves *rajahs*, so impressed were they with the statecraft of Hindu courts. As early as the second century AD, Malay sovereigns adapted Indian legal and governmental traditions, resulting in what historians call "Indianized kingdoms" that lasted until about 1400. Beyond the Malay Peninsula, two other Indian-influenced kingdoms attracted attention. By the seventh century, the powerful maritime empire at Srivijaya on the island of Sumatra dominated trade between India and China. And at Angkor in what is today Cambodia, the Khmer kings ruled a powerful empire for nearly six centuries. The Hindu temples they left behind at Angkor Wat, spread over hundreds of square miles, testify to the richness of Cambodian culture and the technological prowess of its architects and builders.

Meanwhile, Indian merchants, again in small numbers, sailed at the end of the thirteenth century

from Gujarat, through the Strait of Malacca, to establish Muslim settlements in northern Sumatra, an event noted by Marco Polo. The wealth and sophistication of these traders brought still more converts to Islam, while the influence of the faith became even stronger after a Muslim sultanate was established at Malacca astride the narrow strait of water by the same name about 1445. Over the next several centuries, ever-larger numbers of Southeast Asians embraced Islam—from across the Indonesian Archipelago, to the island of Borneo, and as far away as the Philippines. Today, Indian cultural traditions survive in many parts of Southeast Asia, from the huge number of Hindu believers on the Indonesian island of Bali to some of the rituals of the Muslim Malay wedding ceremonies of Malaysia, Indonesia, Brunei, and the southernmost Philippine islands.

Like the Chinese, the other great civilization to leave its mark on Southeast Asia, Indians came to the region in great numbers only in the nineteenth century. But unlike the Chinese, they usually arrived in the service of the British Empire in Asia—what Cambridge University historians Christopher Bayly and Tim Harper call the "great crescent which stretched from Bengal and Assam in eastern India through Burma to the Malay States and Singapore, interrupted only by independent Thailand." As in other parts of the world, Indians took jobs that local inhabitants could not or would not do, always with an eye toward bettering themselves and their families. Some were foot soldiers, or *sepoys*, others plantation laborers, still others convict laborers. The streets of Rangoon, Penang, and Singapore all bore the stamp of the British Raj out of India, with Tamil stevedores, Sikh policemen, and Chettiar moneylenders. Depending upon caste or religious group, Indians also built and ran the railways, supervised the rubber estates, and served as administrators in government offices. Perhaps the most controversial were the moneylenders, whose unscrupulous practices led to widespread resentment throughout Southeast Asia and were a key factor in the expulsion of thousands of

Indians from Burma in the early 1960s. Still, Indians and their descendants have become some of Southeast Asia's top professionals—and often its moneyed elite—as the region prospered from globalized trade and investment in the last decades of the twentieth century.

When Sir Thomas Stamford Raffles and Major William Farquhar of the East India Company claimed Singapore in January 1819 as a British base for shipping between India and China, sepoys of the Bengal Native Infantry accompanied them. "I remember the boat landing in the morning," recalled Wa Hakim, an eyewitness quoted in an account of the takeover of the troublesome island of pirates and fishermen. "There were two white men and a *sepoy* in it . . . the *sepoy* carried a musket." By April 1819, some 485 Indian soldiers had landed in Singapore to establish the first British garrison on the island, whose natural port would make the trading post a spectacular success in the decades to come. Other Indian regiments protected East India Company outposts at Penang and Malacca further north on the peninsula.

Singapore of the nineteenth century soon filled with contract laborers under an indentured system called *kangani*, a South Indian name for the recruiters

Indian moneychangers, many descendants of Hindu Cettiars from South India, squeeze a profit from the thinnest of margins in Singapore's Little India. Indians are the most stratified ethnic group in Singapore with many in the top ranks of the professions and business, others at the bottom, running all-night convenience stores, gas stations, and money-changing stalls.

Once crowded with Indian and Chinese stevedores shouldering the riches of Asia between lighters, bumboats, sampans, and godowns, the Singapore River helped make the former British colony one of the most famous trading centers in Asia. Today, high-rise office towers line the river, testifying to Singapore's status as the region's premier business and financial center.

who traveled to the subcontinent. These newcomers included washermen, called *dhobis,* and dairy farmers, or *doodhwallahs,* from Uttar Pradesh. Other Indians took up posts as watchmen, prison wardens, betel-leaf sellers, teashop owners, or *chaiwallahs,* and worked in the brick kilns in Serangoon Road, now the heart of Little India. The British brought still more indentured laborers, mainly South Indian Tamils, to work the plantations and build military bases, which soon attracted a substantial Indian "bazaar contingent" of prostitutes, servants, and other camp followers. From 1825 to 1873, Singapore was the region's major penal colony and Indian convicts from all parts of the Subcontinent, and nearly every caste, were used as slave labor to clear swamps and jungles, build roads, and erect buildings. Most settled in Singapore after their release, say historians. Other so-called "free passage Indians," including South Indian Muslims, arrived as clerks, bureaucrats, teachers, and importantly, traders. By the middle of the nineteenth century, Indians had become Singapore's second largest community—some 13,000 people.

Today, Indians in Singapore comprise about 8 percent of Singapore's 4.4 million citizens and occupy top positions in government, business, trade, law, medicine, biotechnology, and academia. Even the country's president, Sellapan Rama Nathan, is of Indian descent. Nathan, sitting in his office in the *Istana,* or presidential residence, is quick to tell a visitor that Indians feel a strong sense of allegiance to the island city-state, in part because every citizen is treated equally before the law. Yet in a country based on merit,

Singapore still has an underclass of contract Indian laborers—thousands recruited in questionable labor schemes directly from India to satisfy Singapore's thirst for more ports, freeways, and high-rise office towers. They—and the contradictions they represent in a country with one of the world's highest per capita incomes—can be seen crowded in the back of pickup trucks and found in squalid dormitories to which authorities turn a blind eye.

If some of Singapore's newest Indian immigrants do not yet share in the country's fabulous wealth, Indians in neighboring Malaysia say they have more pressing concerns—a glass ceiling for Indians who have made it to the top rungs of the police, the judiciary, medicine, and information technology, the lifeblood of this most globalized corner of the planet. Malaysia has a constitutionally imposed affirmative action program for the Malay Muslim majority that has resulted in quotas for Indians in the top universities, professions, and government offices. The problems of Indians in Malaysia—they number 1.67 million or slightly more than 7 percent of the country's 25.6 million citizens and include Hindus, Muslims, Buddhists, and Christians—are compounded by a substantial underclass of laborers who have been steadily driven off the dwindling number of rubber plantations and into slums that ring major cities. The marginalization of Malaysia's displaced Indian workers further complicates the fractured racial politics that divide Muslim Malay from the Chinese and Indian minorities. A recent report by the Indian government faults Malaysia for allowing Indians to falter "in economic progress and education"—a sentiment shared by Indian human rights groups in Malaysia. The captain of a Malaysian Airlines jumbo jet, who asked for anonymity because of the sensitivity of race in his country, summed up the divide: "I am happy that I like flying all over the world because for Indians, there is no hope of making it into top management. Every place has a glass ceiling."

With the exception of Singapore, this sense of not fully belonging—either to the lands of their ancestors

or to their adopted countries, where their roots are generations deep—connects Indian immigrant communities across Southeast Asia and beyond.

Take Myanmar, formerly Burma, where Britain ruled with Indian soldiers, policemen, and civil servants until independence in 1948. A wave of xenophobia and ethnic resentment called "Burmanization" led to the expulsion of almost 320,000 Indians between 1962 and 1964. Today, the remaining Indians, thought to number perhaps 2.5 million, are largely working-class traders, day laborers, and domestic servants. Gone are the prosperous big trading families, the doctors, lawyers, and other professionals who once made Rangoon, now called Yangon, a decidedly Indian city and one of Southeast Asia's most vibrant capitals. In Thailand, Vietnam, and Indonesia, where large numbers of Tamils went to work on Dutch and English plantations in Sumatra at the end of the nineteenth century, Indians have accumulated some measure of wealth, though their political power and influence is circumscribed.

In Jakarta, small numbers of Indians can be found in the information technology business, in textiles, and even in the manufacture of sporting goods, a business where Punjabi Sikhs hold special sway. Indian immigrants can acquire Indonesian citizenship, no small consideration in a country frequently beset by ethnic strife. Thailand's first links with India date to the thirteenth and fourteenth centuries and the Kingdoms of Sukhotai and Ayutthaya, where Western travelers reported sizable numbers of Indians in the Thai courts. Today, Indians number some 70,000 in the Thai kingdom and are concentrated mostly in the capital city, Bangkok, prospering in textiles and real estate. Further east in Vietnam, many of the some 25,000 Indians who lived in Saigon fled after the collapse of the United States–backed South Vietnamese regime in 1975. But some Indian professionals have returned since Vietnam opened its economy to trade and foreign investment in recent years, working for multinational and Indian pharmaceutical companies. The several hundred Indian tradesmen who remained in Saigon, now renamed Ho Chi Minh City after the communist takeover, are married to Vietnamese women, though none hold Vietnamese citizenship.

Today, Southeast Asian countries look not only to India for investment, trade, and talent, but increasingly to China, with its outsized markets, cultural ties, and muscular military presence in the region. And while the influence of Indians is limited in Beijing and Shanghai, Indians in Hong Kong have long played a key role in its economic life. Indians have been in Hong Kong since January 26, 1841, when four Indian merchants and 2,700 soldiers watched Royal Navy captain Sir Edward Belcher raise the British Union Jack over Possession Point on Hong Kong Island during the First Opium War. Indians, in fact, helped create some of Hong Kong's most venerable institutions, including Hong Kong and Shanghai Banking Corporation, or HSBC, the world's largest bank; Hong Kong University; and the venerable Star Ferry. Today, the former city's nearly 50,000 Indians—some have British citizenship, others Hong Kong residency—retain a prominent role as exporters and middlemen in trade between China and Africa, the Middle East, and beyond. Others have set up manufacturing plants in nearby Shenzhen just across the border from Hong Kong in mainland China, turning out watches and textiles.

"We Indians are good business people and have good relations with the Chinese," says Dr. Hari Harilela, an affable octogenarian who came to Hong Kong at age seven with his father, a Sindhi trader in jade and ivory, and who now owns hotels on four continents. One of the few non-Chinese appointed an adviser on Hong Kong affairs by the government in Beijing, Harilela believes one of the secrets of his success has been a network of Indian associates in London, the United States, and the Middle East. "Good men have good friends," he says. "If you're good to people, something is going to click."

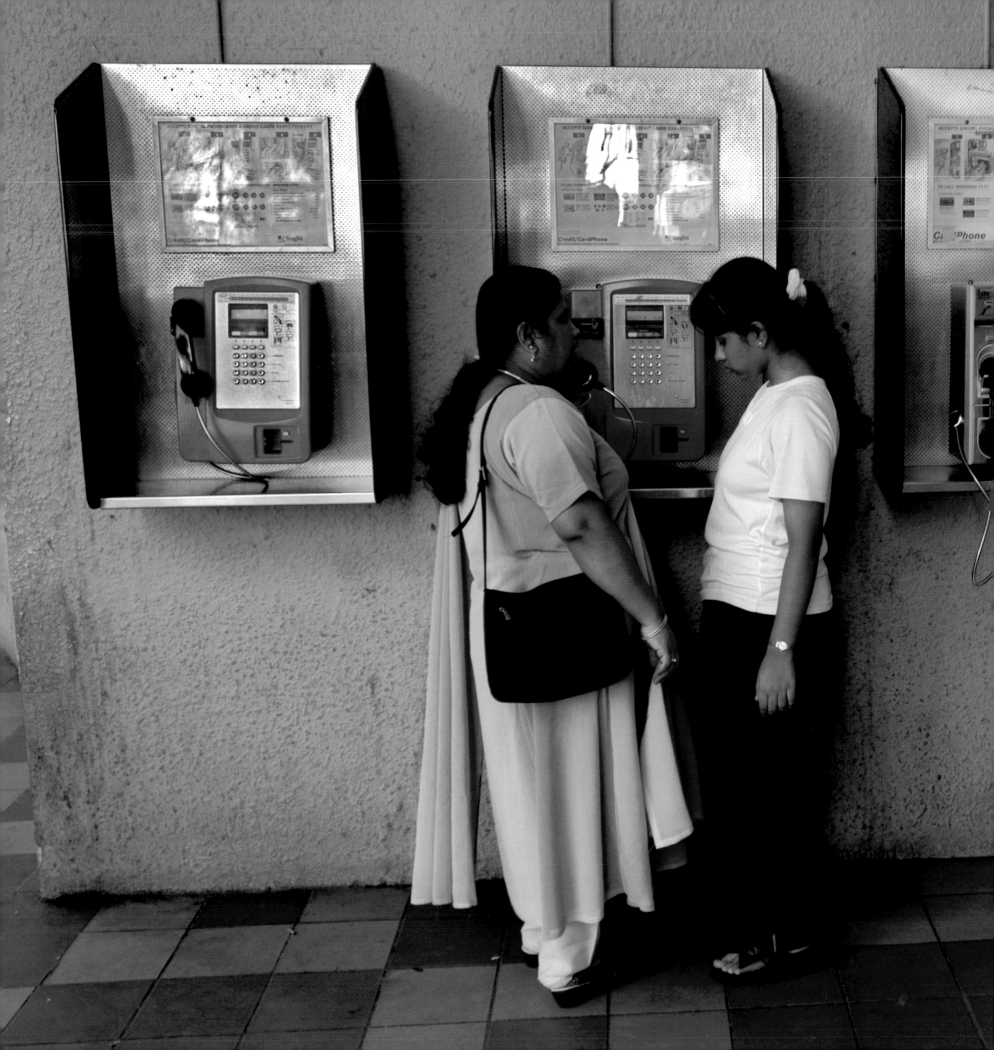

The generation gap looms large for many Singaporean families like this mother and daughter at a public phone in Little India. Indian youth are graduating from Southeast Asian universities in higher numbers, while dating—some of it interracial—is becoming more common, often to the chagrin of tradition-bound parents. The vast majority of the some 350,000 Indians in Singapore are descendants of immigrants who arrived during British rule.

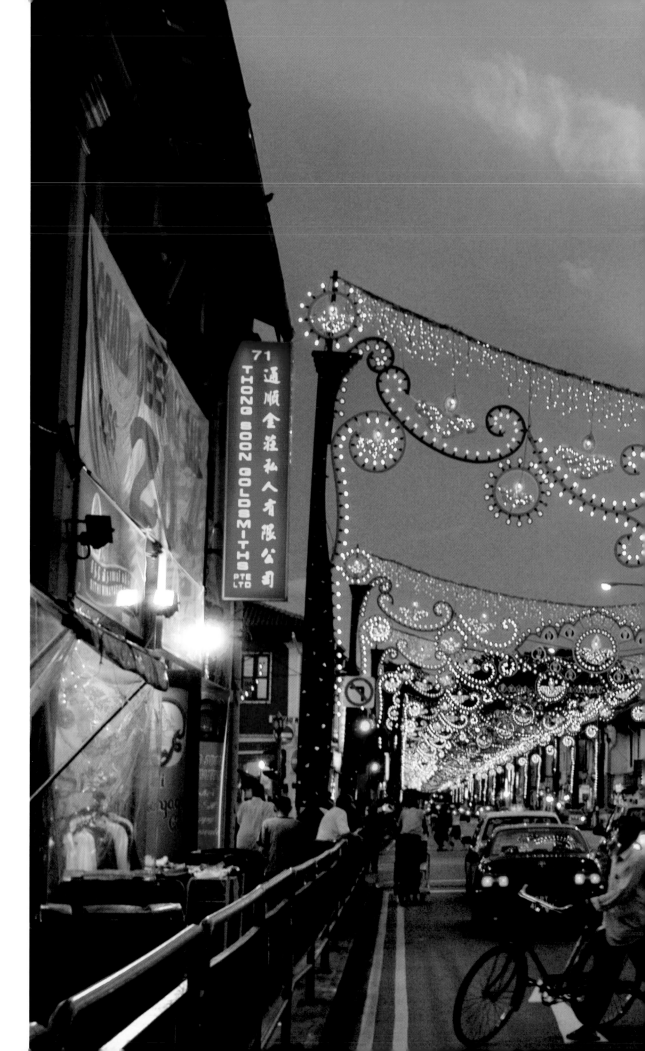

Locus of Indian commerce and cultural life in Singapore, Serangoon Road is the main thoroughfare through Little India. Indian immigrants settled along the one-time bridle path in the 1820s, grazing cattle and working the brick kilns. In recent years, new condominiums, shopping complexes, and a subway line have encroached on the arcades and shophouses that line this always-colorful road.

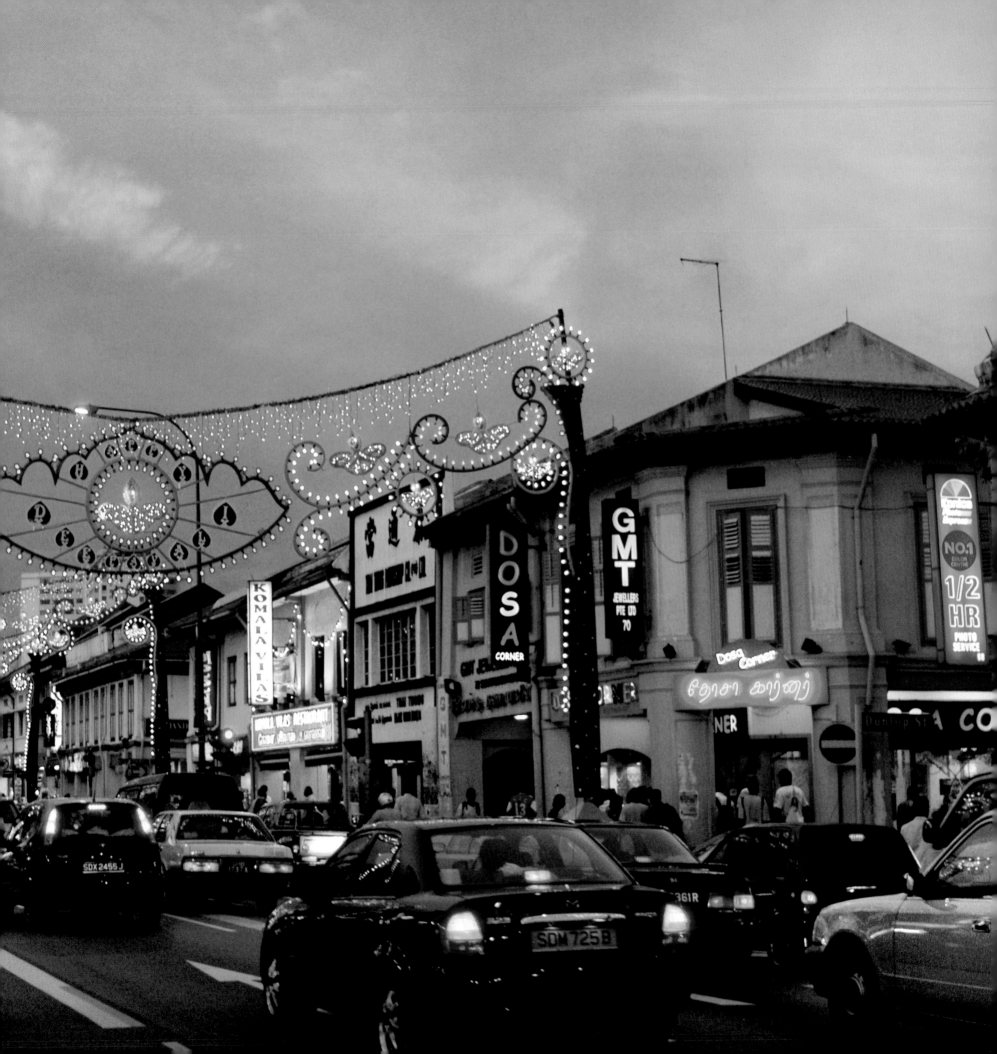

Mee Hoon Goreng $2.50 Chicken

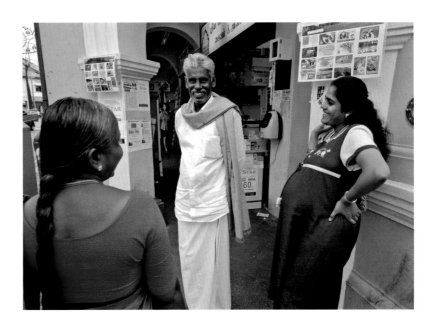

Savory Indian food, often called *mamak*, fills open-air stalls throughout Singapore's Little India. Shops sell everything from *roti prata*, or unleavened bread, to *rojak*, a kind of salad in which pieces of boiled potato, fried dough, prawn fritters, hard-boiled egg, bean sprouts, and slivers of cucumber are slathered liberally with a thick, spicy peanut sauce. Rice cooked with seasoned chicken or mutton called *biryani* simmers in open-air kitchens up and down Serangoon Road, where this family met in front of an arcade full of Indian delicacies.

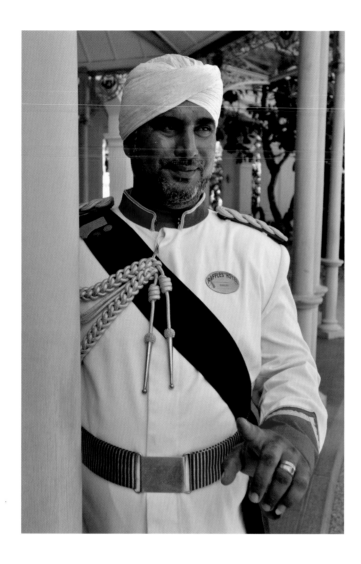

Like a character from a Somerset Maugham novel, a Sikh doorman
greets guests at the Raffles Hotel in Singapore. Maugham called the
Raffles, which opened in 1887 in the heyday of British colonial rule,
the archetype for "all the fables of the Exotic East." Numbering today
about 20,000, Sikhs came to Singapore as *sepoys,* or soldiers, and
policemen. Hanging on to a tradition that is fast disappearing, a
reader scans a Tamil newspaper in a Singapore teashop. Though at
least 1,000 languages are still spoken in Southeast Asia, Tamil, the
largest language group of Indian minorities in Malaysia and
Singapore, is fast disappearing in favor of English.

Singapore native Arul Ramiah, a Harvard University–trained lawyer and chief of regulatory policy at the Singapore Exchange, bids goodbye to nephew Sanjeevan at the beginning of a 12-hour day. Standing shoulder to shoulder with Eurodollar traders, Shirley Thilaga works the floor of the exchange, the nexus of one of the world's most important financial centers. Known as SGX, the exchange was the first in the Asia-Pacific basin to deal in integrated securities and derivatives, reflecting Singapore's status as one of the world's most competitive information-based economies.

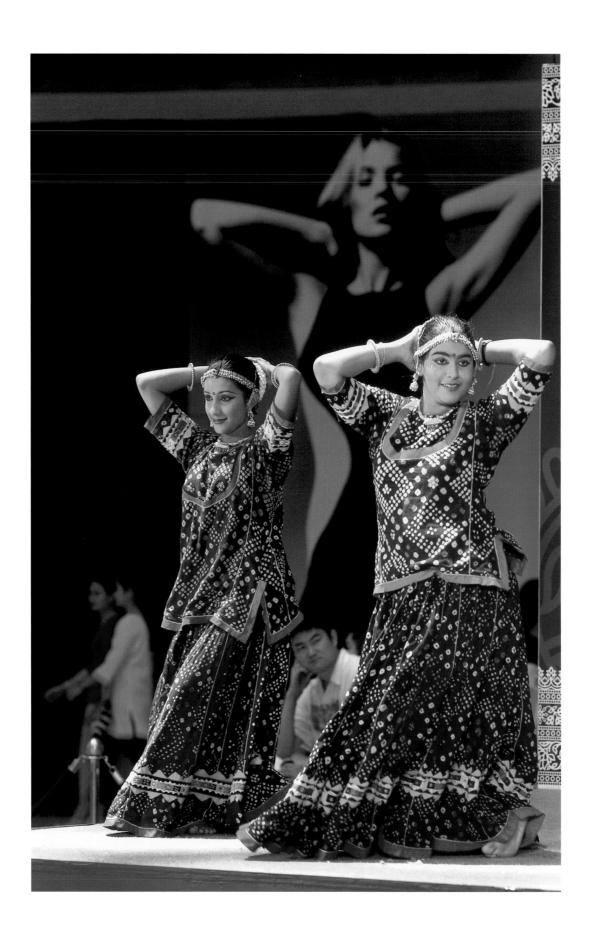

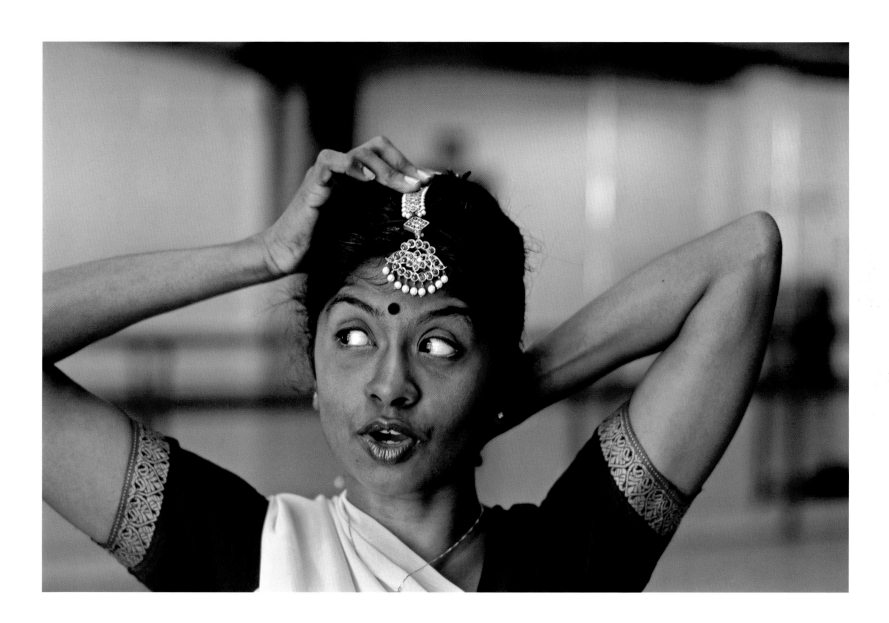

The rousing repertoire of a Punjabi Sikh dance troupe at a luxury shopping mall in Malaysia on the eve of Diwali, also called Deepavali, one of the most festive holidays observed by South Asians around the world, contrasts with the solo recitals, sometimes set to contemporary music, of Arul Ramiah. Here, a world away from her executive job, she selects a head ornament for a Bharata Natyam performance, the classical Hindu temple dance known for its grace and sculptured poses. Ms. Ramiah has traveled across South India to learn the intricate hand gestures, or mudras, that are an essential element of Bharata Natyam.

Indian construction workers enjoy a playful moment at a high-rise building site in Singapore. Blue-collar workers from some of India's poorest regions have been the backbone of Singapore's transformation from colonial backwater to a center of global trade, investment, and research with a gross domestic product (GDP) that makes it one of the world's 25 richest countries.

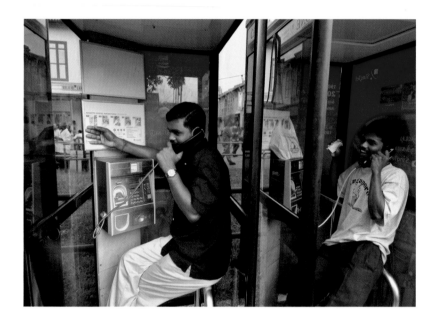

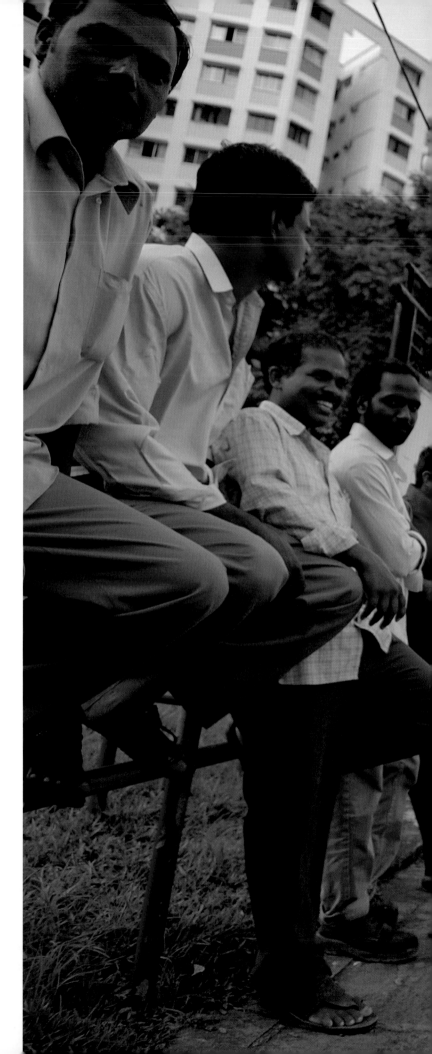

With time on their hands, Indian guest workers on short-stay visas gather by the thousands on Sundays to call home and gossip in Singapore's Little India. Most live in overcrowded hostels and send part of their wages back to families and moneylenders in India. Critics of Singapore's use of semiskilled Indian workers call them an exploited underclass with virtually no rights. However, over the past two decades Singapore has attracted more skilled immigrants from around the world, including a growing expatriate community of well-educated and wealthy professionals who have retained their Indian citizenship.

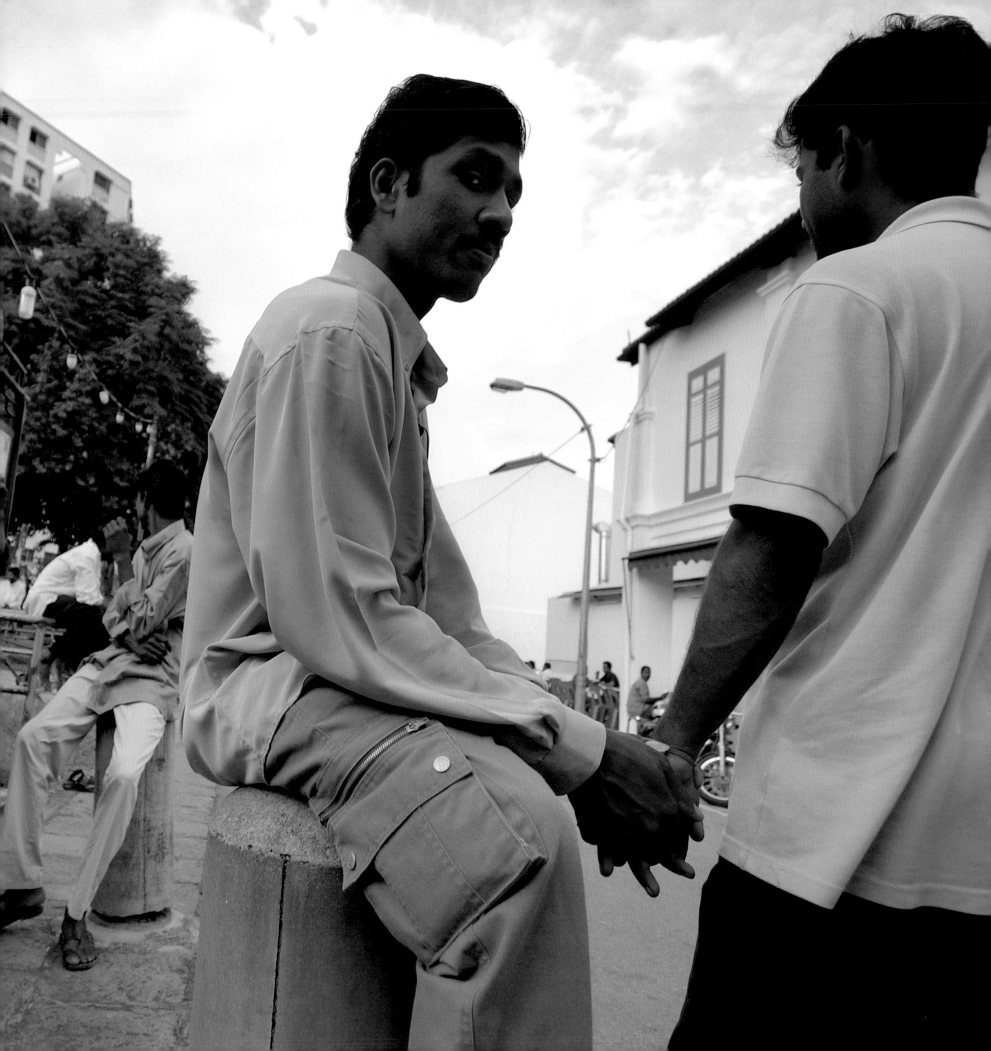

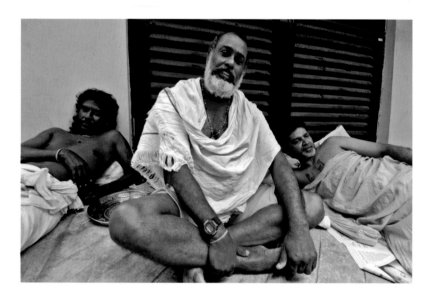

Firewalkers rest outside Singapore's Sri Mariamman
Temple after midnight runs across white-hot embers
in honor of Draupadi, heroine of the Hindu epic
Mahabharata. Their daring—a test of faith and purity
for Draupadi's devotees—is a highpoint of the
Thimithi festival. Firewalkers spend weeks mentally
preparing to walk barefoot across the pit of coals and
must have a special permit from the Singapore police.
In the prayer hall of the Shree Lakshami Narayan
temple in Kuala Lumpur, women and children are
segregated from the men. A center of Hindu religious
and cultural life in the Malaysian capital, the temple
was founded by devotees from northern India in 1921.

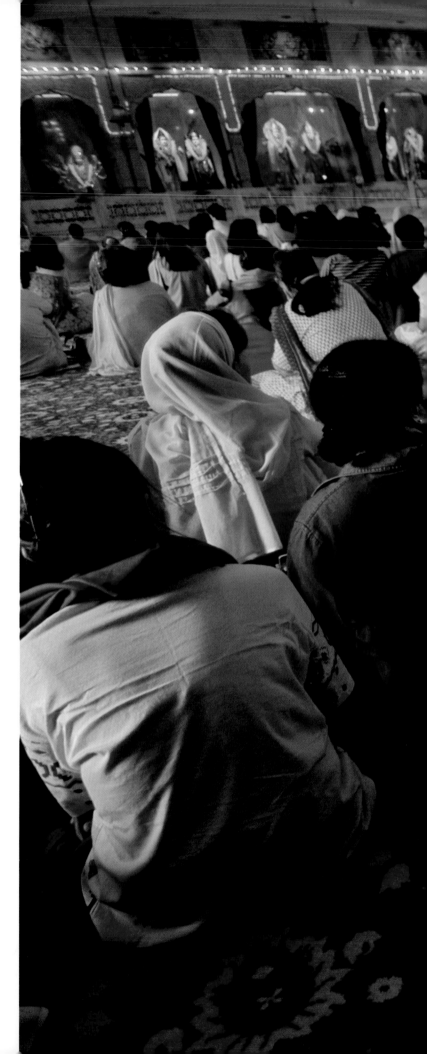

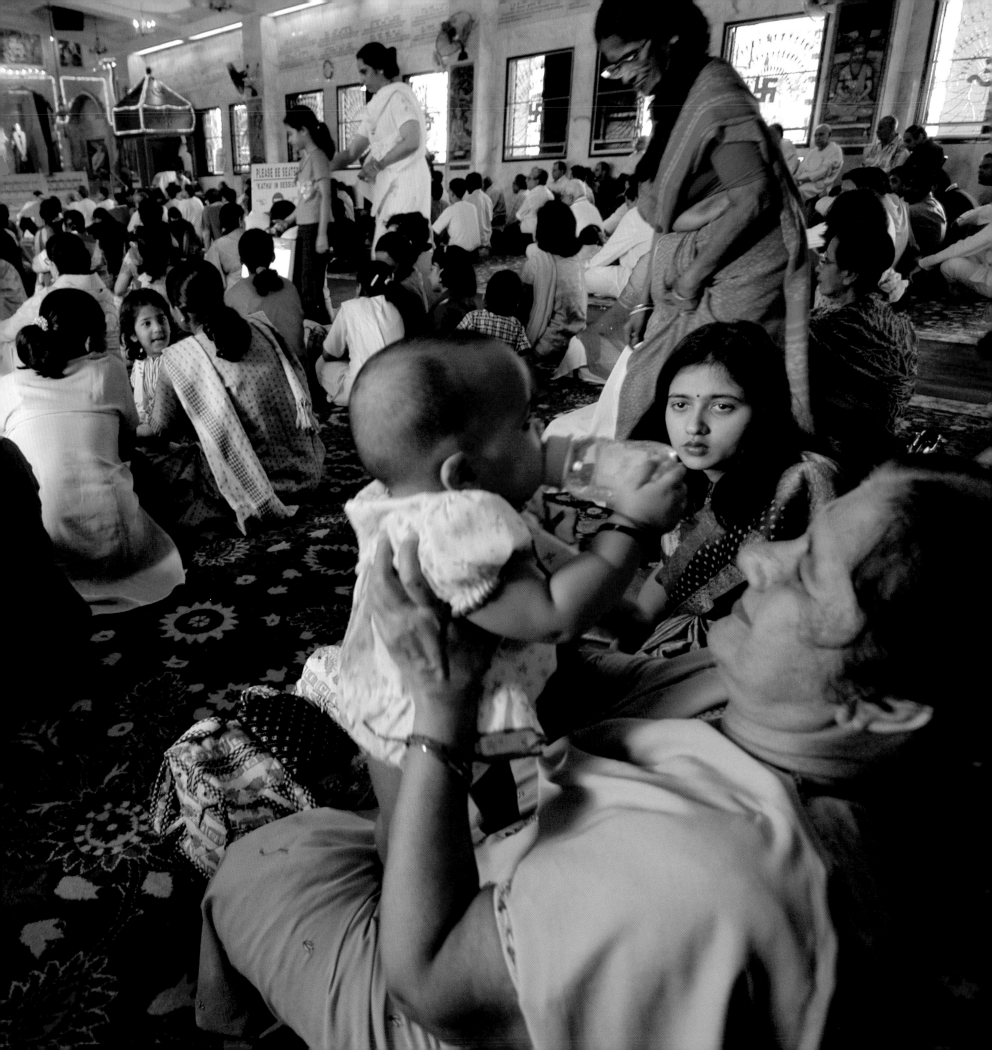

In Singapore's Sri Mariamman Temple, a woman brings her hands together in the traditional Hindu greeting—a sign of respect or deference at the island city-state's main Tamil shrine. The temple, built in 1843 by ex-convicts mostly from Madras or Chennai, is dedicated to the goddess Mariamman, who is worshipped for her power to protect against disease and death.

At the Sri Mahamariamman Temple in Kuala Lumpur, the creases of age and smeared *vibhuti*, or holy ash, line the face of a visitor to the Hindu shrine. The temple is the starting point for the yearly Thaipusam pilgrimage to the Batu Caves, where devotees of the god Subramanya Swamy pierce their bodies with steel hooks and rods.

Greeting Deepavali visitors in traditional South Indian fashion, Vidhya Muthu of suburban Kuala Lumpur lights oil lamps around a *rangoli,* or *kolam,* an intricate design of colored rice, chalk, and flour. The center contains the most sacred and powerful of Hindu symbols—*Om*—the omnipotent source of all existence. In the family garden, Vidhya's mother, Gomathi, offers prayers to *tulsi,* an Indian basil plant that is venerated by Hindus and grown in specially built structures. For Tamil-speaking Malaysians like the Muthu family, Deepavali begins with family prayers, offerings, and gifts of new clothing.

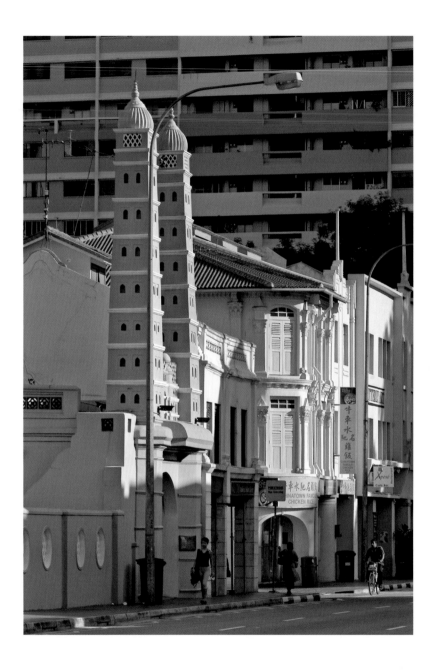

A Singapore landmark, Masjid Jamae is one of the country's oldest Muslim holy places. Established in 1826 by Chulia Muslims from the Coromandel Coast of South India, the mosque has remained almost unchanged since it was completed in 1830 in what is today Chinatown beside, appropriately, Mosque Street.

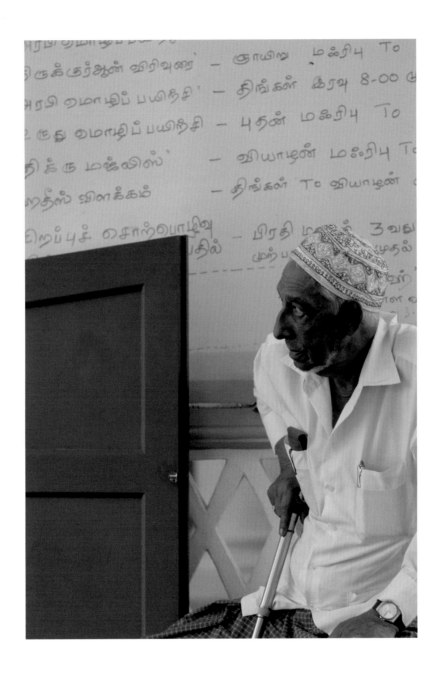

Waiting for Friday prayers to begin, a Singaporean Muslim sits in the distinctively South Indian foyer of the Masjid Jamae. Indians are the most religiously diverse of Singapore's ethnic groups with an estimated 25 percent Muslim, 55 percent Hindu, 12 percent Christian, 7 percent Sikhs, and a smattering of Buddhists.

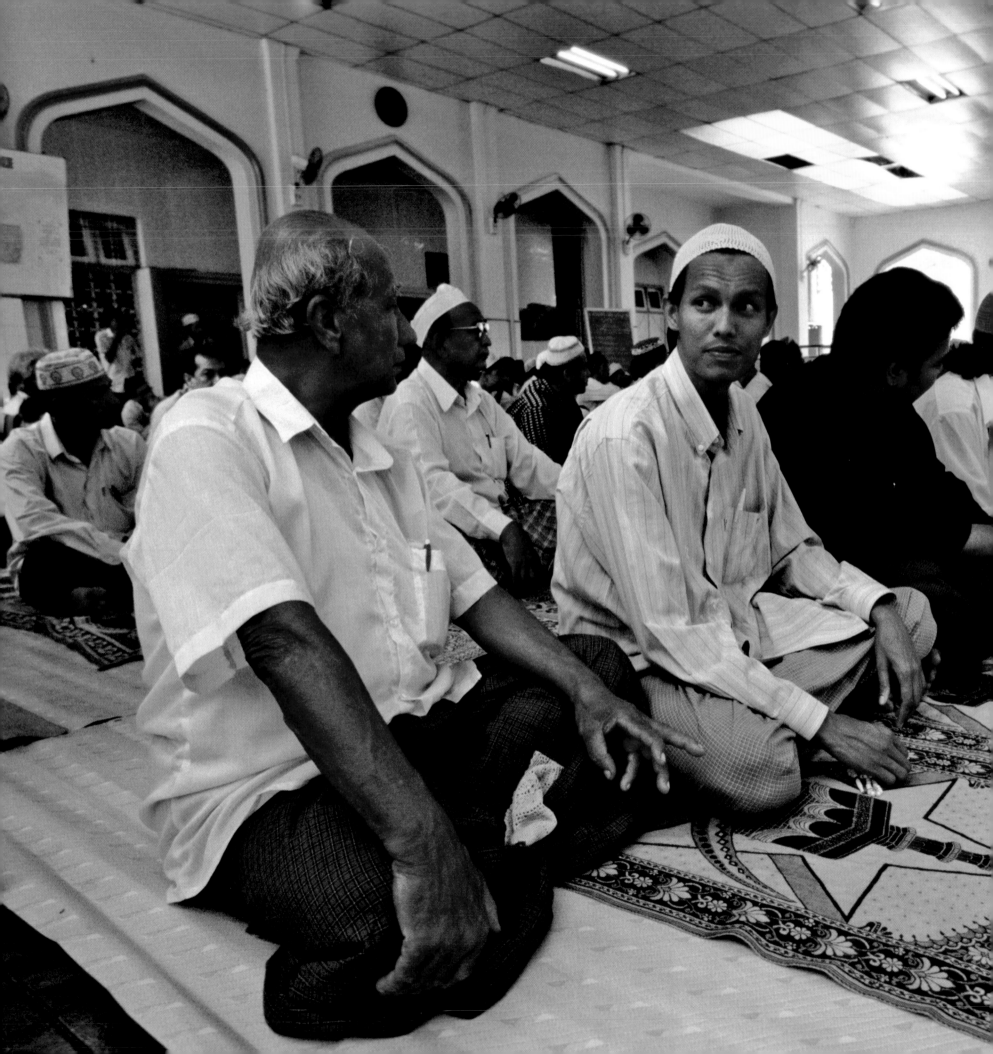

A Muslim cleric preaches to Burmese Muslims of Indian ancestry at the Dargah of Bahadur Shah Zafar in Yangon, where the last Mogul emperor of India is buried. Great Britain ruled Burma with the help of Indian merchants, soldiers, policemen, and civil servants, leading to violent clashes with resentful Burmese in the 1930s and again in the 1960s, when large numbers of Indians were expelled. At a *madrassa,* or Islamic school, Burmese Muslim students of Indian descent gather around their teacher. Using the Qur'an as their principal text, *madrassas* are funded by groups in Pakistan and the Middle East and are increasingly common in Myanmar, home to some two million Muslims.

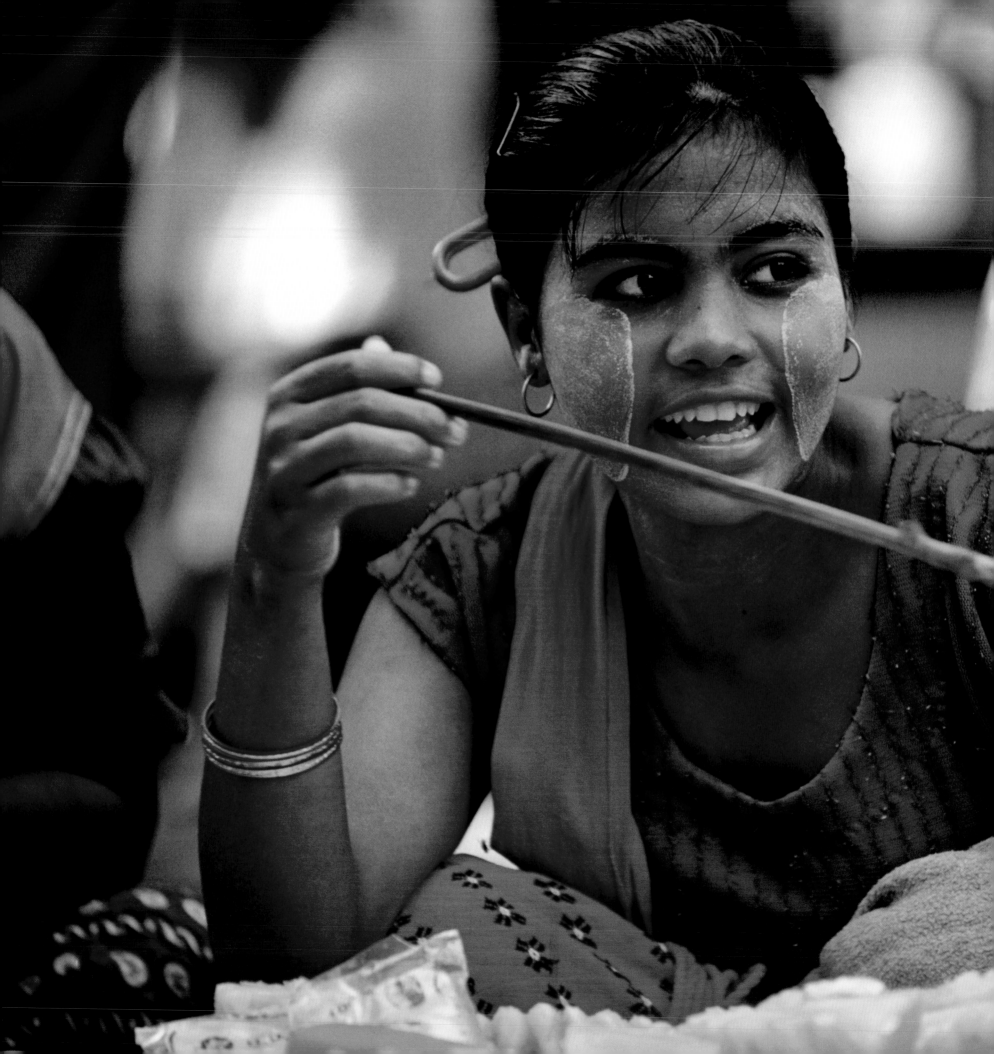

ॐ भगवते नम

A SOLDIER
OF THE
INDIAN ARMY
1939 - 1945
IS HONOURED HERE
24TH JULY 1945

Batting insects away, a Burmese woman of Indian
origin sells pineapple slices in a marketplace near
Yangon. She wears *thanaka*, a yellow paste made of
pulverized tree bark and worn by many Burmese
women as a combination of sun block and make-up.
Invoking the Almighty with the Sanskrit phrase *Om
Bhagavate namah*, a headstone marks the final resting
place of an unknown Indian soldier at the Taukkyan
War Cemetery and Memorial outside Yangon. The
cemetery contains the graves of some 6,000
Commonwealth soldiers of many races and faiths
who died in the service of the British Crown in
Burma and Assam during World War II.

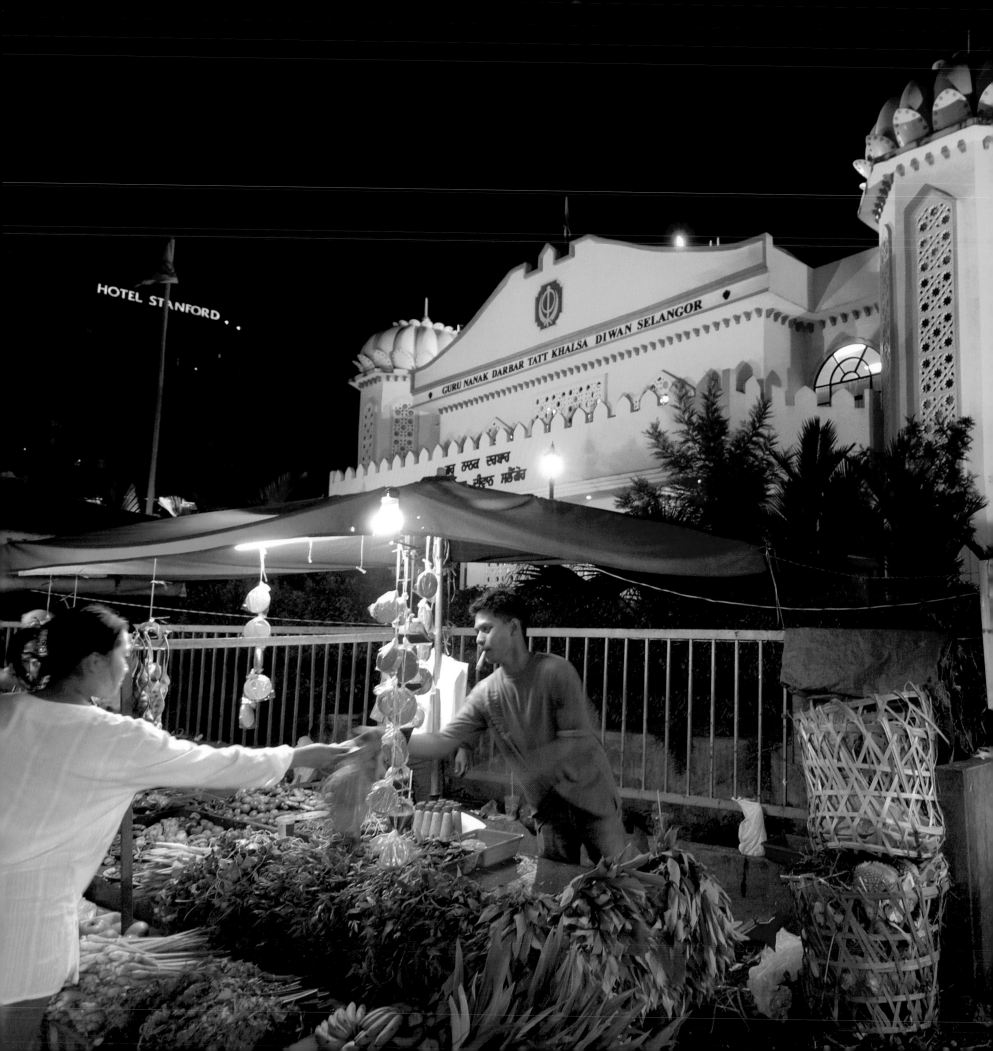

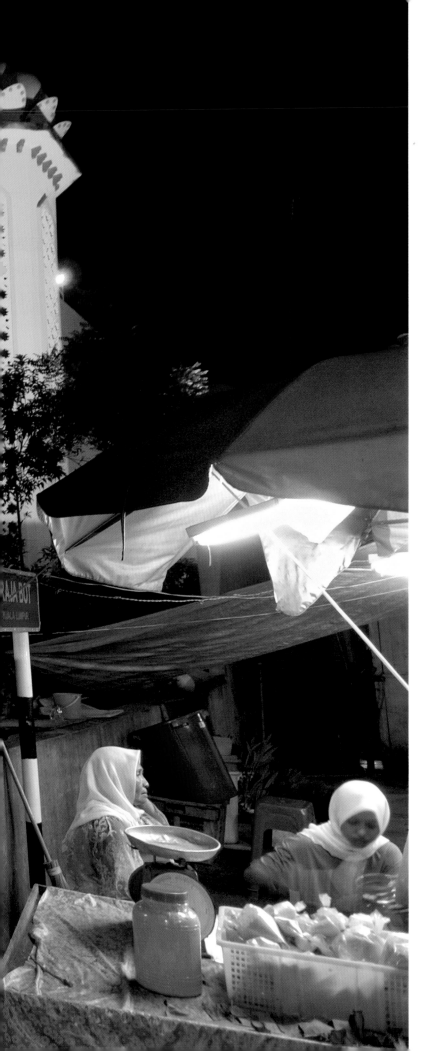

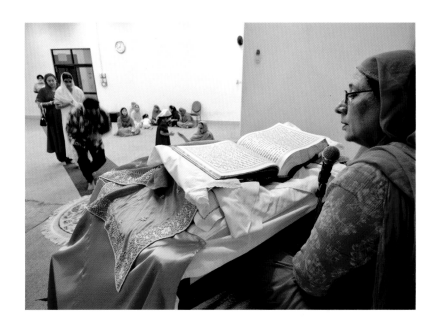

Malay Muslim street vendors work through the night in front of the main Sikh temple in Kuala Lumpur. The Guru Nanak Darbar Tatt Khalsa Diwan of Selangor State was established in 1824 on British Crown land. Inside the temple, a devotee reads from Sikhism's sacred text, the 1,430-page scripture of Guru Granth Sahib. With more than 23 million followers worldwide, Sikhism is a monotheistic religion based on the teachings of ten gurus who lived in northern India during the sixteenth and seventeenth centuries.

For a few Ringit, the Malaysian currency, an Indian-Malay couple asks a Kuala Lumpur fortuneteller to look into their future. And well they might. While Indians in Malaysia make up between 7 and 8 percent of the country's 25 million citizens, they occupy a disproportionate share of jobs at the bottom of the social-economic scale and make up a whopping 50 percent of all prison convicts. Mainly Tamil-speaking, Indians also have seen their birthrate decline over the past decade.

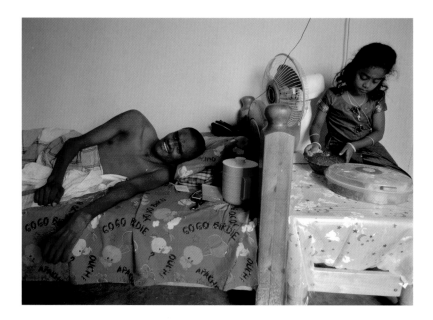

Seemingly invisible to passersby, a homeless Indian-Malay man sleeps in the shade of an overpass in downtown Kuala Lumpur. Driven from rubber and palm oil plantations that have been turned into suburbs and shopping malls, Tamil-speaking Indians cling to the bottom rungs of the economic ladder in Malaysia, a country aspiring to First World status. As many as 20,000 poor Indian-Malays are considered second-class citizens with no access to government assistance because they lack identity cards or marriage or birth certificates. Attended by a niece, Maran, a paralyzed Indian-Malay who uses only one name, runs a small business from a cinder-block house in a Kuala Lumpur slum called Kampong Medan.

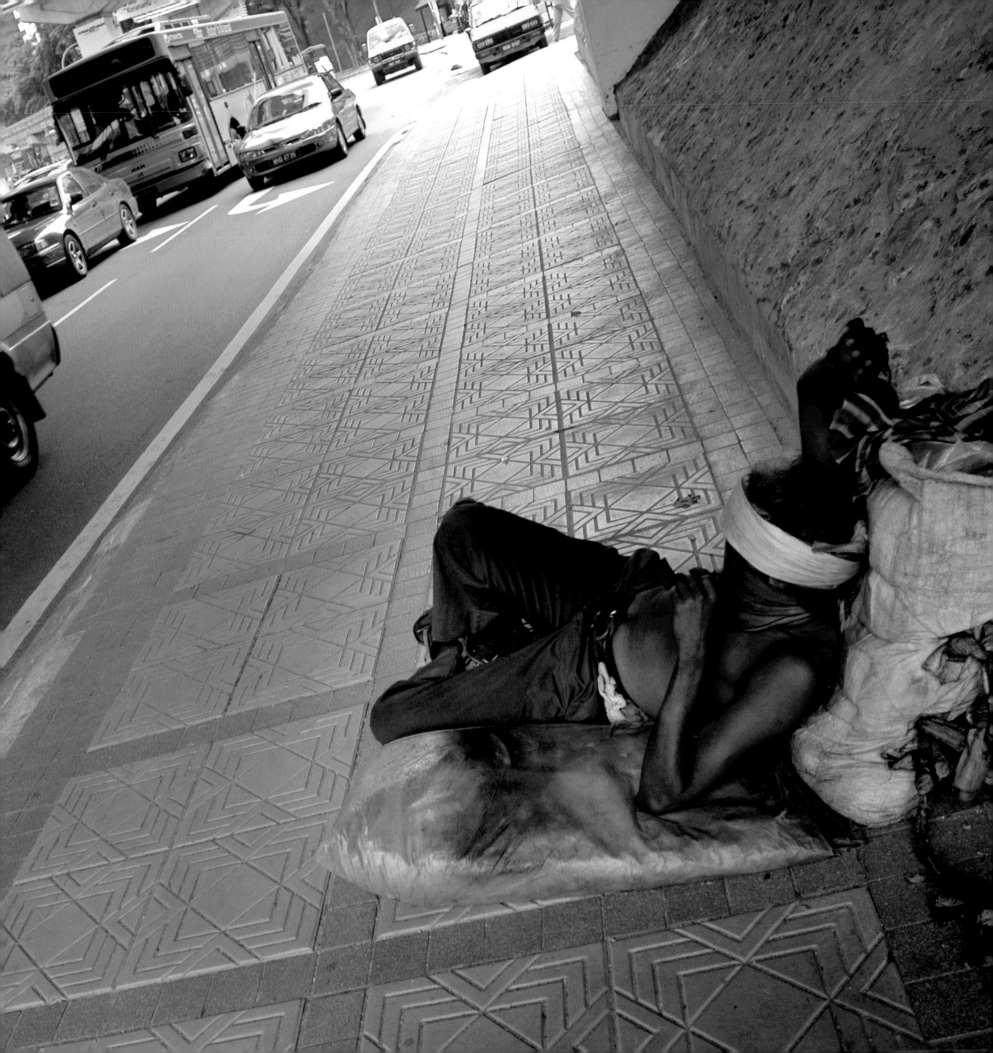

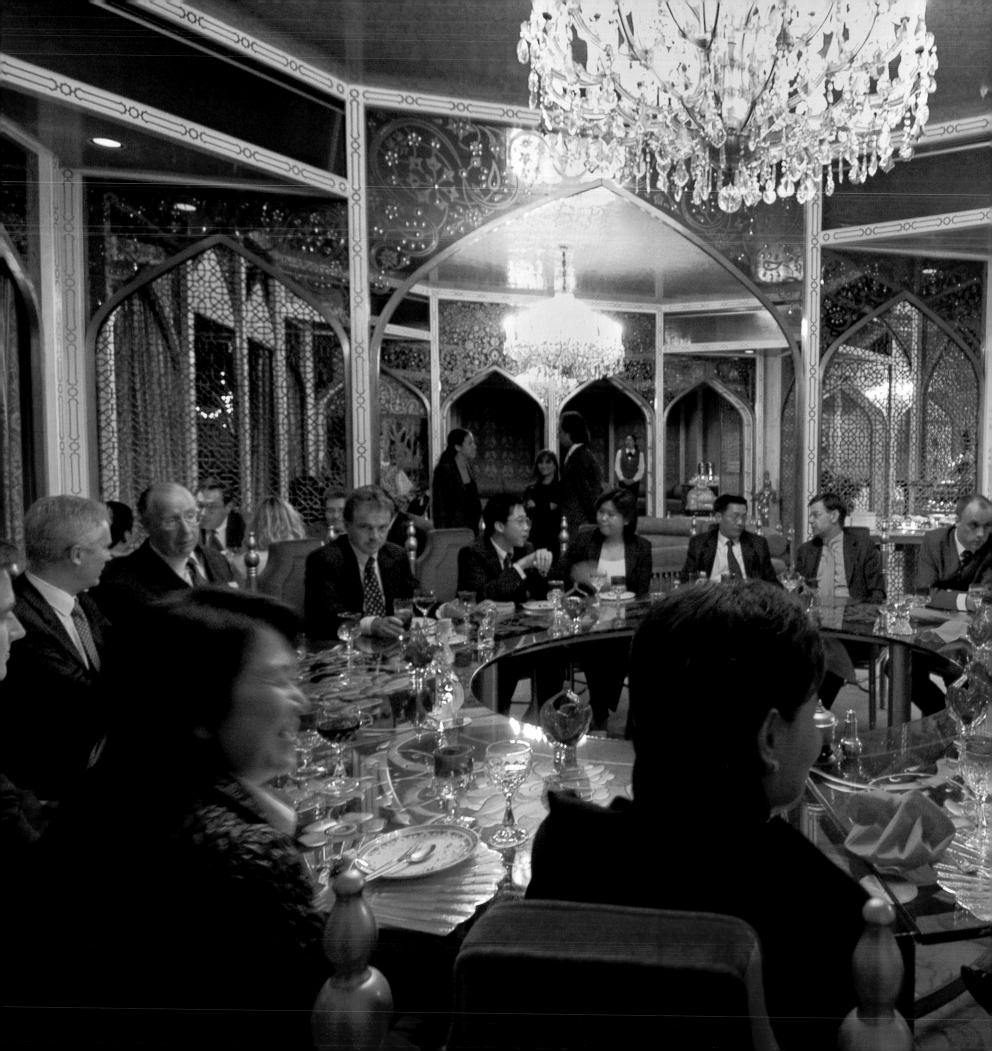

One of the most celebrated philanthropists and dealmakers in Hong Kong, Dr. Hari Harilela hosts a dinner in his Kowloon mansion, where he lives with about 70 family members and 40 servants. Harilela owns hotels around the world and his company has a seat on the Hong Kong stock exchange. In his chauffeured Mercedes, Harilela recalls beginning his career as an impoverished food and sundries vendor in Japanese-occupied Hong Kong during World War II. Harilela has devoted his later years to charitable activities in India and Hong Kong, where he has been the driving force behind the new Hong Kong University of Science and Technology.

North America
Dollar Dreams

A few years ago, an Indian film called *Dollar Dreams* delighted critics because it asked a question that has perplexed the Subcontinent for two generations—can money change human nature? Or, will looking for El Dorado in the United States—a term used by many Indians—cut the umbilical cord between would-be immigrants and their mother country? The answer seems to be a resounding no.

The investment bankers J.P. Morgan Chase say that far from forsaking family and country, immigrants to the United States—a land that has always defined success for ambitious Indians of every class and caste—and those in other developed countries send home more than $23 billion a year. Overseas remittances, in fact, now act as a powerful stimulant to India's unprecedented economic growth, now approaching 10 percent annual GDP, and account for double the amount of money foreign investors are spending in India. Indians abroad, including those in the United States, have in the past few years deposited $32 billion, or 23 percent of India's foreign exchange reserves, in local banks. And they invested heavily in research centers and information technology campuses like those in Bangalore, Hyderabad, and Chennai.

Not surprisingly, the most generous Indian immigrants live in the United States. The 2.32 million Indians in the United States—most live in New Jersey, New York, Texas, and California—send home almost $11 billion a year through banks and Western Union, and probably more in cash through "unofficial channels," according to a World Bank study.

These same Indian immigrants who faithfully send money home are so varied in background and occupation that they defy easy categorization, say scholars who study the diaspora in America. The one thing everyone seems to agree on is that Indian-Americans are close-knit—critics call them tribal and unassimilated—in their adopted neighborhoods, be it Jackson Heights, a working-class South Asian enclave in the New York City borough of Queens, or the comfortable palm-lined streets of Palo Alto near the Stanford University campus in California. Most Americans see Indian newcomers as good neighbors and high achievers—the standard against which all other immigrant success stories are measured. Yet, Indians have discovered that life in the United States "is not an easy road," in the words of a Silicon Valley software engineer from Bangalore. Since the first Indian émigré arrived in 1790—appropriately, for a country that celebrates the story of Plymouth Rock Pilgrims, in Massachusetts—Indians have faced many of the same hardships—especially racism and bigotry—as other immigrant groups before them.

Determined to make a better life for themselves and their families, Indians began arriving in the United States in substantial numbers in the late nineteenth century, when Punjabi Sikh soldiers mustered out of the British Army in Canada and came to Washington, Oregon, and California as loggers, railroad workers, and farmers. Indian professionals and large numbers of students came later, beginning in the 1960s and 70s,

when the United States developed an insatiable appetite for doctors and engineers, and immigration laws were loosened. And today, many Indians are comfortable—even rich—compared to the rest of the United States.

According to the latest census data, the median income of Indian-American households was almost $60,000, or 35 percent higher than the nation overall. Indeed, affluence and education defines Indian-Americans—some 42,000 are medical doctors, another 25,000 are owners of hotels and motels, and three are CEOs of Fortune 500 companies. Thousands more Indians dominate the top technology companies in Silicon Valley, where Indians make up about one-quarter of the high-tech workforce. In academia, Indians also have achieved prominence beyond their numbers, including Harvard University economist Amartya Sen, a Nobel Prize winner who has helped give voice to the world's poor. Increasingly, Indians are gaining fame in the news media, broadcasting, the arts, literature, fashion, and as restaurateurs of national and international standing. The international investment firm Merrill Lynch calculates there are an astonishing 200,000 Indian-American millionaires, though Indians represent only slightly more than $1/2$ of 1 percent of the U.S. population.

And as almost any teacher in New York, Chicago, or San Jose will attest, Indians are outstanding students. About 64 percent of Indian-Americans have earned at least a bachelor's degree, while about 12 percent of all medical school students are Indians, many at the nation's top schools. The dominance of Indians in the National Geographic's annual Geography Bee, National Spelling Bee, and the Intel Science Talent Search is the stuff of urban legend. Often, it is a story of immigrant children giving up TV, or foregoing socializing with their classmates, to deliver a tangible part of the American dream to their parents, who are just as likely to be shopkeepers as doctors. Accordingly, say scholars who study the diaspora, these high levels of education and English-language skills have allowed Indian-Americans to

become one of the United States' most productive groups ever, with almost 75 percent employed in the nation's workforce.

Parmatma Saran, a sociologist at New York's Baruch College who came to the United States as a young man in 1967, says Indians have prospered because they balance modernity with old-world values. "South Asians are following in the footsteps of Jews," he told *Newsweek*. "They're following the Jewish model of penetrating the structural arrangement of society—economics, politics—without losing their cultural identity." And that cultural identity remains strong, sometimes for reasons not readily apparent to outsiders. "The Indian family unit is so powerful," says author and writer Ved Mehta, who was born in India, became a staff writer on the *New Yorker* magazine for more than 30 years, and has written 25 books, many about family, identity, and exile. "Indians live to eat and you seldom find them totally acclimatized to Western food. Food and the family keep Indian communities tightly knit."

Still, second- and third-generation Indian-Americans, like Pulitzer Prize–winning author Jhumpa Lahiri, say navigating between cultures can

Bollywood movies shops line the "Little Madras" stretch of El Camino Real, the main thoroughfare connecting San Jose and Palo Alto in California's Silicon Valley. In the United States, Bollywood films now earn about $100 million a year through theater screenings, video rentals, and the sale of movie soundtracks.

Advertising art director Saraswathi Ghanta, a second-generation Indian-American, models a T-shirt she designed for MTV Desi, formerly a Viacom channel heavy on Bollywood videos, electronic tabla music, and Gujarati hip-hop, and aimed at young South Asians in the United States.

side, lacking the counterpoint India has until now maintained, begins to gain ascendancy and weight."

But there is a darker side of the Indian diaspora in North America. Several authoritative studies indicate that one-tenth of the Indians in the United States live in poverty and as many as 400,000 are undocumented or illegal immigrants. Even affluent Indians often must support unusually large families and live in more crowded conditions than their suburban neighbors. Indian-American families may often include parents, children, two sets of grandparents, plus random relatives—some with a limited command of English and limited earning potential.

Moreover, evidence suggests that Indian immigrants face not just "glass ceilings," or unspoken limits of professional advancement in some businesses, but so-called "tin roofs"—outright discrimination by upper-caste Indian executives against their countrymen and women they believe are untouchables, now usually called *Dalits*, or downtrodden, or members of other low castes. Indian immigrants also are not immune to racially motivated violence, particularly in working-class neighborhoods along the Mid-Atlantic states. In one notorious case of mistaken identity after September 11, 2001, a Sikh by the name of Balbir Singh Sodhi was murdered at a Phoenix gas station by a white supremacist who mistook Sodhi for an Arab because he wore a turban and had a long beard.

In the meantime, what surprises scholars is not so much the achievements of Indian immigrants and their families in the United States, but how long it has taken them to break out of their self-imposed political isolation. By contrast, Indians in Canada have moved into the political mainstream faster than their American counterparts, who are only now starting to flex the muscle of their wealth and education. For example, Ujjal Dosanjh, a Canadian lawyer and MP, emigrated from India to England, then to Canada, and became the thirty-third premier of British Columbia in February 2000, making him the country's first nonwhite and first Indo-Canadian provincial leader. While Indian immigrants have served in the U.S. House of Representatives, none

be painful in the best of families. Not quite accepted by either their Indian relatives or American friends, immigrant children nevertheless are closer to mainstream American culture than their parents, despite growing up eating rice and dal with their fingers or disappearing over school holidays to visit relatives in India, when everyone else seems to be at the beach or celebrating Christmas or Hanukah. There is even a term for it—American Born Confused *Desi*, or ABCD. "The traditions of either side of the hyphen dwell in me like siblings, still occasionally sparring, one outshining the other depending on the day," writes Lahiri. "I can see a day coming when my American

have attained cabinet level or won a state governorship. "People who came to the U.S. in my generation through the 1970s and early 80s were in this country to make a good life for themselves," says Inder Sud, a former World Bank economist. Now that Indian-Americans have achieved a substantial measure of economic success, they are prepared to focus on civic activism, he told the *Wall Street Journal.* The U.S. India Political Action Committee, a nonpartisan group formed in 2002 to lobby for issues of importance to Indian-Americans, says that about 60 percent of Indian immigrants vote Democratic, 40 percent Republican. But Republicans are making substantial inroads among Indian doctors, particularly over the issue of escalating malpractice insurance premiums and lawsuits.

While Indian doctors have become a powerful influence in medicine across the world, nowhere is their authority more keenly felt than in the United States, where Indians make up the largest non-Caucasian segment of the American medical community. In fact, so commonplace are Indian physicians that American television viewers could be forgiven for failing to notice that it was an Indian doctor, U.S. Army Major Sam Mehta, who, in May 2006, saved the life of CBS News correspondent Kimberly Dozier in a state-of-the-art trauma center in Baghdad's fortified Green Zone—a chilling incident broadcast around the world. Dozier was gravely wounded, and two of her CBS colleagues and a military escort officer killed, by a car bomb while reporting on what was supposed to be a quiet Memorial Day with American troops patrolling the Iraqi capital. Instead, Dozier ended up on a gurney bleeding to death in front of Mehta.

"We're going to put you to sleep," Mehta calmly told Dozier while a CNN crew recorded the heroics of the Army's 10th Combat Support Hospital staff—heroics that have become sadly routine. "We will take good care of you, OK? We will get you back home, OK?"

Mehta is used to bringing soldiers back from the brink of death, but even by his standards, Dozier's injuries would tax his skills as a surgeon that day.

While Captain Tiffany Fusco rounded up every available doctor, nurse, corpsman, and soldier to donate blood, Mehta fought to stem Dozier's gushing head and leg wounds. "If this would have happened back in the states," says Mehta, "she probably would have died. I think for me, Memorial Day will never be the same." Indeed, Dozier survived her wounds and flew home to the United States to a heroine's welcome from the national media. But perhaps the real hero of this sad vignette stayed behind, on duty, in Baghdad, a reminder to a war-weary nation that Indians are as patriotic and selfless as other hyphenated Americans.

Yet the achievements of highly visible Indian-American professionals blur, in the words of an Indian government report, "the difficulties and prejudices faced by earlier generations of Indian immigrants" to the United States. For example, Punjabi Sikh railroad and farm workers endured hardship and prejudice in the early twentieth century—a time of inflamed anti-Asian passions exacerbated by a large influx of unskilled Chinese, Korean, and Japanese immigrant workers. The some 3,000 Sikhs who settled in the western United States between 1905 and 1915 were denied citizenship—or in some cases stripped of their adopted U.S. nationality. There were anti-Indian riots in Bellingham, Washington, and Sikhs in the Sacramento, San Joaquin, and Imperial valleys of California were barred from owning land or marrying white American women. In 1917 Congress effectively halted immigration from Asia, including India, and Indians were not legally allowed to come to the United States again until 1946. Sikhs, however, went on to prosper in California and today are proud of being able to trace their roots back five generations in America.

"Most Sikhs came here as average guys," says Jasbir Singh Kang, a physician in Yuba City, California, where 10 percent of the population has Punjabi roots. "But their values of free speech and equality of people and the sexes are very compatible with American values." Singh undoubtedly speaks for many Indian immigrants when he says: "A true American is one who has worked their way from the bottom to the top."

Punjab native Pradip Singh races across the Queensboro Bridge toward Manhattan on his noon-to-midnight shift driving a New York taxi. Yellow cabs and South Asians are almost synonymous in the Big Apple, where Pakistanis, Bangladeshis, and Indians account for 60 percent of all yellow cab drivers—or about 20,000 men and a few women.

Keeping traffic moving in Times Square, New York City police officer Nella Latchman is a member of one of the United States' highest-earning, best-educated, and fastest-growing ethnic groups—Indians, or Indian-Americans as they are sometimes called, to avoid confusion with Native Americans. A steady influx of high-achieving immigrants like Ms. Latchman, a native of Trinidad where about 40 percent of the population is of Indian origin, have helped New York avoid the population losses experienced by other northeast urban centers.

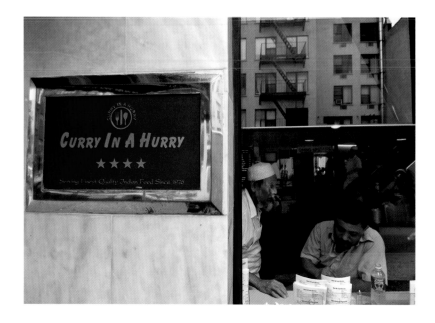

A shopper lingers outside a South Asian supermarket in Jackson Heights, the most polyglot neighborhood in the most ethnically diverse borough of New York City—Queens. As New York's premier "Little India," the shops, curry houses, and restaurants in Jackson Heights just south of LaGuardia Airport attract South Asian patrons from up and down the Eastern Seaboard. Today, Indians share this crowded crossroads with Chinese, Latin American, and Russian immigrants, who live in nearby garden apartments—the first such planned development in the United States that dates to the early twentieth century. Many drivers take their breaks along a tiny stretch of Lexington Avenue between 27th and 30th streets called "Curry Hill," where inexpensive eateries like Curry In A Hurry serve up fried fish, chicken jalfrezi with green peppers and onions, and hot lamb vindaloo cafeteria-style for customers on the go.

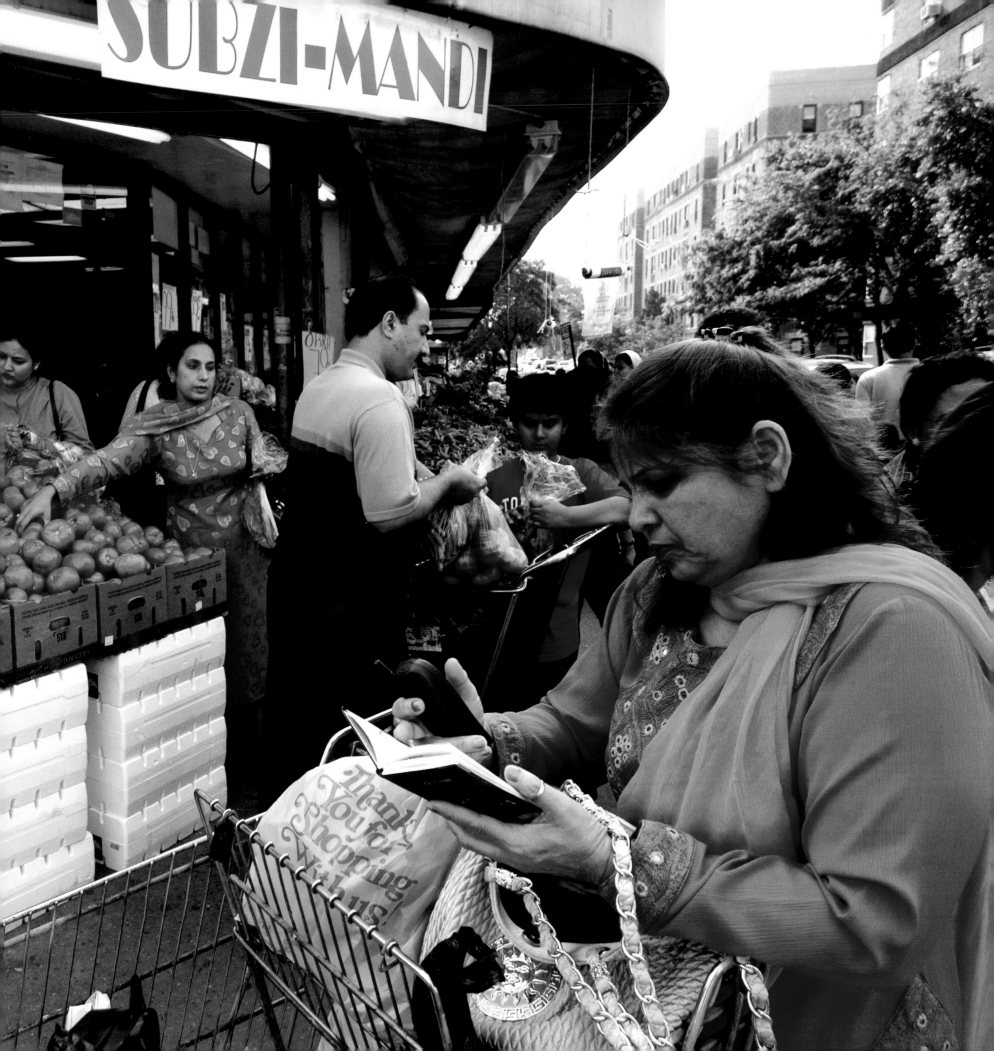

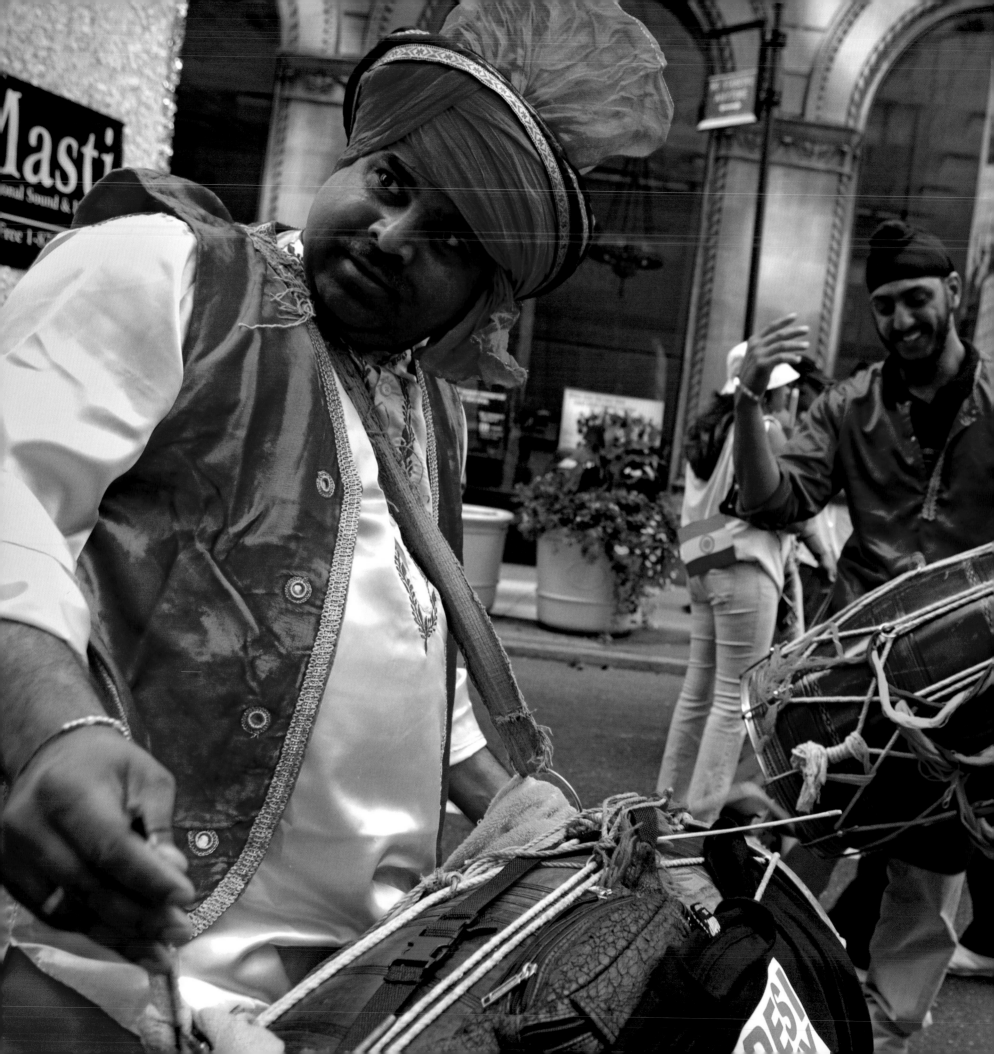

From Devon Avenue in Chicago to Madison Avenue in New York, Indian-Americans celebrate Indian Independence Day with Punjabi bhangra music and its throbbing dhol drums. A New York City police officer keeps a watchful eye on the city's annual Indian Independence Day parade and thousands of flag-waving spectators celebrating the birth of modern India on August 15, 1947. Half a world away in India, the prime minister customarily addresses the nation from the ramparts of the Mughal Red Fort in the old city of Delhi.

Greeting a visitor at the front door, the Raj Gupta family enjoys the quiet suburban comforts of an upper-income American family on Philadelphia's Mainline. Gupta is chairman, president, and CEO of the international chemical giant Rohm and Haas—the first Indo-American to lead a Fortune 500 company. Daughter Vanita is a crusading human rights lawyer with the National Association for the Advancement of Colored People—a stereotype-defying career choice supported by her father and mother, Kamla.

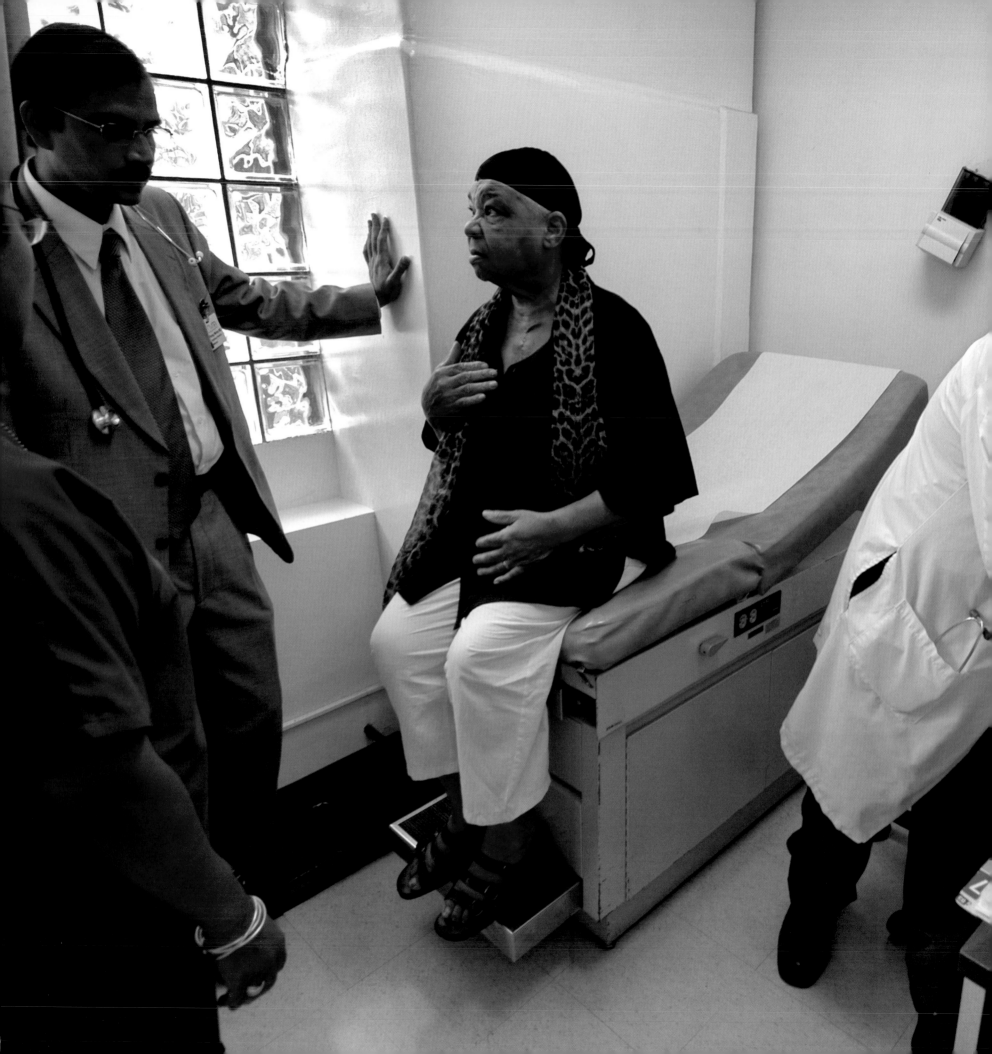

Managing a clinic for immigrants and the indigent at New York Methodist Hospital in Brooklyn, Dr. Parag Mehta (*second from left*) explains a grim prognosis to a Spanish-speaking patient. An internist and attending physician, or teacher, Mehta follows in the footsteps of Indian healers who established medical schools on the Subcontinent more than a century before the Greek physician Hippocrates. Beginning in 1965, South Asian doctors were recruited to fulfill Medicare's promise of free health care for the elderly, but today they find it difficult to stay in the United States unless they work in poor or rural areas after completing specialist training.

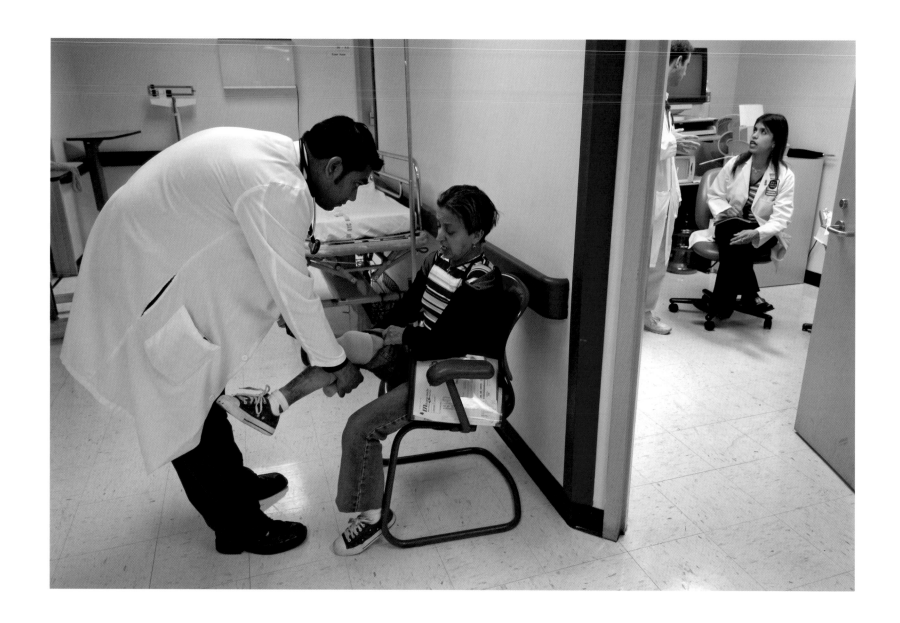

Dr. Rahul Sharma—born in India and educated in the United States with M.D. and
M.B.A. degrees—examines a patient in the urgent care clinic of Bellevue Hospital
Center, one of New York's oldest and busiest hospitals. As a resident, or specialist in
training, in emergency medicine at New York University Medical Center, Sharma plans
to someday become a hospital administrator. In the United States, more than 42,000
physicians of Indian origin account for one in every 20 doctors practicing medicine.

Surgeon Jutin Shah prays for a patient outside an operating room at New York's
Memorial Sloan-Kettering Cancer Center. "When you take on a new patient," says Shah,
author of nine books and nearly 300 peer-reviewed research studies, "it's a life-long
commitment because cancer can come back." While Indian doctors are the mainstay of
primary patient care in large states like New York, Florida, and California, Shah says,
"maybe five percent thrive on the rat race of academic and professional success."

Beauty salons like Pari in Iselin, New Jersey, specialize in "threading," an ancient South Asian practice of pulling facial hairs out at their roots with a length of twisted thread. More than 100 Indian businesses, including 53 restaurants, line Oak Tree Road in the villages of Edison and Iselin in central New Jersey— home to recently arrived South Asian immigrants and an increasing number of affluent Indian professionals and technocrats in the New York Metro area. South Asian households in Edison earned $92,732 a year, or $15,000 a year more than their white neighbors, according to 2005 U.S. Census Bureau figures.

Fareed Zakaria, one of America's most prominent journalists and intellectuals of Indian origin, considers a cover for *Newsweek International*, where he is editor-in-chief. Zakaria also writes a popular foreign affairs column for *Newsweek*, appears on ABC News, and has his own television show called "Foreign Exchange." A graduate of Yale and Harvard universities, he is author of *The Future of Freedom*, which has been translated into 18 languages. Standing in his apartment on New York's Upper East Side, well-known author Ved Mehta says it is a "myth that Indians are very spiritual people. The irony is that they are very materialistic and they can make a better life here in America."

Indian-born and Harvard-educated filmmaker Mira Nair is one of the few female directors to climb to the top of an industry dominated by Hollywood with her movies that document social injustice and close encounters between East and West. Nair is probably best known for her independently produced hits, including *Mississippi Masala, Salaam Bombay!, Monsoon Wedding,* and *The Namesake.*

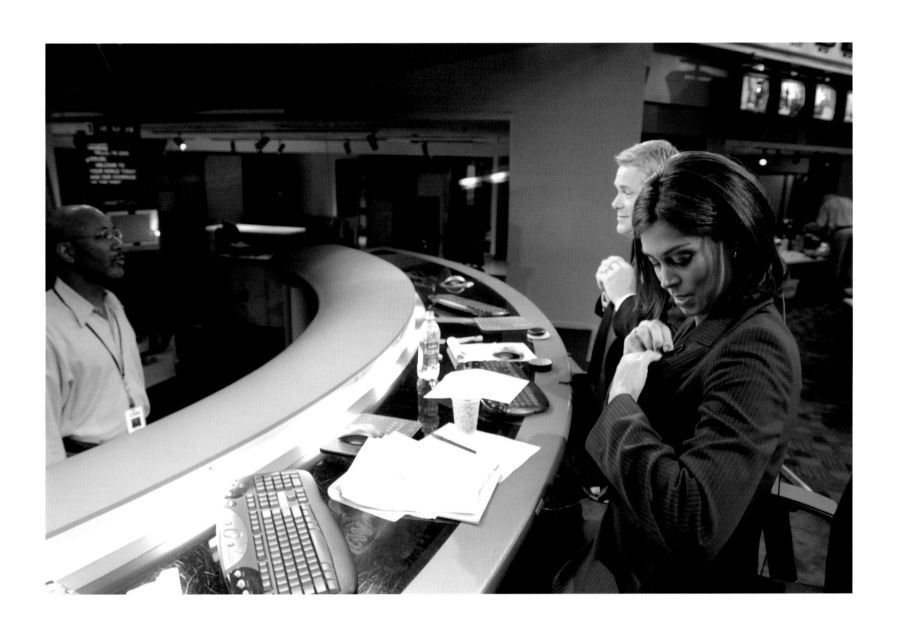

CNN correspondent Zain Verjee clips on her microphone before anchoring the news from the network's Atlanta newsroom. A Muslim from Kenya with roots in India's Gujarat state, Verjee covers the U.S. State Department in Washington and has reported on the war in Iraq, the trial of former Yugoslav leader Slobodan Milosevic, and the *Hajj* pilgrimage to Mecca.

Technology executives match their enthusiasm for
business deals with their love of sweets at the annual
conference of The Indus Entrepreneurs, or TiE, in
Santa Clara, California. With more than 40 chapters
worldwide, TiE helps South Asians, venture capitalists,
and other "globalists" find partners, money, and
advice. Coffeeshop owner Philip Adams in affluent
Mill Valley, California, came to the United States in
1967 from the South American nation of Guyana,
where Indians make up about 50 percent of the
population. Adams started work as a Bay Area
dishwasher and eventually became general manager
of Zim's, a popular San Francisco restaurant.

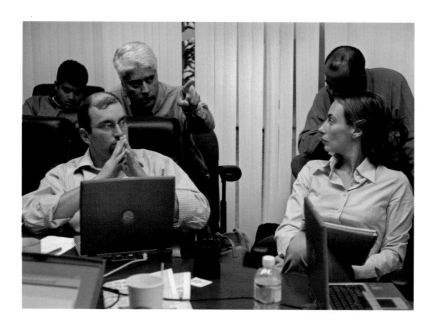

A self-described "serial entrepreneur" who creates high-tech companies and takes them global, Prem Uppaluru, president and chief executive officer of Transera, points to a sales opportunity during a staff meeting at his Silicon Valley startup. Prem, as he is called in technology circles, says "the U.S. was the only source of opportunity for my generation, but in the next 20 years there will be tremendous opportunity in the U.S.A.-India corridor." At Cisco Systems in San Jose, India native and Stanford University graduate Anand Pandharikar checks computer networking gear.

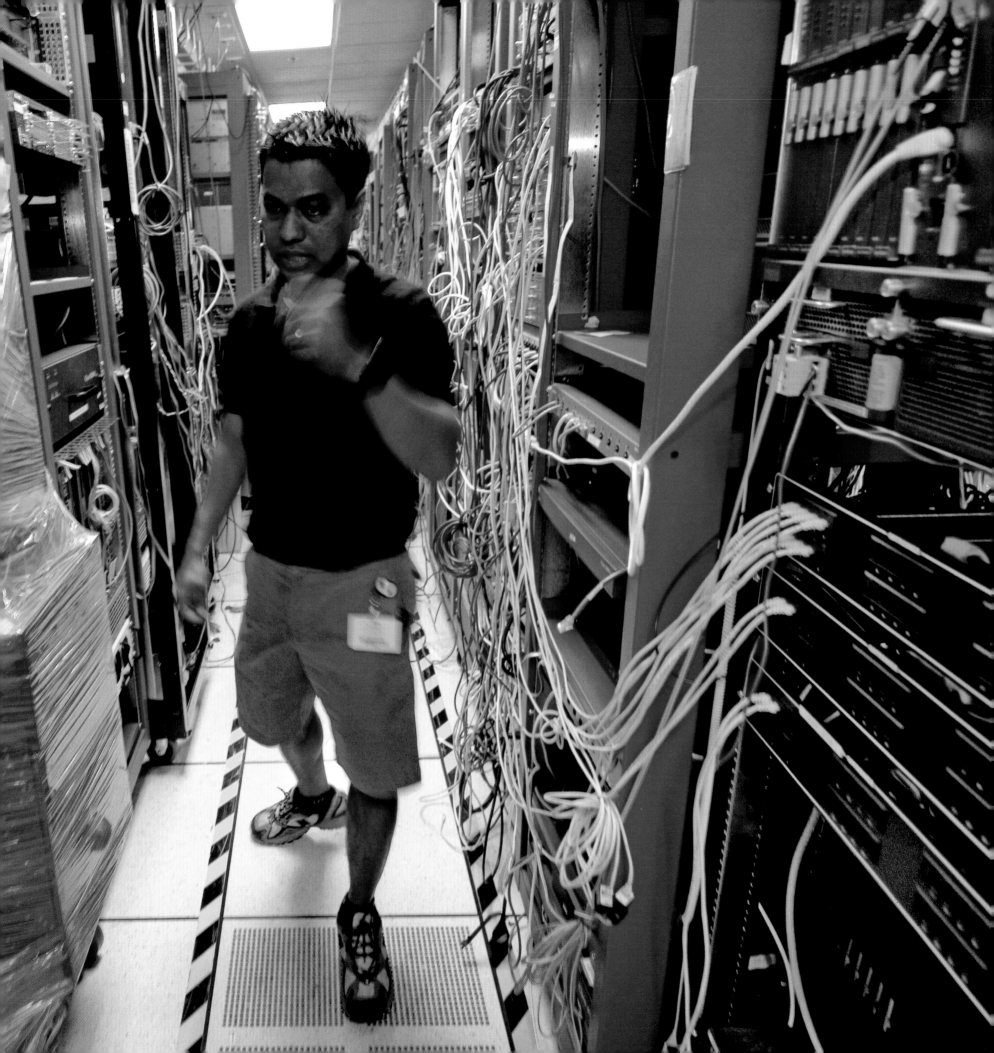

Nurturing almond trees that will help produce California's leading agricultural export crop, Sikh farmers of Punjabi origin take a break under a blistering sun at a nursery in the Sacramento valley near Yuba City. Almond exports earn California farmers about $1.5 billion a year—surpassing wine, cotton, table grapes, and dairy products.

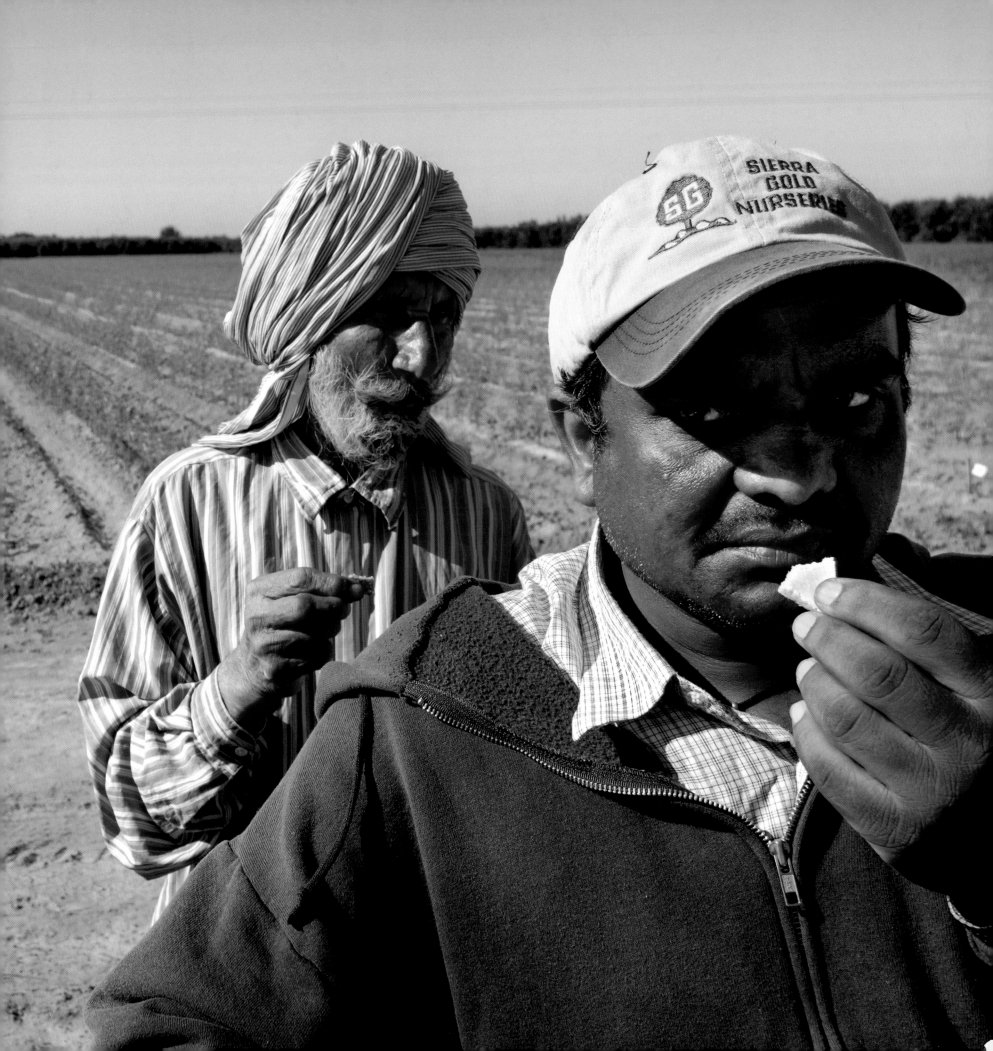

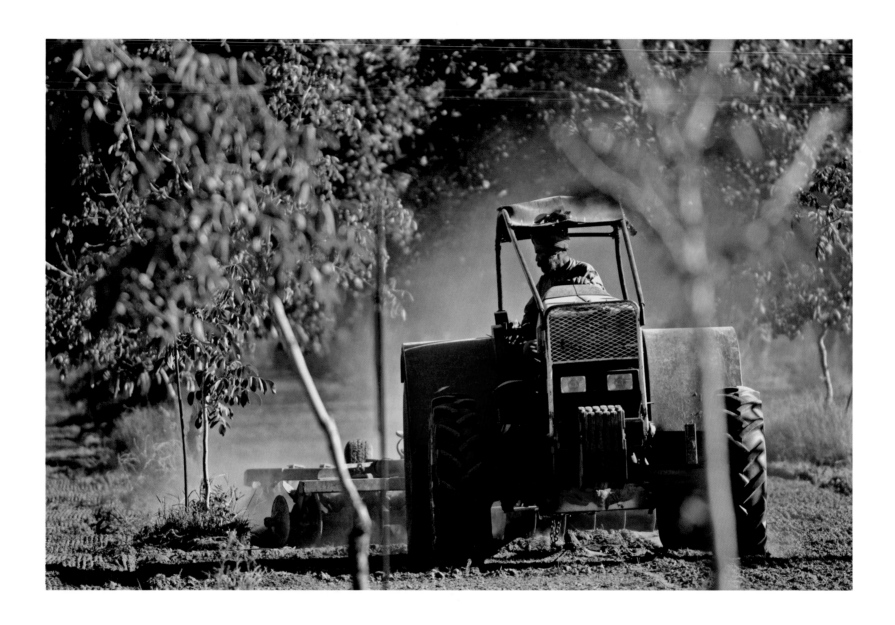

Turbans and tractors dominate Sutter County, California, where more than 10,000 Sikh farmers tend fruit and nut orchards. Sikhs also dominate medicine in nearby Yuba City, as well as run gas stations, mini-markets, boutiques, restaurants, hotels, construction, banking, and engineering firms. The local Punjabi American Heritage Society annually stages a festival that draws thousands of Sikhs from across North America.

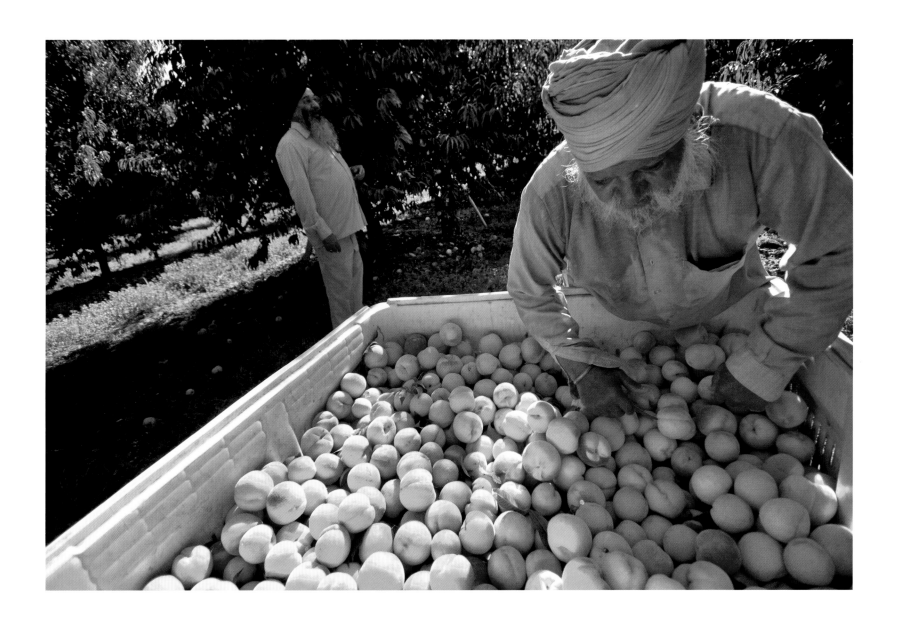

For septuagenarian Bant Nizzar, who sorts peaches in a Sutter County orchard, and thousands of other Punjabis in California's Central Valley, one of the most urgent concerns is being mistaken for Muslim extremists because of their beards and turbans. Temples in Stockton and Lodi have been damaged and three Sikh cabdrivers shot, two of them fatally, in the Bay Area since the September 11, 2001, terrorist attacks.

Gazing across Silicon Valley, a turbaned devotee waits for Sunday prayers to begin at the San Jose Sikh Gurdwara, one of six temples in the South San Francisco Bay Area that caters to some of the estimated 50,000 Sikhs in northern California. Beneath the temple's main golden dome, the words "God is One" are painted on a sky blue ceiling. The gurudwara echoes many of the Mughal-style temples in the Punjab state of India, home of the 500-year-old Sikh religion, and has doors on all four sides, symbolizing that everyone is welcome from all directions.

Padded to protect legs and hands from the hard leather cricket ball, a batsman takes some last-minute practice swings at a match in San Jose. Cricket is king among South Asian sportsmen in the San Francisco Bay area, where the Northern California Cricket Association fields 19 teams. After winning a daylong match, Bangalore native Chandrodaya Prasad, a Cisco Systems software engineer and backbone of the Santa Clara Cricket Club, shows perfect cricket etiquette with a firm handshake and kind words to the losing Marin County team.

Epilogue
The Reverse Diaspora

Residents of the South Indian city of Bangalore, once an orderly enclave of colonial-era buildings and gardens popular with retirees, are turning to earplugs to dampen noise from chauffeur-driven cars, Japanese minivans, motor scooters, and the occasional bullock cart—noise that regularly reaches 120 decibels day and night. Over the last decade, Bangalore, or Bengaluru in the local Kannada language, has been transformed into an Indian version of Silicon Valley, complete with California-style suburbs and campuses made of steel and glass that are connected to the global economy by plasma screens and high-speed internet connections. Call centers, software and engineering companies, and some of the world's most advanced research centers prosper on the capital—both human and monetary—of Indian émigrés recently returned from abroad with foreign passports, foreign bank accounts, and families sometimes more Western than Indian.

Bangalore's frenzy is emblematic of the reverse brain drain—or reverse diaspora—that is helping propel India onto the world stage in ways that were unimaginable just a few decades ago, when Indians routinely thought the only way to get rich was to go abroad to work or study. By one estimate between 30,000 and 35,000 information technology professionals have returned to India from overseas in just the past few years, most to the suburbs of New Delhi, Hyderabad, and especially Bangalore, the nexus of what Indians call their "brain gain." At Bangalore's decrepit airport, packed airliners arrive from London, Paris, Frankfurt, and Singapore bearing Indians with degrees from the world's top universities and plans to reconnect to Mother India, whose economy is growing at twice the pace of the United States.

Americans, particularly in California, see Bangalore as both a threat and an opportunity. A threat because it now boasts 150,000 technology workers compared with about 120,000 in Silicon Valley. Moreover, much of this brainpower, especially at the middle and top levels, has been transplanted from the San Francisco Bay area to India. Bangalore also represents an opportunity for U.S. companies to tap into India's prodigious brainpower and entrepreneurial spirit. From Bangalore, Americans and citizens of other developed countries are having their tax returns prepared, their CAT scans and MRIs read, mortgages analyzed, lawsuits researched, airline reservations confirmed, and computer glitches unsnarled—all at the speed of light, thanks to broadband internet connections that make the city as close as the shop or hospital next door.

As Bangalore moves further up the technology ladder, this city of at least 6.5 million is expected, over the next several decades, to challenge places like Silicon Valley and the Research Triangle at Raleigh-Durham, North Carolina, as a world center for innovation. Microsoft plans to spend $1.7 million in India over the next several years and has opened a research center there, following on ones in Redmond, Washington, Cambridge, and Beijing. IBM, Oracle, Cisco Systems, Intel, and Hewlett-Packard also have campuses and research centers in Bangalore staffed, in part, by returnees from abroad.

The corporate headquarters of Infosys Technologies Ltd., India's second-largest outsourcing firm, are tucked away in a section of Bangalore called Electronics City, which may be a slight misnomer considering the shantytowns and swarms of poor Indians living along its fences. But the view inside the Infosys campus is buoyant with double-digit profit margins, revenues in the low billions of dollars, and plans to hire many thousands of new employees worldwide over the next several years. On its smartly turned-out campus, there are buildings that mimic the Sydney Opera House and the famous Pyramid at the Louvre Museum in Paris, along with food courts, gyms, and a putting green for employees, including returnees from abroad attracted by the Western-style work environment and generous paychecks. In an interview with the *New York Times*, Nandan M. Nilekani, Infosys chief executive and co-founder, said, "Expatriates are returning because India is hot."

Typical of those young Indians moving Infosys into the top ranks of global companies is Smita Agrawal, a savvy marketing manager who has worked in Tokyo, Minneapolis, Los Angeles, and Little Rock, Arkansas. Preferring Western business attire to saris, she nevertheless finds being back in India to her liking. "After office hours is where you lose out in the U.S.A.," she says. "There's a cultural gap in America and you just don't have the face-to-face interaction with Americans that we have here in India." Saying that "Bangalore and its messiness takes some getting use to," Ms. Agrawal nevertheless sees India as a place where she can enchance her career. "Here we have time to undergo training," she says over coffee. "And I don't remember a day in the States when I woke up and had time to read the newspaper with breakfast."

Peers at companies from Yahoo! to startups that only the digital cognoscenti would recognize agree that being part of the reverse diaspora—or as Ms. Agrawal calls it, "the whole 'India Shining' thing"—has its satisfactions, both professional and cultural. In Bangalore and other major cities, there is no shortage of luxury shopping malls and housing developments to help lure home expatriates who already are the highest-paid ethnic group in the

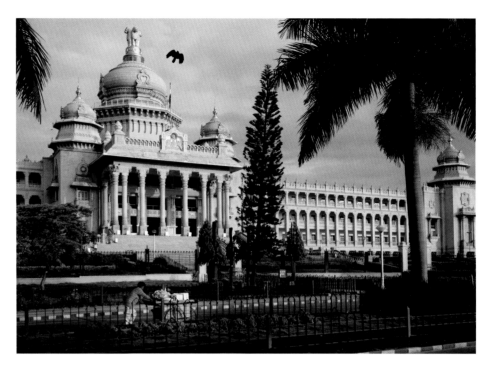

United States. At Palm Meadows, one of several gated communities in Bangalore where the technology-sector elite live, it would be hard to find an Indian passport holder, aside from the maids and gardeners.

Ajay Kela, president of a technology startup called Symphony Services, looks around his neighborhood of four-bedroom Spanish-style villas and says he made his decision in a day to pull up roots in Foster City, California, and return to India. "India is an efficient location for software design and besides, the middle class is exploding here," Kela says. As proof, he looks at his neighbors, all information technology executives from California and the United Kingdom—most, like Kela, with dual nationality and children born abroad.

But the move back to India hasn't been problem-free, Kela and his fellow executives admit. There are the grinding commutes over potholed roads, a yawning gap between educated and poor, and a mind-numbing conformity that inhibits the creative "outside of the box" thinking associated with Palo Alto or Raleigh-Durham. "There is raw talent in India," says Sridhar Ranganathan, managing director of a startup called Blue Vector and a former Yahoo! executive. "But how to polish that talent is India's dilemma and my challenge."

A marvel of neo-Dravidian architecture and one of India's most imposing buildings, the Vidhaan Soudha in Bangalore houses the legislative and government offices of Karnataka state. The gleaming domes, pillars, and archways resemble the old palaces of nearby Mysore. Inside the Vidhaan Soudha, lawmakers recently decided to change the name of Bangalore to Bengaluru, which is close to the original, pre-colonial name in the local Kannada language and literally means "the town of boiled beans."

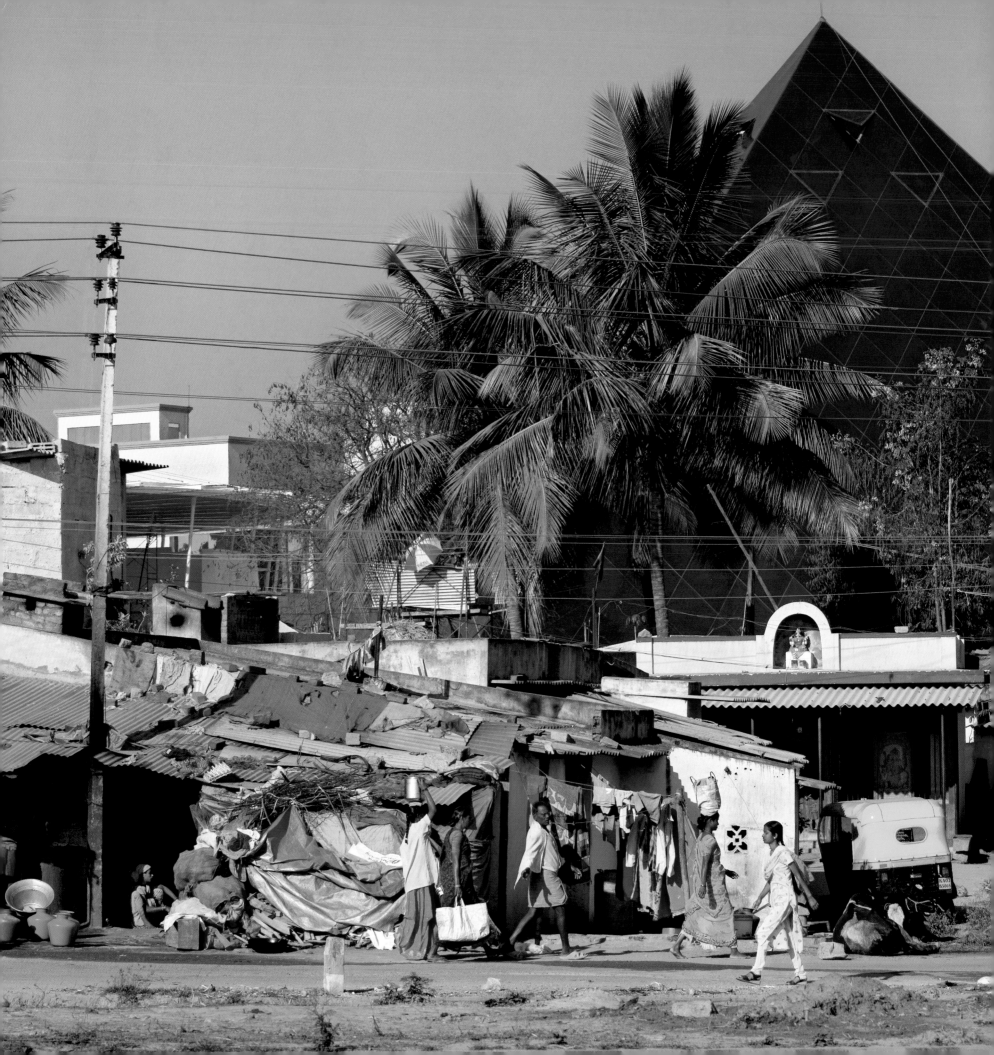

A replica of the famous Pyramid at the Louvre
Museum in Paris—one of the signature
buildings on the campus of Infosys Technologies
Limited—looms over a shantytown in
Bangalore, a juggernaut of a city known for high-tech
products, research centers, and venture capital firms.
Listed on the NASDAQ exchange, Infosys is India's
leading software exporter and earns most of its
revenues from exports, more than two thirds of them
to the United States. Smita Agrawal, who worked in
Japan and the United States before returning to her
native India, talks with a colleague at an Infosys
campus snack bar.

Scooters weave through Bangalore's chaotic traffic on
Mahatma Gandhi Road, known as South Parade in the
days of the Raj. With pot-holed roads too narrow for the
traffic they bear, the city has an exploding middle class
that adds nearly 1,000 new vehicles a day to overtaxed
streets. India's first Kentucky Fried Chicken outlet
opened in Bangalore in 1995, sparking allegations—all
unproven—of cancer-causing ingredients in the food
KFC sells. Undeterred by protests from animal rights
organizations, KFC's parent company plans to roll out
more than 1,000 KFC and Pizza Hut outlets by 2014 to
satisfy India's surging demand for all things Western,
including fast food.

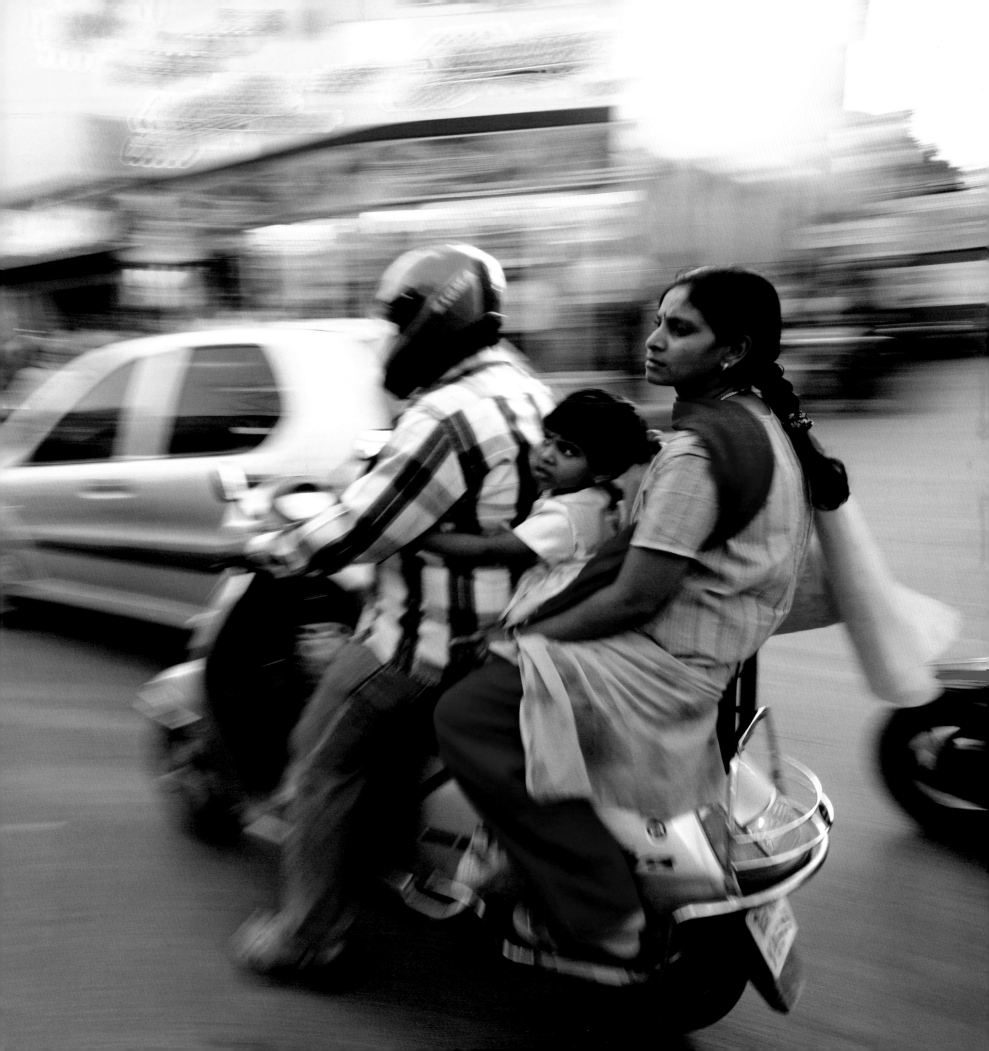

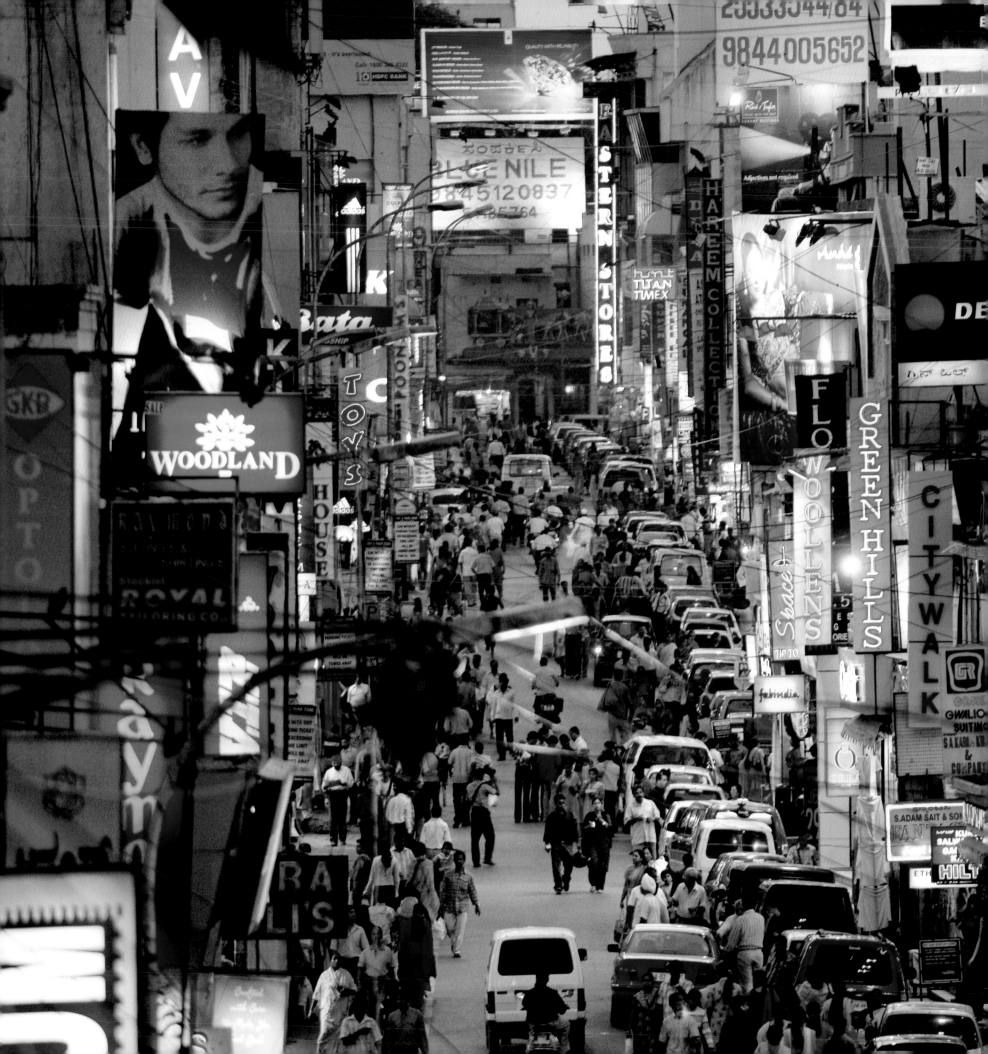

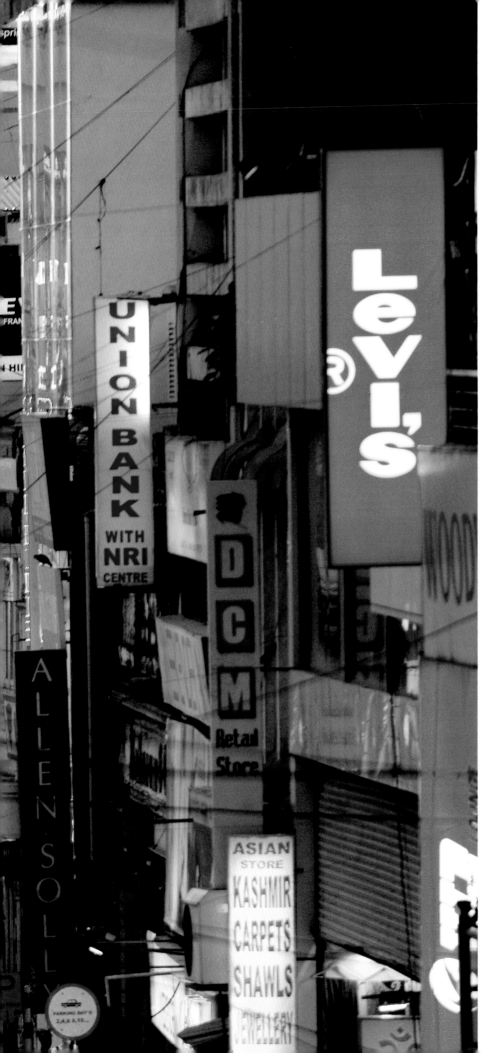

Reflecting the increased spending power of Indians, including those recently returned from abroad, Commercial Street in Bangalore is awash in competing neon signs advertising both international and homegrown brands. The third-largest city in India after years of breakneck expansion, Bangalore is fast emerging as an important manufacturing and distribution hub for top international brands, including Adidas-Reebok, Calvin Klein, Tommy Hilfiger, and Great Britain's Marks & Spencer. Nearly 2,000 textile and garment factories are located in and around the city.

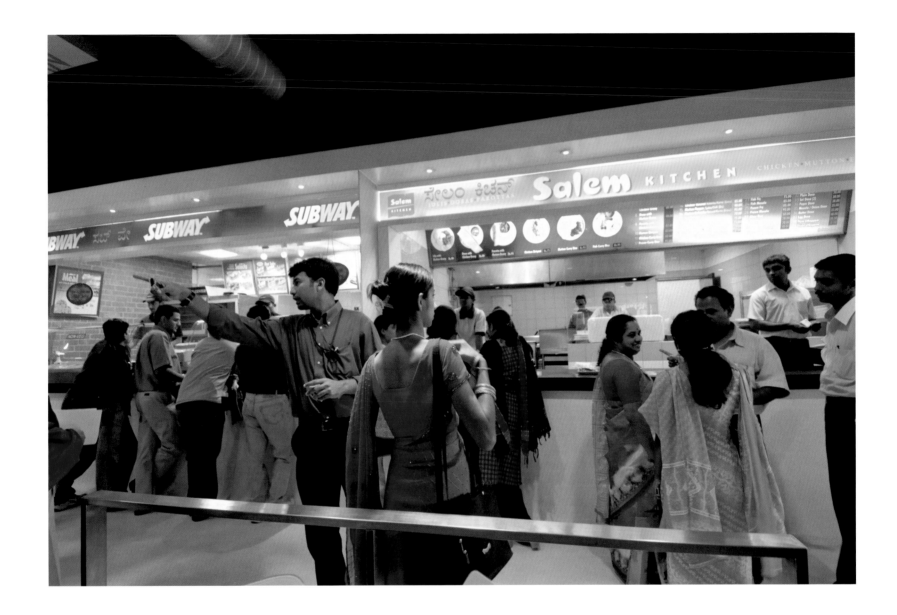

Bangalore's emerging middle class, dominated by thousands of high technology
workers, favors fast-food restaurants, both international and homegrown.
Restaurants like Pizza Hut, Subway, and Salem Kitchen, a local outfit offering more
than 100 dishes, caters to the city's round-the-clock, seven-days-a-week work ethic.
The young and newly rich also gravitate to an abundance of bars and pubs that have
earned Bangalore the moniker Pub City of India.

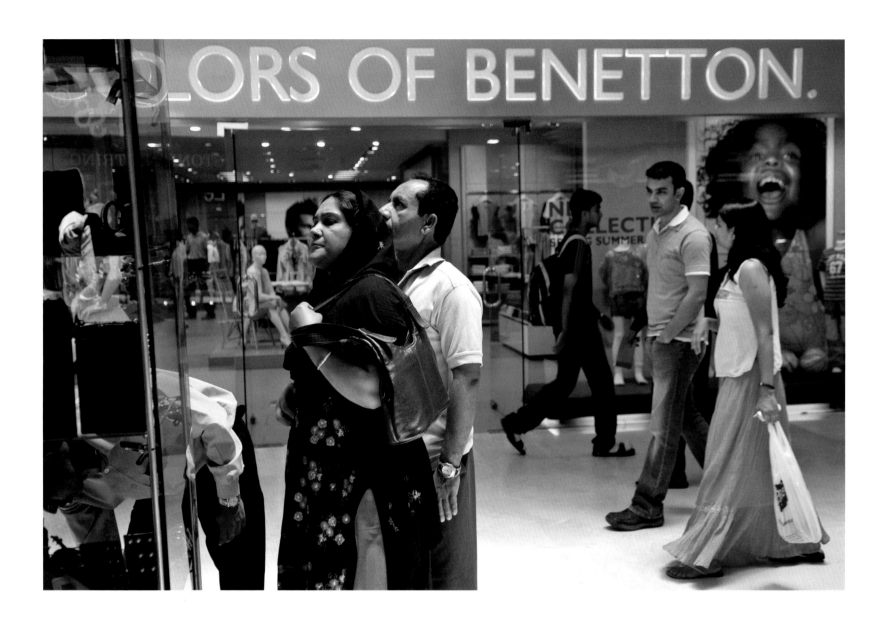

Shrewd shoppers looking for international brands tailored for the Indian market patrol the isles of the 300,000-square-foot Forum Mall in Bangalore. A decade ago, Indians returning from abroad lugged overstuffed suitcases full of consumer electronics and brand name fashions. But today Indian malls are full of the latest merchandise from the United States, Europe, Japan, and China.

Sealed off from the clamor of India, where as many as 800 million people survive on less than $2 a day, American-born Payal Kela and her dog Cookie find security inside the gates of Palm Meadows, one of dozens of enclaves in Bangalore for returning Indian families—many from California. The red-tiled villas sell for upwards of $500,000 and help ease the cross-cultural problems that both children and parents experience by recreating part of what they left behind in America. Kela's father, Ajay, president of a software company, and her mother, Monisha, and brother, Ankur, look over the Palm Meadows pool and clubhouse, where families order out from nearby Pizza Hut and Domino's.

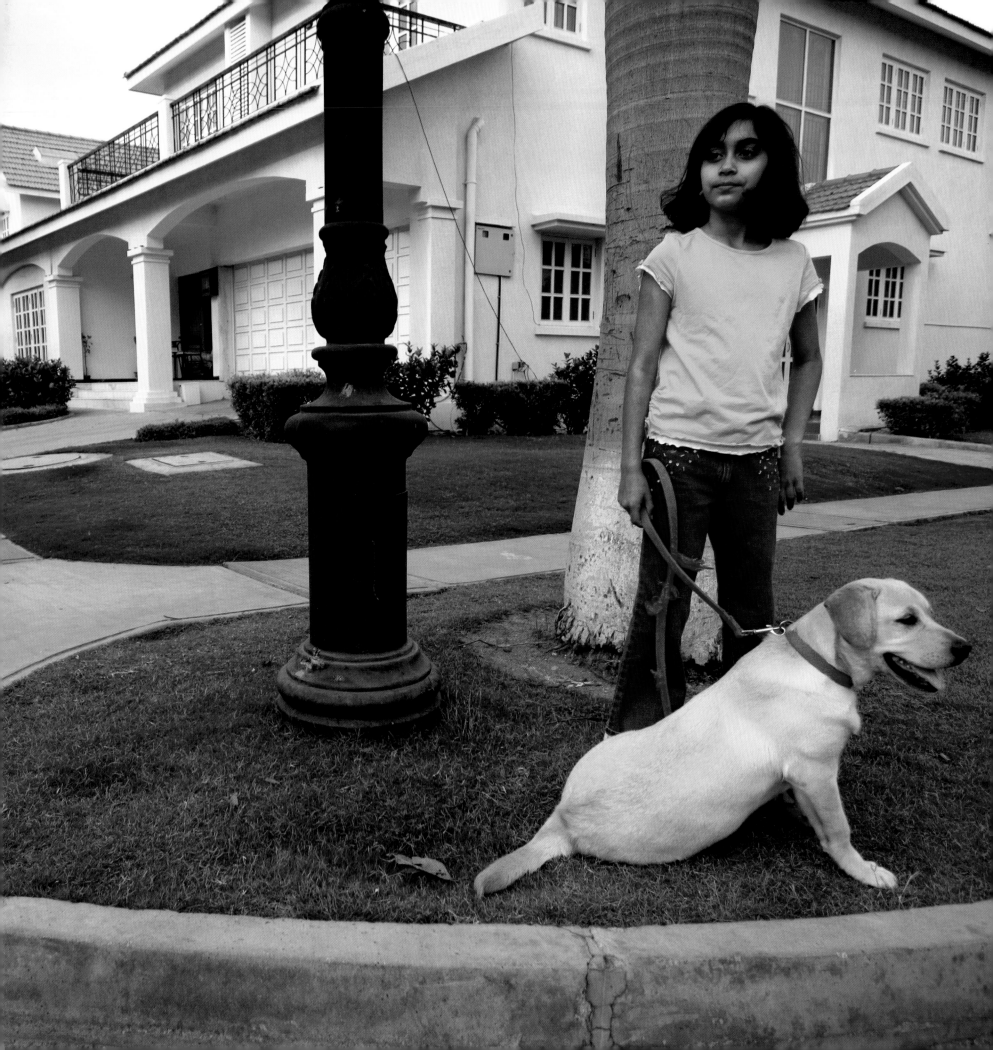

About the Author

Steve Raymer, a *National Geographic* staff photographer for more than two decades, teaches photojournalism, media ethics, and international newsgathering at Indiana University, Bloomington. He is also on the advisory committee of the university's India Studies Program.

Raymer earned B.S. and M.A. degrees at the University of Wisconsin–Madison and studied Soviet and Russian affairs at Stanford University as a John S. Knight Journalism Fellow. After service as a lieutenant in the United States Army, he joined the staff of *National Geographic* in 1972, launching a career that has taken him to more than 85 countries. From famines in Bangladesh and Ethiopia to the collapse of the Soviet Union, Raymer's photographs have illustrated some 30 *National Geographic* articles. From 1991 to 1995, Raymer was the director of the National Geographic Society News Service, a joint venture with the *New York Times* and the Associated Press.

Raymer is author and photographer of *St. Petersburg*, a 1994 illustrated book about the imperial Russian capital, and *Living Faith: Inside the Muslim World of Southeast Asia*, published in 2001. He also is photographer of *Land of the Ascending Dragon: Rediscovering Vietnam* (1997) and *The Vietnamese Cookbook* (1999).

In 1976, the National Press Photographers Association named Raymer "Magazine Photographer of the Year"—one of photojournalism's most coveted awards. He has received a citation for excellence in foreign reporting from the Overseas Press Club of America and is winner of numerous awards from the White House News Photographers' Association, as well as a Fulbright Research Fellowship from the U.S. State Department.

Raymer has lectured on photojournalism, international newsgathering, and war correspondence in the United States, Great Britain, Russia, Poland, China, Malaysia, Singapore, the Philippines, Hong Kong, and Vietnam. He also has appeared on the "Today Show" and as a panelist and lecturer on war correspondence at The Freedom Forum Newseum in Washington, D.C.

Nayan Chanda, a distinguished foreign correspondent and author, is editor of *YaleGlobal Online* magazine at the Yale Center for the Study of Globalization. As a Reuters correspondent he covered the fall of Saigon in 1975 and was correspondent and editor of the *Far Eastern Economic Review*. Chanda is author of *Brother Enemy: The War After the War; Bound Together: How Traders, Preachers, Adventurers, and Warriors Shaped Globalization;* and many other works on Asian politics, security, and foreign policy.